HOT ROCKS

ALSO BY LEV RAPHAEL

HOT ROCKS

A Nick Hoffman Mystery

LEV RAPHAEL

PERSEVERANCE PRESS / JOHN DANIEL & COMPANY
PALO ALTO / MCKINLEYVILLE, CALIFORNIA, 2007

This is a work of fiction. Characters, places, and events are the product of
the author's imagination or are used fictitiously. Any resemblance to real
people, companies, institutions, organizations, or incidents is entirely
coincidental.

A PERSEVERANCE PRESS BOOK
Published by John Daniel & Company
A division of Daniel & Daniel, Publishers, Inc.
Post Office Box 2790
McKinleyville, California 95519
www.danielpublishing.com/perseverance

Distributed by SCB Distributors (800) 729-6423

Book design by Eric Larson, Studio E Books, Santa Barbara
www.studio-e-books.com

Cover photograph from Getty Images

10 9 8 7 6 5 4 3 2 1

LIBRARY OF CONGRESS CATALOGING-IN-PUBLICATION DATA
Raphael, Lev.
 Hot rocks : a Nick Hoffman mystery / by Lev Raphael.
 p. cm.
 ISBN-10: 1-880284-83-9 (pbk. : alk. paper)
 ISBN-13: 978-1-880284-83-4 (pbk. : alk. paper)
 1. Hoffman, Nick (Fictitious character)–Fiction. 2. Personal trainers–
Crimes against–Fiction. 3. Physical fitness centers–Fiction. 4. Gay men–
Fiction. 5. Michigan–Fiction. I. Title.
 PS3568.A5988H67 2007
 813'.54–dc22
 2006028755

for Krissy

"mon ange, ma soeur"

ACKNOWLEDGMENTS

For medical information of various kinds, my thanks go to Dana D'Haem, R.N. and Dr. James Richard, D.O. of the Ingham Regional Medical Center. Officer Erin Linn, Meridian Township Police, was very helpful in the early stages of this book.

Brandi Johnson gave me information about personal training from the standpoint of trainers, as did my friend Chris Johnson, Director of Business Development at the Michigan Athletic Club.

GK Consulting, Inc. came through with advice whenever called upon and I took advantage of its full range of services, finding the rates so reasonable, and the staff so very accommodating.

The health club depicted in this book is not a portrait of the Michigan Athletic Club, and any similarity between characters or events in this book and persons living or dead is entirely coincidental.

Who's Who

(who they think *they are is something else)*

Nick Hoffman, professor of English composition at the State University of Michigan (SUM)

Stefan Borowski, his partner & writer-in-residence at SUM

Vlado Zamaria, head trainer at Michigan Muscle health club

Dr. Alfred Aftergood, cardiologist

Juno Dromgoole, professor of Canadian Studies at SUM

Franklin Pierce, wealthy right-winger

Detective Darius Fahtouzi, Michiganapolis Police Dept.

Barbara Zamaria, Vlado's wife

Heath Wilmore, new manager of Michigan Muscle

Fred Gundersen, trainer at Michigan Muscle

Robert Kleinstein, member of Michigan Muscle

David Karamata, member of Michigan Muscle

Celia Aftergood, Alfred's wife

Jean-Marie Bourguignon, restaurant owner

Ruby Strockbine, member of Michigan Muscle

Fabian Albahari, trainer at Michigan Muscle

Eric Romanov, Michiganapolis jeweler

Maureen Jones, the Zamarias' neighbor

Merry Glinka, SUM's provost

Byron Summerscale, chair of Nick's department

Parker Bush, SUM attorney

PART ONE

Surely one does not have to read history very much or ponder over philosophy a great deal in order to realize the truth that the one certain way to invite disaster is to be opulent, offensive, and unarmed.

—*Theodore Roosevelt*

1

EVEN AFTER CLOUDS OF STEAM in the steam room had begun to clear, it took me a while to realize that Vlado was dead.

At first I thought he was asleep, because lots of guys fell asleep in the handsome steam rooms or saunas at Michiganapolis's toniest health club (there was a steam room and sauna in each of the men's and women's locker rooms). It was easy enough to do, I suppose. Each steam room was fragrant with eucalyptus and dark as well as warm, with only a brace of low-wattage bulbs in pendulous frosted-glass fixtures flanking the inside of the heavy glass door. The two-tiered bench seating along the left and back walls was wide enough and long enough to lie down on comfortably. That is, if warm, wet tile was your idea of comfort.

Of course, you risked getting sat upon when the steam was thick and you were almost invisible to anyone walking in, but that didn't seem to bother the guys who did sack out there now and then. Most of them were old and overweight and spent more time talking when they were in the gym than working out. The kind of guys who would flock around a decrepit ex-college football coach at a bar, buy him drinks, and press him for his opinions on everything in the world, reverently calling him "Coach" as if he had no other name and using his title gave them a share of his former glory. Talkers, idlers, loungers. For them, even if they did play an occasional game of tennis or lift a weight or two, the gym was more of a men's club

than anything else. They sat around. They moaned about getting older. They talked sports, politics, weather, the stock market. Their wives came up, sometimes. The really old ones joked about their bowel movements and compared surgeries and medications.

These men took up more than just physical room, for many of them had become rich in the Michiganapolis area through real estate, medicine, or law and were so used to deference–or at least to talking over other people–that even their silences were loud. They lived in a world of entitlement at the gym: they left their soggy towels on the floor, didn't bother to wash shaving-cream globs dotted with beard hair down the sink, and clipped their toenails on the locker room benches without cleaning up the mess. Someone else would surely do it for them, so why bother considering anyone's discomfort or disgust? It seemed to me that with the opening years of the twenty-first century and a change in America's government, their sense of privilege and their swagger had increased. The world had bowed before the power of their champion, and they followed in his messy wake.

Vlado Zamaria took up room, too, but in a different kind of way. Swarthy-faced, he was one of the best-built trainers at the club, with an almost perfect body that overshadowed his Balkan good looks (Byronic hair, ironic eyes). Tall, lean, muscular, and hairless, he had enormous, long thighs that were so veined and rippled they seemed to have a life–or at least an intent–of their own. He had in fact been a college sprinter and had taught kickboxing before being hired at the club as head of personal training.

He worked out with quietly demonic intensity, as if each rep were his last, but he wasn't at all like those hardcore weight lifters with their grotesquely convex and concave bodies. Men like that, who looked like tufted leather sofas and actually seemed to creak when they walked, those men made me think of the steroids and other drugs sluicing through their bodies.

Though Vlado's typical pace was a cross between strutting and gliding, there was a strength in his limbs that brought to mind the clean power of a marathon, or something more violent, perhaps, like the "mad pursuit" that Keats saw on his Grecian urn. Vlado did not ever waddle, the way so many weight lifters did.

Vlado was understandably arrogant about his body, and would have long conversations in the nude in the locker room, towel exiguously draped over a shoulder as if posing for a sculpture, one hand affectionately cupping his weighty package from time to time as if to keep it warm, or to prevent it from feeling lonely. I think this posing creeped some guys out, but the rumors at the gym were that women couldn't get enough of him.

Though he was Croatian and not Romanian, because of his name he was sometimes called either "Vlad" or "the Impaler" by people who worked out with him or by other trainers (like the nickname of the original Dracula whose name was Vlad). Our Vlad loved the nickname, didn't find it remotely offensive, because it was understood to refer to his personal stake, so to speak, though in Vlado's case, spelling it "steak" would have been just as appropriate.

When I'd stepped into the steam room and noticed him lying off to the left on the upper level, I could just make out his face and high-arched feet in the swirling fog, and then it steadily rose so high that he disappeared, which was fine with me. Looking at men that perfect depressed me; no matter how hard I worked out and how cleanly I ate, I would never come even close, now that I was middle-aged and gravity was taking hold of me. Hell, levity was taking a toll, too.

I just couldn't work out seriously anymore. Even swimming too much, too hard, bored me—and I'd been swimming most of my life. I'd recently read an article in the *New York Times* about the American fantasy of perpetual renewal as far as the body was concerned—that you could smoke for decades but if

you gave it up and started jogging, you'd repair the damage. A cynical doctor had been quoted in the article as saying that when you hit middle age, perfection wasn't the point, the goal now was just "functionality." Though I didn't run anymore because my knees were shot, by working out, I was running in place, trying not to fall behind. And even though I was in marginally better shape now than I'd ever been, I was still middle-aged, and nothing could change that. Except getting older. Or death.

I'm not sure how long I'd been in my self-created post-work-out fog before I glanced over at where Vlado lay and thought, He's been very quiet. There was no way of knowing the duration of my daze, but I was sure that I hadn't heard him snore, or stir, or even sigh contentedly as long as I had been there. As the steam began to dissipate in its regular cycle, I could make out that his position was a bit odd: He was partly on his side and one arm hung down off the top bench.

I peered across at his broad, dark chest. It did not seem to be rising and falling. His face also seemed to be preternaturally still.

Suddenly I realized his position reminded me of a famous English painting: *The Death of Chatterton*, where the young poet is pictured lying on his side in a garret, head slumped, one arm brushing the floor, palm up. Was Vlado dead?

I know people always say they feel a chill when something terrible happens, or when they're just afraid something terrible *will* happen, but I started to feel hotter and sweatier than I'd ever felt in the steam room before, almost feverish. I tried not looking at Vlado, but I couldn't stop staring, and I knew I had to do something, get up, walk over and see if he was really not breathing or just deeply asleep. Maybe he'd passed out?

But I couldn't move. No, it was worse than that. I didn't *want* to move. Like a little kid who hopes that staying in bed will somehow keep a school day filled with humiliating tests and bullies from starting, I had succumbed to magical think-

ing. If I stayed where I was, nothing would happen, my day would proceed as usual and my life would be untouched by darkness.

"Hey, Vlado," I said, "how's it goin' ?"

No response. Trying to sound hearty and not intrusive, I raised my voice: "You okay, bud?"

Nothing.

I could just walk out, I thought wildly. Head out of the steam room, grab the towel I'd left hanging outside the door, step into a shower, let someone else, anyone else, find Vlado and take over. If it turned out he was dead and I was questioned about what I'd seen, I could just plead the Steam Defense: "What? I thought I was alone! How could I see anybody with all that steam?"

But as the room continued to get clearer, Vlado's body seemed to loom larger and larger as if I were in a runaway car heading off a road right into an enormous, punishing tree. And still I hesitated.

"You're a coward," I finally said aloud, shocking myself into action. I stood up, wishing I'd brought my towel inside to sit on because now I could wrap it around me like a warrior girding his loins. Feeling awkward about my own nudity, I approached the other side of the steam room. It was definitely creepy being naked and walking over to where he lay seeming even more naked, because he didn't react to my being there.

Vlado's eyes were closed. Peering closer in the dim room, I couldn't detect any motion in his chest or his face. Movie scenes popped into my mind of people holding mirrors up to someone's nose or checking for a pulse, but I didn't have a mirror and I couldn't imagine touching him.

Could he be that still and not be dead? Surely it wasn't possible. Unless he was in a coma. I steeled myself and reached down for his pendulant hand to feel for a pulse, but just barely grazing his wrist freaked me out and I couldn't go on with it.

Suddenly I felt panicky. Had he died while I was sitting

there? A stroke or a heart attack, or maybe even a drug overdose? Wouldn't I have heard something, sensed something? Breathing hard, I hurried to the glass door, slammed it open, grabbed my towel off one of the hooks near the door and headed straight for the red wall phone that was ten feet away near the large empty whirlpool. There was no one anywhere in sight, and my anxious breathing seemed as raucously loud to me as a band at a halftime show.

I hit the button marked FRONT DESK and a cheerful voice asked how she could help me.

"Page a doctor–there's somebody in the steam room–" I gulped. "He's not moving." Then I added a bit desperately, "I don't know CPR!"

I hung up and felt assaulted now by the surging jets of the hot tub off behind me, the water in one of the nearby shower stalls that someone had left half-on, and the blaring fluorescent light. I felt trapped, but had to stay there, didn't I?

Over the loudspeakers that were in every corner of the club I heard a soft voice asking for a doctor to come to the men's steam room in Locker Room 1. How did they know where I was calling from, I wondered, then realized it had to be some kind of caller ID.

I desperately wanted to relax, and eyed the hot tub longingly, but it would seem perverse for me to be sitting in there letting jets massage my back while someone might be dead in the steam room.

The steam room! It was such an innocuous place, something I had always thought of as medicinal and good for you–like vitamins, long walks, flaxseed oil, and National Public Radio. I went there as a reward for a hard workout and sometimes to escape everything crazy in my life, and yet now craziness had snuck up on me like an unwelcome birthday. I paced back and forth on the gray, blue, and white tiled floor, wishing I'd slept late and stayed home. And then I wished I could be dressed and face whatever questions might come at me wear-

ing more than a towel, but that seemed inappropriate. Wouldn't people think I was heartless or strange to abandon the scene, wouldn't it make me look responsible somehow? I had to stay there.

I'd just returned from a week's vacation in the Caribbean, and had planned to spend the rest of my winter break from the university reading and relaxing, but I already needed to get away again. Far away.

A good-looking, slim, tanned man in a stylish olive green suit hurried into the shower area. "Where is he?" he asked briskly, and I rushed to open up the steam room door for him. He ripped off his jacket and stepped inside, rolling up the sleeves of his white shirt. He looked familiar, and when he cried out, "Jesus, Vlado!" I knew why. I'd seen him training with Vlado before. His name was something like Aftergood. Alfred Aftergood, that was it. And he was a doctor of some kind.

"Did you call nine-one-one?" he shot, and I felt like an idiot. I hustled back to the wall phone, got the front desk, and asked them to make the call.

"Already done," was the reply. "Be cool."

Had I sounded frantic? Or was a slacker at the end of the line? A slacker who worked there just to get a free membership.

The shower area was still empty and I propped open the steam room door to help make it easier for Dr. Aftergood to see.

"Don't let anyone else in," he said. "We don't want a crowd."

Though the men's locker room had seemed empty, it was possible gawkers would drift down here once the news spread through the club.

From the doorway, I could make out that Aftergood was crouching by Vlado's head. Using the index and middle fingers of his right hand, he gently lifted Vlado's strong chin. His other hand seemed to be keeping Vlado's head from tilting too far back. Aftergood turned to look over at his powerful hairless

chest, then brought his cheek down next to Vlado's mouth, checking for breathing, I assumed.

Did Vlado's chest rise and fall just then? Or was I imagining that?

Then he blew two breaths into Vlado's mouth, let his head down gently, and put two fingers on the side of his neck, apparently trying for a pulse.

"Is he okay?" I asked, but Aftergood ignored me. I couldn't help thinking that his expensive-looking suit pants and shoes would probably be ruined by crouching on the wet tile floor. His suit jacket lay in a heap on the floor outside the steam room. I fought the urge to hang it up.

"He's dead, isn't he?" I announced, feeling my throat tighten with panic. With a doctor there, it seemed so much more terrible and real.

Aftergood turned and his eyes were so fierce I thought he wanted to punch me out. "That's your diagnosis?"

"No, no, I meant—"

But he turned away before I could explain that I had burst out with my question hoping he'd contradict me.

I heard commotion out in the locker room, someone shouting, "Where?" and I figured the EMS people had arrived. I headed for my locker through the other door from the shower area as a small crowd of dressed, half-dressed, and undressed men surged towards the first door to see what was happening. When I opened my locker I dug out my cell phone to call my partner, Stefan, but the call didn't go through, as sometimes happened down there, and I hurried into my clothes.

People did have accidents at the gym, they fell off treadmills, they got knocked out by racquetballs, and even succumbed to heart attacks. But none of them was as gloriously fit as Vlado.

It didn't make sense, I thought, getting dressed in my quiet corner of the locker room. In this vast temple of health, he was a god. What could have brought him down from his pedestal?

2

I TRIED STEFAN AGAIN, making my slow way upstairs from the locker room, but all I got was his voice mail, both phone and cell. Very frustrating. Outside the club's restaurant, I decided to go in and have a drink because I was wiped out.

I'd glanced at an article in the monthly newsletter about our health club having been bought by a chain called Michigan Muscle, which was the club's swaggering new name, just like every other branch across the state. The glossy mailing had mentioned major changes in the management and the physical plant, and I discovered one of them when I walked into the restaurant. It was still dominated by a mammoth TV in one corner and plasma screen TVs over the bar, all tuned to Fox.

But the interior had changed dramatically while I was away. Everything had been transformed into black lacquer and chrome, appropriately cold and angular enough to be a set for some dim original series on the Sci-Fi Channel.

I supposed that fit with another alteration in the club's management that had apparently taken place during my vacation. I'd noticed a change in the gofers who ran fresh towels from the laundry to various carts stationed around the club and collected the used ones. They were all now wearing black pants, sneakers, and black ballcaps that made them look as if they were meant to blend in and be invisible, like the scene changers in Japanese Noh drama. They had evidently also been given new operating instructions, because their caps were pulled low and they all scurried by the members with their

heads down, whereas before they'd been encouraged to smile and chat.

I made my way to an uninviting table and a black-clad waiter (perhaps "waitron" fit the decor better) approached before I even sat down, handing me a menu and asking if I wanted anything. This was also new, but in a good way because service in the old restaurant had been dilatory at best, as weak as the coffee. Glancing around, I noted that the shambling, rumpled staff had been replaced by glowing-cheeked athletic types whose faces were as scrubbed as those faces in Communist Party posters, you name the country. They didn't have much to do at the moment, but none of them was slouching, and mine looked like he could do a back flip as easily as tell me about the specials.

I asked the varsity-gymnastics type to bring me a scotch and soda. He started reciting the single-malt honor roll, but I cut him off.

"Whatever. And make it a double."

I kicked my gym bag under the table and draped my car coat on a chair, then slumped into another which was surprisingly comfortable, given that it looked more like a concept chair than an actual seating device. The restaurant of about thirty tables was almost empty. It was too early for dinner and too late for lunch.

Too late for me, too.

I tried Stefan a third time at home and on his cell but I had to leave more messages. It was unusual for him not to answer his cell if he was out of the house. I could have gone home to wait for him, but I did not have the energy to leave now that I'd taken a seat.

"Nick!"

A sharp cry from the restaurant entrance hit me like the kind of Italian slap to the head you see in comic movies. It was my buxom, brawling colleague Juno Dromgoole, and she advanced on me, looking as large as life and twice as natural–to

misquote Oscar Wilde. She was dressed somewhat modestly–
for her–that afternoon: a black mink vest over a tight velvet
leopard-print tunic, black leggings and black high-heeled half-
boots. The sleeves of her tunic were edged with what looked
like remnants of a black-and-gold boa.

She plumped down in the seat opposite me and announced,
"As soon as I heard downstairs that you were there when Vlado
died, I couldn't wait to talk to you, and then they said you were
heading out, so I took a chance I'd catch up."

I wonder if she had tried rousting me in the locker room; she
certainly would have tackled me in the parking lot to find out
whatever she wanted to know. Juno did not take no *or* yes for an
answer; she was anything but deferential. Her every waking
moment seemed part of a campaign to disprove the stereotype
of Canadians as quiet and inoffensive. I remember a Mavis Gal-
lant story describing a Canadian audience *ooh*ing when they
saw a puppy on the screen, then covering their mouths in em-
barrassment for having expressed themselves in public.

That was not Juno. She never seemed embarrassed, though
the things she said could be alarmingly frank. Her outrageous-
ness was even more striking given that she was an academic
in my basically bland and overly bureaucratic department of
English, American Studies, and Rhetoric. Imagine a bird-of-
paradise in a flock of starlings, or better yet, a Venus's-flytrap
nestled amid ragged daisies.

"Vlado was so alive, it's hard to picture him dying. A meaty
lad, and now he's just dead meat."

The way she said it made me think that vegetarianism might
not be a bad path to take in the future.

"They couldn't revive him–that's what I heard," Juno went
on. "Amazing, really, to think of him that way when he could
have raised the dead with his skills in the bedroom."

"Did you know him?"

She smirked. "Everyone knew him." Then she paused and
reached over to cup my chin and hold my head up to get a good

look at me. "You need a drink." She withdrew her hand and I felt as if my chin were hot.

"It's coming," I said.

The waiter appeared with my scotch, took an order from Juno for an amaretto sour on the rocks, and left us alone.

I grabbed my scotch to take a sip, aware that once again, Juno was working on me physically in a way that no woman ever had. I'd been happily gay since my teen years, was in a very long-term relationship with Stefan, but now, approaching middle age, Juno had hit me the way a dam break hits the towns below it, washing away the past and scarifying the future.

We had a bizarre friendship—if that's in fact what it was: I thought I wanted her, she flirted with me sometimes, we had never really discussed it with each other, and I had only confided in two people about my attraction to Juno. One was a worldly Québecois neighbor who thought Juno was vicious and dangerous. The other was my practical and loving cousin Sharon, who was like a sister to me. After meeting Juno once, Sharon had warned me, "Honey, if you're going to branch out, start with modest goals. Sleeping with Juno would be like having group sex in a wind tunnel." Stefan thought Juno was a liberal Ann Coulter: that is, deliberately outrageous, somewhat crazed, and using her sexuality to club people over the head. But I think at some level the novelist in him admired the material she offered. He'd be a fool not to. She was a tantalizing blend of Auntie Mame and Madonna at their most outrageous.

Juno's drink came more quickly than mine had and the waiter lingered, but Juno waved him away, muttering, "Trailer trash."

We raised our glasses in a half toast. Juno asked what I thought of the restaurant's new look.

"It's like too much Philip Glass," I said.

She nodded vigorously, and her large breasts echoed the movement in their soft cuirass. "They have big plans," she said darkly. "The fuckers."

"Who?"

"The Pierces. The new owners of Michigan Muscle."

"*They* own this place?" I knew that the Pierces were one of Michigan's most powerful political clans, with a family tree that seemed to offer shadiness, not shade. Though outwardly just conservative, they had some historical connections to right-wing Michigan lunatics who believed that the Jews in the world were actually imposters and the real Jews were Anglo-Saxons, who were descendants of the Ten Lost Tribes. Stefan and I were actually acquainted with a Pierce in-law, one of the graduate students in our department who was himself not whacko, as far as we could tell. But the rest of Peter de Jonge's family had tentacles in the state's political and business worlds in ways that made people angry or afraid.

"It's all rumor, of course, but that doesn't mean it's false. I assume you've seen how they've turned the support staff into serfs, scuttling about as if there's something shameful in working a low-end job? And the trainers don't just have to punch time clocks anymore, they have to check in with the manager physically when they arrive and when they leave! Little Nazis, that's who's in charge now. The administrators are going to wear identical white polo shirts, the trainers royal blue, the grunts black. Tell me that color-coding isn't like *The Handmaid's Tale*. Christ, it makes my flesh crawl."

I tried remembering what the colors were in Margaret Atwood's dystopian tale. The domestics wore green, the women who could bear children wore red, but that was all I could come up with.

Meanwhile Juno added that one of each set of locker rooms was going to be refurbished with walnut lockers, plush carpeting, plasma TVs, thicker towels, and bottled water instead of the stuff spouting from steel fountains.

"You'll have to pay more for the deluxe locker rooms?" I guessed.

"Of course. It's not the money that bothers me, it's creating

two classes of membership. It'll make people envious, and the asshole snobs around here will be even more unbearable. You Americans pretend you have no classes, but you leap at the chance to act superior. Even if it's only by buying deluxe toilet tissue!"

I ignored the slam, since I didn't always disagree with Juno's observations about America. My parents were Belgian Jews and I had grown up with a double consciousness: they loved our country's opportunity and freedom, but they deplored its inveterate vulgarity. That trait cropped up in all sorts of ways, whether my father was complaining about the ugliness of our election campaigns or my mother grousing about sales clerks and waitresses calling her "hon" or "dear" and strangers on the phone using her first name.

"But why would the Pierces buy Michigan Muscle?"

"The family is branching out, taking a higher profile. And what's better than adding a successful chain of health clubs?"

I wasn't sure of the logic there, since in national surveys of health, Michiganders did not rate very highly. I think we even led the country in rates of childhood and adolescent obesity, though nobody seemed to know why.

As if reading my mind about the sad state of Michiganders' health, Juno said, "Think of all the sad, fat fucks out there who think joining a gym will automatically make them lose weight and shape up. There's an endless supply of the poor stupid bastards. Wasn't it your H.L. Mencken who said nobody ever lost money underestimating the intelligence of the American public? Working out is *work*." Juno knew whereof she spoke; she swam, she lifted weights, she did Power Yoga, and all of it showed in her taut, tempting body.

"There's more," Juno said. "You know how the big buzzword at universities is 'branding' and schools have been changing their names to go more upmarket? Well, there's a rumor the Pierces want to buy SUM from the state and call it Pierce University."

"Can they do that, is it legal?"

"Nick, it's money. The state is broke, unemployment is higher than anywhere else in the Midwest, why *wouldn't* they sell that snakepit to anyone stupid enough to buy it?"

Well, if people donated money for endowed professorships and for buildings with the intent of glorifying their names, why not go all the way and just re-brand the whole school?

"You know," Juno said, studying me, "you don't have to talk about Vlado. I'm sure you were shocked...." She raised her thin eyebrows, waiting for me to fill in the blanks. Then, when I hung fire, she said provocatively, "What a waste. All alone in a steam room with a body like that, and it *is* just a body. A dead body."

"How'd you know I was all alone with him?"

"Nicky, don't you realize I could probably find out if your towel was wrapped left-to-right or right-to-left if I asked? This club isn't a fish bowl, it's an *aquarium*, with everyone and everything on display and everybody watching. I'm sure I know more about Vlado than his little wife."

"He was married?"

She dismissed it with a roll of her eyes. "They always are."

"Meaning–?"

"Men like that. They need a lot of women, but they need one woman as a base, someone they can count on. And that goes double around here."

"I'm not following."

"Vlado slept with some of his clients, didn't you know that?"

"The women he trained?"

"The very same." She could have been dealing with a querulous old relative whose hearing had grown dim. "You're still traumatized, aren't you? By finding him?"

"I didn't find him, really. He was just there when I went into the steam room." And that's when I recounted to Juno everything that had just happened downstairs, as well as I could remember it. She listened with the same ferocious concentration

she did most things, and even in her silence I felt electricity like Angelina Jolie could generate with one of those half smiles. They actually looked a bit alike, though Juno's lips weren't as full, she was shorter, and her hair was Tina Turner-wild.

"Isn't a trainer sleeping with his clients unethical?" I asked.

"Please, it's not as if he's a doctor or anything." Then she added quietly, "Was."

"Okay, maybe not unethical, but inappropriate."

She sighed. "It's inevitable, that's what it is. All that working together closely, touching, directing, adjusting posture, counting reps, *looming*." And she smiled wickedly.

"But how do you know it's true about Vlado?"

"How do I know? I watched him in the weight room. Every now and then I could sense something slightly different in the smallest things, how he said hello, how he stood near a woman he was training. It wasn't obvious. He did a good job of covering up. But still–" She shrugged, looking very sophisticated, and I felt we could have been characters in some crude update of a Henry James novel dealing with his International Theme: I was the innocent American, she was the seductive, knowing European.

"Maybe you were just fantasizing," I said.

"That's one thing I didn't need." She winked at me and gave me a creamy smile.

"Wait–you slept with him?"

"Of course I did. I had to see what all the fuss was about."

"And?"

She made a moue and her eyes seemed to focus on a list she had drawn up somewhere. Perhaps she was remembering a page from her journal. "Determined. Skillful. Long-lasting. Oh, and hot rocks."

"Hot rocks?"

"Yes, large balls that hit you when you did it doggy-style. I can't believe you're gay and you don't know that." She squinted

now. I did not conform to her image of gay men–I wasn't sexually outré or even adventurous. I was basically married, which to her meant dull.

"Well, we call that 'low-hangers.' "

"That's a bit too topographic, don't you think?"

"Okay, so you slept with him, and–"

"Nicky, we fucked, we didn't sleep together." Juno often called me Nicky, though no one else did, and I'd asked her to stop, without having made much of an impression.

"Fine. But how do you know there were others?"

"You think he, what, slipped up once, lost his head?" She laughed. "I know because he told me, and some of them told friends who told me. You hear things. You think women don't talk about each other's affairs? What, we just compare fashions? You'd be amazed what you hear in the women's locker room. Vlado was very popular, but if not him, it would have been someone else. There are far too many lonely women out there. What your country needs is another FDR to put them to work."

"Doing what?" I asked. I was feeling the effects of the scotch and called over to our waiter to bring me a large Perrier. I needed to dilute the alcohol.

"You have no idea what goes on at this club, Nick. Rich, bored housewives, their kids grown or almost grown so they don't need supervision and driving from one activity to another. These women have too much money, too much free time, and they resent not knowing what to do with themselves. They have to put up with their boring husbands and rattling around in those enormous overdecorated houses, so haven't they earned the right to a little fun now and then?"

"But their husbands made that lifestyle possible."

"Don't be logical–you sound like a prude. I've met lots of women who don't even enjoy sex–can you imagine?–and just do it to keep their husbands happy and to keep things on an even keel. Or they know their husbands cheat on them, but

every time there's an affair, the wife gets a diamond bracelet, or a cruise, or some other treat."

"You're making this up."

"If you weren't working and Stefan was making millions as a writer, you have no idea what that might do to both of you."

My Perrier came and I downed half of it, not bothering to disagree, because I was too tired to imagine that alternate life for myself, though I doubted I could ever truly get bored.

Juno summed up: "Just think of Vlado as 'Mother's Little Helper.' "

Despite myself, I smiled. "That was a good song."

"It was a *great* song, name one Stones hit that wasn't." Suddenly Juno sat back in her chair, with a strange, veiled look in her eyes. "A man like that, a body like that, a superb athlete, what are the chances he had a stroke or heart attack at his age?"

"It happens," I said weakly.

She cocked her head at me. "So does murder."

3

"YOU'D BE THE prime suspect, of course." She was not kidding.

"Why?" I felt very cold.

Juno laid it out quite reasonably, ticking off each point by clasping one slender, French-manicured finger after another. "You were alone with him in the steam room. You made the report. There was nobody else down there to verify your version of events. We only have your word for what happened. You've been involved with murders before."

She was right about that. I'd had the misfortune over the past few years to wind up involved in crime stories that were real, not imagined, and it had not done my academic career any good at all.

"But I didn't kill anyone—it was somebody else each time!"

"There's always a first time. And you have been a suspect before."

"Stop. I solved some of those murders."

"True, but you were involved, it's unseemly, it's suspicious, it rubs off."

"So were you."

Juno cut her eyes at me. "But I have tenure, and I'm a mean bitch and nobody fucks with me. You, on the other hand, are much too nice. Worse, you're a bibliographer, for crissakes, and you enjoy teaching composition to freshmen. What could be more suspect?"

"But what's my motive?"

She shrugged and took a thoughtful sip of her drink. "You're an untenured, middle-aged professor, that's a motive for a host of crimes."

"Great, I'm an academic psycho-killer." With the chorus of that Talking Heads song running through my mind, I pulled out my wallet to put a twenty down on the table, and told her I had to get myself home.

"Think about getting yourself a lawyer," she said companionably. "In case it turns out he *was* murdered."

I pulled on my coat, grabbed my gym bag, and thanked her for the advice. As I plunged from the club out into the vast parking lot, I was sure people entering and exiting had been staring at me. It wasn't my haste–they had probably heard about Vlado and me.

Vlado and me–that's how the story would be told. I'd be inseparable from the narrative and his death would discredit me in some undefined but damning way. Juno was right–all the experiences I'd had to this point had rubbed off, and today's misadventure would only add to the portrait of me as tainted, cursed.

Vlado's death was certainly a shock. People were seriously injured or even died at the club now and then, but they were usually middle-aged men determined to prove that they were as tough as the college kids on the basketball, squash, and racquetball courts–or older men who didn't eat well and consistently did exercises incorrectly enough to endanger their health. And in every case, I realized, I'd heard within a day–somebody or other would break the news. The fact that it was a trainer, and one of the club's most colorful ones, whose body had been taken off in an ambulance, meant the news would inspire frenzied gossip. E.M. Forster's definition had never seemed so apropos to me before: in *A Passage to India* he'd called gossip "one of those half-alive things that try to crowd out real life."

I found my new sky blue Lexus RX 330, which had been

delivered to the dealer while we were on vacation, opened it with the remote, and climbed into the SUV and shut the world out. I sat there for a while, enjoying the *luxe, calme et volupté* of the ritziest and quietest car I'd ever owned. I felt as I had in the steam room: don't move, don't go anywhere, and somehow all the trouble will vanish.

I couldn't understand it. Most people lived their whole lives without being sideswiped by crime or violent death, yet it had happened to me more than a handful of times (much to my parents' chagrin, given their dim opinion of American manners), and the only pattern I could see was no pattern at all, except bad friggin' luck. I sat there with my eyes closed, praying that Vlado had not been murdered by anyone, that he'd died from an overdose, or some congenital heart problem that had gone undiagnosed. It happened. Back at Columbia where I met Stefan, I remembered a cheerleader had died running for the Broadway bus. Nineteen, and a heart attack.

But the smell and feel of the SUV cradling me brought me slowly out of my funk and I glanced around at the sharp and sexy appointments with delight, imagining my parents' sighs about my love affairs with cars. They drove a Volvo, and though they could easily afford to buy a new one every year, their current model had 75,000 miles on it. They were always praising its virtues to me. "You live in Michigan—it's cold and snowy—just like Sweden." I'd object that the Volvo—which Stefan also drove—was too boxy, too bland, and they'd laugh. "You're so American!" But there was as much disappointment as delight in their eyes; they were proud of how well I had fit in as a child of immigrants, but they regretted what had been lost from their generation to mine. I spoke a plodding cart-horse French, I had little interest in the past that Hitler had done his best to wipe out, and though I loved books I had no passion whatsoever for my father's distinguished little publishing house.

Though I was only five to ten minutes from home even in

heavy traffic, I set the navigation system for HOME and felt gratified that before each turn, a calm voice told me the turn was coming up and then there were beeps to alert me in case I'd missed the message. There was also something deeply reassuring about the blue arrows on the screen drawing me along from point A to point B. Driving through the bleak, winter-bare streets, I wondered why life couldn't have a nav system like this.

Heading up our street lined with mid-century Colonials, I remembered my mother's quiet comment when they visited me and Stefan right after we'd bought the house: "It's very suburban." Their image of suburbia, anyway, though it was really a densely built, tree-lined neighborhood like many others in college towns across the country. My parents, of course, were in love with New York and the Upper West Side and I might as well have been living in a tent or an igloo. For me, though, there was nothing like the sense of rootedness I felt parking in our driveway, opening the fanlighted door, and stepping into the entryway with its console table and Venetian mirror. As soon as I closed the door behind me, I understood Stefan's absence and inaccessibility. There on top of today's mail was a *New York* magazine with a writer Stefan despised on the cover, grinning a bestseller's smile.

When you live with a novelist, you also live with his creative aches and pains, his history of disappointments and bad reviews, and his jealousies. Stefan had a plum position here at the State University of Michigan since he was a tenured writer-in-residence, but no matter how successful he was—and many writers never attained even his status—there were always writers whose success corroded his self-esteem. What the psychological roots of this might be for Stefan, I didn't know. I'd eagerly done therapy more than once in my life and found it liberating each time to have new ways of understanding myself, but though Stefan had seen a therapist or two, it hadn't really helped with his competitiveness and longing.

Lawrence Fishbein Faux–grinning on the cover of *New York*–was one of the latest writers to work Stefan's last nerve. Half-black and half-Jewish, Faux was a young performance artist–novelist who'd written *Everything is Cremated*, a hip-hop Holocaust novel that reviewers across the country had praised as stupendously daring, revelatory, beyond fiction, beyond life, beyond kudos. One major critic had bizarrely written: "I never thought I'd live to review a book this dazzling." Even before Stefan mentioned Faux and his reviews to me, I had read the novel and found it to be labored, trite, pretentious, gimmicky crap. But too many American readers and critics mistake a hyperactive surface for substance and parlor tricks for profundity.

Faux profited by that lack of taste. And audiences were thrilled by the handsome Jew with dreadlocks, a poster boy for diversity, pretty authors, and literary-reinvention. Or was it post-literary re-invention? Or literary post-invention? All the encomia put me into a coma, so it was hard to keep track of the critical huzzahs as reviewers tried to outdo one another in extolling this novelist, whose handsome full-length portrait graced the back of the daringly all-black jacket with raised black print. I admit that the cover was a brilliant marketing device, because you just had to draw closer to make out the title, and who wouldn't wonder why a book was so somberly packaged?

Faux's readings were always standing-room-only and he sang parts of his book rather than read them, in a warbling, weepy Star-Search kind of tenor. After one reading, a rising cultural critic with the vulturine charm of Robert Novak had said on TV, "It's about time there were some hot Jewish writers on the scene. Has anyone taken a good look at Philip Roth lately? He's turned into Camilla Parker Bowles."

My own problem with Faux was something different. He was what people in publishing call a blurb whore. Since his fame, he had apparently become enamored of seeing his name in

print even on other people's books. With sickening regularity, I'd see a paragraph of his effulgent "Look at me! Look at me!" praise on the back of some new novel. His enthusiasms were scattershot and his prose was Kama Sutra–contorted. If I saw his name on the back of a book, it always militated against my reading it, though I was doubtless in a minority.

Now, I put my coat away, took the gym bag downstairs to the laundry room, and started my wash. It made me sad to imagine Stefan drinking a cappuccino somewhere in town, brooding, or riding around aimlessly, or sitting in a movie theater, eyes blankly fixed on the screen.

As I headed back up, I heard the front door open and I called to welcome him home. We hugged inside the door, but he wasn't that enthusiastic. I didn't expect him to be, though I could have used a cosmic hug, given my afternoon. We headed to the kitchen, which had been remodeled the previous summer with antiqued glass–doored cabinetry, gray-blue granite countertops and backsplashes, appliance garages that reduced the clutter, and a new granite-topped kitchen island.

Though he seemed somewhat defeated, he was as handsome as ever, having moved into middle age looking more and more like a burnished, burly version of Ben Cross, the star of *Chariots of Fire*. Our week in the Caribbean had done him some good, until today.

I sat on a low-backed stool at the counter while Stefan wandered around the kitchen like someone overplaying an amnesiac, staring at everything with his forehead creased in befuddlement. As he passed the CD player, he switched it on and soon Lorraine Hunt Lieberson's unearthly mezzo-soprano was filling the room with Bach's *"Ich Habe Genug."* Painfully appropriate, I thought, not remembering having left that CD in. Had Stefan been listening to it?

"I saw the *New York* magazine."

Stefan shrugged and took beans out of the freezer to brew a pot of coffee.

"I figured that's why your cell was off. You didn't want to talk."

His back stiffened a little, and I assumed I was right. He went on to grind the beans, set the filter in the Chemex coffeemaker, add the ground coffee, and bring filtered water from the fridge.

"But I think most people would rate my day higher on the It-Sucks scale."

"Why? What happened?" He moved to the island, suddenly alert.

And me, I felt drained at the thought of telling my story all over again. But I did anyway, and it mobilized Stefan, who sat next to me and kept a hand on my shoulder as if I might lose heart and bolt from the terrible narrative I was recounting to him.

"I could use some coffee," I finally said, feeling as weary as the Ancient Mariner.

"How about a shot in it?"

I nodded and he rose to pour me a cup, then opened the liquor cabinet to bring out a bottle of Glengoyne. He brought me the doctored coffee and went back to pour himself a few fingers of the single malt we'd brought back from the Caribbean.

"Poor Vlado," he muttered. "Dead in a steam room. What a way to go."

"Did you ever play squash or lift with him?"

Stefan shook his head. "No, he was too competitive."

I let that one alone, picturing the way Stefan and our neighbor Didier egged each other on at the club when they worked out together.

"Sharon gave us those scotch glasses," I said, remembering my cousin's description of a wonderful trip to Ireland, which included a visit to the Galway Crystal factory.

Stefan smiled faintly. "That's why I like using them. I always picture myself toasting her."

I hadn't told Stefan everything. Now that we were both

having some scotch, I mentioned Juno's notion that Vlado might have been murdered.

"Juno was there?"

"In the restaurant–I stopped for a drink. She found me."

"That woman is bad news. She's incendiary."

This stopped me because I often thought of Juno in connection with the line from an Anaïs Nin novel where a character's first thought about a woman is: "Everything will burn!" And because I felt guilty about my attraction to her. In another book I had read in graduate school, Nin had written: "I think we are more severe judges of our own acts than professional judges. We judge our thoughts, our intents, our secret curses, our secret hates, not only our acts."

"Where are you?" Stefan asked. "You disappeared."

"I– I was thinking of Anaïs Nin."

"Nin?" He looked quizzical. "When's the last time you read Nin? When's the last time anyone read Nin?"

"Come on, you liked the *Diaries* as much as I did back then."

"I liked a lot of writers in college and grad school. Hell, I loved Doris Lessing. Even Margaret Drabble. But I grew up." He shrugged. "The novels were easier to take, though. Nin's, I mean. They were short, at least."

Now I flushed, as if the lines I'd been thinking had been as visible as a news crawl on cable TV.

"Juno raised a possibility," I ventured. "That somebody might have killed Vlado."

"In the steam room? Bullshit. It would be too risky, people walking in and out, going to the showers, the whirlpool, the sauna."

"But nobody was there when I found him."

"How do you know there wasn't anybody down there while you were inside the steam room, or before you walked in? With the steam going, you can't hear anybody outside or see them through that glass door. The sauna's right next door and even with that glass panel in the door, someone could be off in a

corner–" He shook his head decisively, restored by conviction and the scotch. "No. You'd have to be really dumb to kill somebody in the steam room."

"Or really clever."

"Nick, people always say that in mysteries, and it always turns out the murderer isn't as smart as he thought he was. You know that, you've read enough of them."

Read them, and was about to teach a course in the American Mystery, focusing mainly on PI novels, which meant I could have my students read some of the best: Raymond Chandler, Loren D. Estleman, Marcia Muller, Sue Grafton, Dennis Lehane. It was called "America's Mystery/Mystery's America," and the focus was on the PI as the quintessential American figure who combined social commentary and social correction.

"You have a point," I admitted.

"But if he was murdered," Stefan said thoughtfully, making one of his quick mental shifts, "wouldn't you think it was some kind of sign?"

"A sign?"

"From God."

"You're kidding." I didn't think he'd had nearly enough scotch to be drunk, so I couldn't imagine where this question was coming from.

"How many people encounter as much violence as we have in the time we've lived in Michigan?"

"Plenty. Cops, doctors, football players."

"Seriously. You and I live in some kind of mini-war zone."

"So all that has come from God, or is it just Vlado being dead? To tell us to do something? To warn us?" Bizarrely, I thought of Whoopi Goldberg playing a medium in *Ghost*, turning to Demi Moore and saying, "Molly–you in danger, girl."

"I didn't say I knew what it meant, just that maybe it meant *something*, maybe it all fit together somehow."

"That would be creepy."

Stefan demurred. "It might be beautiful," he said, and I decided it really was the scotch talking at this point. I checked my watch and suggested we start getting ready for *shabbat*. While he went to shower, I took out the previous day's boeuf Bourguignon to reheat it on the stove, set the table in the dining room with dishes and silver both our families had given us, laid out the challah I'd bought on the sideboard, got the candles and *kiddush* cup ready.

Though Stefan was Jewish like I was, he had grown up in a very strange family. Holocaust survivors, his parents had jettisoned their Jewish identity on the boat across the Atlantic and pretended to everyone that they were Polish Catholics, lapsed, agnostic, but Catholic just the same. Stefan found out the truth as a teenager and had been angry and confused about it for much of his adult life.

Jewishly, he was in some ways a spiritual feral child, having grown up in the wilds of his parents' fear and denial. We didn't belong to a synagogue, but because I enjoyed *shabbat* and taking a break from customary time, I'd over the years brought him along to feel its quiet power. But we'd never turned the day into a true retreat for contemplation or even Torah study—not that I'd have known where to begin.

I'd been bar mitzvah'd but like many Jews of my generation had drifted after that. I was glad to be committed to someone Jewish, but what exactly did that add up to? My parents didn't offer an example to follow, so Stefan and I were sort of isolated; we didn't have any Jewish connections except when we flew to New York for holidays with my parents or my cousin Sharon. Stefan's father—a retired and remarried professor—actually now lived in Ann Arbor an hour away, but we quite literally did not go there, since their relationship was still unresolved and I doubted it ever would be. Stefan could not let go of hating his father for lying about the past. It's not that I believed all traumas could be healed and that "closure" was the highest goal in

human life, but I hoped that Stefan could reconnect with his father–who was over eighty–before it was too late.

When Stefan came back downstairs in a crisp white shirt, his face shining, his thick dark hair rumpled and damp, I strolled upstairs to take my turn in the shower, already feeling I had surrendered to the slower, more contemplative pace of *shabbat*. Dressed, I joined Stefan in the dining room to do the series of *shabbat* blessings together over the candles, challah, and wine. Though they further eased my mind, as did the Hebrew chant I set to play on the CD player, and I felt miles distant from the afternoon's darkness, I had the feeling that Stefan's heart was not really in it.

4

IN THE MORNING I woke up remembering how distant Stefan had seemed until I'd told him about Vlado and then how he'd drifted off afterwards. It made me anxious, and like Auntie Mame, I needed a simple breakfast: black coffee and a Sidecar.

Was it just the *New York* magazine? I hoped Stefan hadn't had more bad news about his career–it came unexpectedly. In waves, like nausea or the return of paisleys. An old book of his had recently been optioned for a film, but the more we learned about the deal from his agent, the more we realized that the money was likely to be the end of the road. Most "properties" were just that, and never made the full transmigration onto the screen.

The option money was wonderful, but it had raised Stefan's expectations in the obvious ways: attending the premiere, enjoying a new paperback tie-in edition of the book with some famous actor on the cover, and then of course reveling in Golden Globe and Oscar nominations.... It was the chorus of the old disco song, "How do you like it? More, more, more." Or as my cousin Sharon used to say, "There is no such thing as *enough* in America," and coming from an ex-model who'd lived the high life, that line had dark certainty.

So the good news about the film option had already faded and didn't quite compensate for all the false starts and dead ends his career had been plagued by. Like Brando in *On the Waterfront*, Stefan wanted to be a contender–but he really

wasn't. He was just one of the many hundreds, maybe thousands, of fine writers in America. And being that good wasn't good enough or satisfying enough anymore. Though he and I were happy together, quoting that line from *Gaslight* that "happiness is better than art" wouldn't mean enough to him because he wanted both.

Stefan walked in bearing the *New York Times* and the local paper, with a steaming mug of coffee which he put down on my night table. Suddenly the king-size cherry sleigh bed felt less like an island I'd been washed ashore on and more like a destination, a retreat. He looked tousled and handsome in his steel blue Calvin Klein sleepwear. Had he been taller, he would have made a perfect rugged model; you know, the kind they photograph in T-shirt, barefoot, with a baby in his arms to look handsome, relaxed, sincere.

Stefan sat in the burgundy armchair catty-corner from the bed, sexy bare feet up on the fat, ball-footed ottoman. He split up the papers and handed me the parts he thought I'd like. We read in silence for a while, with the sounds of Bach's *Art of Fugue* drifting up from the living room. The bedroom was something of a stage setting, and Sharon had instantly recognized it as done in Eddie Bauer Home: the walls were sponged sage-and-beige and all the bed linens were in either a burgundy, peach, and sage floral or beige-and-sage windowpane plaid.

We lost ourselves in various world crises until the doorbell rang in what Oscar Wilde memorably called "a Wagnerian manner," and Stefan bolted up. "Who the hell is that?" He padded quickly downstairs and I had a feeling who it might be that was confirmed when I heard a loud cry of "Nick! I must see Nick!" Juno came storming up the stairs and burst into the bedroom dressed like a funky commissar: black turtleneck and jeans tucked into high leather boots, a black leather trench coat swirling about her. The outfit bothered me in some way, or suggested something, but I couldn't pin it down.

"He was murdered!"

She plumped down on the chair Stefan had abandoned. Stefan appeared in the doorway, gave me a "She's all yours" shrug, and said he was going to make us some breakfast.

"I'm in bed," I said.

"I can see that. But you're not Camille, and you and Stefan certainly weren't humping, so—"

"How do you know?"

She gave me a "Duh?" look and shook her head. "Because you're so terribly domesticated, that's why. Saturday morning sex? Doubtful."

I didn't think I needed to sell her on the fact that Stefan and I did have sex, because I knew that wasn't her point.

"Vlado was murdered," she repeated, crossing her legs tightly.

"How do you know?"

"The new medical examiner is a friend of mine, well, more than a friend, and I called him. Not my type, usually, but you know..." She shrugged. "*Six Feet Under*, *CSI*, mortuary chic. It's the Zeitgeist."

I didn't ask for details. "Are medical examiners allowed to give out that information to—?"

"To people they're fucking?" She grinned. "I don't know what the regulations are. I'll check later. Meanwhile, isn't it amazing?"

"You're excited."

"Of course I am!"

"But why—?"

She leaned forward, eyes flaring. "Because I'm *alive*."

If that's the effect Vlado's murder was having on Juno, it did not boost me in any way. I felt burdened, even cursed. Why did this have to come into my life, why couldn't someone else have been in the steam room?

"They're sure it was murder?"

"Blunt force trauma to the head," Juno brought out with relish.

"But what if he just fell on the floor or something like that?" I drank down the rest of my coffee.

"He fell in the steam room, then crawled back onto the ledge and lay down? Why wouldn't he try to get help?"

I thought it over, holding the empty mug to my chest. "He was dazed? And the door's pretty heavy."

Juno dismissed that with an imperious wave of her fine-boned hand. "Nonsense. Besides, there wasn't any blood, so death was instantaneous." She relayed these facts as briskly as if sharing a weather report, but for me, they brought back those moments of profound anxiety and dread in the steam room.

Juno snapped her fingers to get my attention and despite myself, I smiled. Even though she had barged into a quiet Saturday morning and invaded my bedroom, once again and despite myself, I was enjoying her personal theater of the absurd. She seemed to feel totally comfortable at what was turning into my levee, and I wished I could be that relaxed. But I was only a bibliographer, which had trained me to be so humble and helpful that I had often thought those two words should be the motto on my coat of arms.

"Cheer up, Nick! Don't you see what this means? We have another case."

"What are you talking about?"

"We're going to solve Vlado's murder."

"What about the police?"

"Nick, you read all those mysteries, you're going to teach a mystery course, and you ask a question like that? Please, the police are hopeless. This won't be easy. They won't be able to narrow down the time of death very easily, because he was in a steam room and that throws off all the calculations about body temperature. Besides, even if they do solve it, don't you want to find out for yourself, find out things they won't? I know I do."

"Why?"

She arched an eyebrow and said, "Two reasons. Curiosity, of

course. I know we can do it. We're both extroverts, right? We can't check phone records or do lie detector tests or subpoena anything. But we can talk to people in ways the police can't and we can find out more. Suspects won't be on guard with us the way they would with a cop."

"You have a point. What's the second reason?"

"Research."

"What kind of research?" I asked warily.

"I'm thinking of writing a mystery. Something high concept."

"Like what?"

She shrugged. "A female secretary of state solving crimes while she flies around the world solving diplomatic crises. I haven't thought it all the way through yet, but I do have a friend who works in your State Department, so I have that side all covered."

I obviously must have looked dubious, because Juno said, "It's just dumb enough to work. But anyway, before I can write I need to immerse myself in crime, and here we are. I may even audit your course."

Juno let loose among my juniors and seniors? I didn't go there. I didn't even drive past or look it up on a map. Not that it mattered, since Juno wasn't just on a roll, she was on a rolling boil.

"Think of it, Nick! Vlado was the hottest trainer at the club, can you imagine how much scandal is waiting to emerge?"

I asked, "Does scandal wait–for anything?"

"Don't be pedantic." She peered at me. "You're not secretly one of those Log Cabin Republicans are you? That might explain a few things."

I assured her I did not support a party that didn't support me.

"Why do you think there's something scandalous?"

"Nick, Nick, Nick. He was young, hot, horny, and his clientele were mostly bored, rich, middle-aged women." Suddenly

she uncrossed her legs and leaned towards me. "Wait. You're not trying to deflect attention, are you? Did you kill him?"

I slammed down my mug on the night table. Luckily it didn't break or even crack.

"Why would I kill him? I didn't even know him."

She shrugged elaborately, like a silent screen diva miming insouciance. "Homosexual panic?"

"Gay men don't get that, *straight* men do."

"Jealousy?"

"Because he was young and gorgeous? Juno, he wasn't the only guy like that at the club."

"But he *was* the only one in the steam room with you," she noted, and then she started to laugh. "I'm sorry. I was just winding you up. You wouldn't kill anyone, but the police won't think that. *Cherchez le pédé.*"

Having dispensed this rhyming bit of wisdom—"Look for the fag"—Juno left as abruptly as she'd arrived, and I was glad that the newspaper had been across my lap, because despite being mocked and toyed with, I had still found myself physically reacting to her presence. Getting out of bed when I heard Juno's jaunty good-bye to Stefan and the door slam, I recalled Sharon once saying to me, "Sex has ruined more lives than Communism, and that's saying a lot."

We had another visitor after breakfasting on pumpkin-banana pancakes. And this one was in his own way as stylish as Juno. Stefan had gone off to the library on campus, and I answered the doorbell to find a swarthy metrosexual giving me a clinical once-over.

"I'm Detective Fahtouzi, with the Michiganapolis police." He carefully showed me his ID and badge. About five feet eight inches, he had the good-natured, cleft-chinned charm of Rob Lowe or John Stamos, with a shock of thick black hair that was expensively cut. "Can I come in to ask you some questions?"

"Darius Fahtouzi," I said, nodding for him to put away his ID. "Persian?"

He frowned; clearly I was not supposed to be interrogating *him*. He eyed me steadily, as if daring me to ask more questions. But I hesitated. He was almost unnaturally good-looking, not just for a detective, but for anyone: elegant, slim, sexy, and dressed too well. I couldn't identify the cowboy boots or the black suit, but the latter was stylishly tight at the hips and legs, and the burnt orange tie was definitely Hermès, since Stefan had one like it in blue.

"I'd like to ask you some questions about Vlado Zamaria." He had the quietly emphatic voice of someone who was teased as a kid and has learned to hold his temper, but doesn't mind letting you see he's controlling himself.

I'd seen enough crime shows to know that I could have refused to talk to him and refused to let him in unless he had a warrant, and that I did not need to come to "the station" with him, but I also knew being refractory at this point would look suspicious. So I waved him into the large, comfortable living room, but not to the best seat for a man his height. I pointed to the oversoft sofa, and when he sat down, he sank a little and looked uncomfortable. I made myself not smile.

As he'd passed me, I could tell he was wearing Eau de Rochas, which was one of Stefan's favorite colognes.

"So your parents left before the fall of the Shah?" I asked.

"How did you know? And why did you say Persian before?"

I shrugged modestly. "Iranian always sounds like a synonym for terrorist."

That surprised him, and he almost nodded. Then he raised a thick eyebrow and I took that to mean I should answer his first question. I had actually recognized his name because a department chair in SUM's prestigious business school was a Dr. Fahtouzi, and I'd read something about his background in the campus paper once, but I wasn't going to reveal my source.

"I could tell," I said, "by your age, your looks, your

bearing." I was bullshitting, but how would he know? I took one of the comfortable chairs near the fireplace and turned it to face him.

"Very observant," he said flatly. Then he shook his head, either in admiration or annoyance. He brought out a small leather note case and opened it, produced a Mark Cross pen, and asked how well I had known Vlado. His feet were planted firmly on the rug, as if he'd attended some kind of seminar in postural intimidation.

"Not at all."

"But you're a member of Michigan Muscle, and he was a trainer there."

"The club probably has a few thousand members, and thirty trainers."

"Twenty-two," he said with quiet satisfaction, as if correcting me now held the satisfying possibility of future, more damning contradictions. "Eight full-time, the others part-time." I couldn't tell from his manner if he was sullen, cold, or just constitutionally affectless, but whatever the case, I didn't like him, and could feel myself getting prickly.

"Whatever. I don't work with a trainer."

"Why not?"

"I don't need to. I'm not an old man whose doctor just told him he better hit the gym or else, but he doesn't have a clue how to start. I've been swimming for years, and working out, too." I sounded strangely defensive even to myself.

"So you've never talked to Zamaria?"

"Sure I talked to him."

"What about?"

"The way guys talk in a gym. 'Workin' hard, dude.' 'You looked pumped, buddy.' Like that. Nothing substantial."

"And did you talk to him in the steam room?"

"He wasn't talking to anybody."

He pounced quietly. "How do you know that?"

"Okay, he wasn't talking to *me*." I took him slowly–and I

thought patiently–through what had happened. He asked me to repeat a few things, and sometimes stopped and had me start over, but the only pattern I could detect in his questions was an attempt to make me contradict myself. I didn't, as far as I could tell. But was that good or bad? I was getting nervous and couldn't recall if making mistakes was considered a sign of lying or of telling the truth.

"Do you know why anyone might want to murder him?"

Juno's gossip flashed through my thoughts, but I shook my head no.

"You're sure?"

I nodded. He hadn't written very much down to this point.

"And you're sure you didn't know him, you didn't have any reason to hate him?"

"Hate him? Why? What for?"

"It's well known that you're gay."

"So?" I tried not to imagine what he might have heard or what he and his colleagues could have said about me before he came by.

"And you're there in a steam room, it's dim, the two of you are alone–"

I sighed. "You think, what, I made a pass at him, he refused me, and I killed him in a rage? That's total crap. I don't make passes at people, and if I did it wouldn't be in the fucking steam room in my gym where anybody could walk in."

"Maybe you like danger."

"I teach composition! I wrote a bibliography! Do you know how dull that is? Five years of reading every book and article, no matter how insignificant or crackbrained, ever written about Edith Wharton, in any language, and summarizing it. The book had five indexes! The only danger I was in was losing a computer file or getting numbering wrong."

"Exactly." Obviously I had just made a perfect case for a secret life to him. "He was very handsome, and you're gay." He didn't add "boring," but I'm sure he was thinking it.

"So what does that mean to you? I fit the profile for people who murder hunky trainers?"

He smiled faintly. "You thought he was...hunky?"

"Gimme a break, Detective. Everyone in the club thought he was hunky. There's nothing surprising there. And I may be gay, but I sure as hell have never had a manicure."

He looked defensively down at his well-groomed hands and nails. "My wife likes it," he said quietly.

"I bet you've had a pedicure, too," I charged. And now I'd really hit home, because he was blushing. "Hell, you're gayer than I am."

"But I wasn't in the steam room with Vlado Zamaria. Alone."

I couldn't argue with that.

Fahtouzi went back a few pages in his little note case and found something. "You're teaching a course in the coming semester about mystery novels, yes? So it's safe to say you know this kind of book very well?"

I nodded, not sure where he was going.

"I have read many mysteries," he said. "Sometimes, the person who reports a death is the one who committed the murder, and makes the report to cover up."

"Okay, sometimes, but not often. And so what?"

"You could have killed him, and then hoped nobody would suspect you if you were the one to call for help."

"By that kind of reasoning, *you* could be the killer."

He frowned, his eyes looking darker and larger. "Say again?"

"You're the least likely person: the man investigating the case. In lots of mysteries the killer is the one nobody would suspect. Someone told me once that Iranian men are all bisexual. Maybe you made a pass at him and he rejected you–and you're putting me in your place." I said all that to piss him off and it worked. He shut his note case and jammed that and his pen into a jacket pocket.

"I am completely heterosexual," he said. "One hundred percent."

"I know that."

"What?" Now he looked puzzled.

"You have to be. You know why? Because you're obsessed with gay men having sex, or wanting to have sex. Don't you straight people have anything else to think about, don't you ever get laid? That's all you think we do is screw. Someone's dead? Oh, it must be a homo who killed him, and it had to be about sex."

"We have other suspects," he said grimly.

"So I *am* a suspect? Officially?"

He didn't answer, just thanked me for my time and headed for the door.

I followed. "Am I a suspect?" I opened the door for him.

Over his shoulder, as he walked out, he said, "You're helping us with our inquiries."

I knew well enough what that meant. Not a suspect—yet.

PART TWO

Truth is entirely and absolutely a matter of style.

—*Oscar Wilde,* The Decay of Lying

5

I TRIED STEFAN'S CELL, but once again he wasn't answering. I left a message, feeling really annoyed. Why was he so forgetful or careless suddenly? Before 9/11 we'd just shared a cell phone, but afterwards felt it important to always be able to reach each other and we got a second one. I had come to take it for granted that I could always get through to Stefan, and he could reach me as easily.

I phoned Juno and asked her to meet me for coffee near campus, because I didn't think Stefan would be pleased if he found Juno ensconced at our house a second time in one day. We met at Noir, one of a new chain of coffee bars around town that wasn't much different from any of the others—the same roasts, the same chairs, the same muffins—but the name appealed to me, along with the black-and-white posters of New York City in the '30s and '40s.

"You've talked to the police," she said, when she joined me in a corner. "I can tell. You look guilty."

"I'm not guilty."

"But you could be, and that's enough." She sipped from her cappuccino and then slipped off her leather coat. The effect of her large sweater-clad breasts coming to light was as stirring as watching a battleship get christened and slide into the sea. It suddenly occurred to me that she must have had implants, because a woman over forty couldn't defy gravity that well, no matter what kind of Victoria's Secret bra she had in her arsenal.

"They could frame me," I said, trying not to stare.

"Yes. They'll find your DNA on Vlado. You touched him, didn't you? That could be enough." She nodded sagely. "It would all be circumstantial, but with the right jury—"

"—you mean the *wrong* jury."

"Sorry. The wrong jury, prosecutor, and judge, you're toast. No, not toast." She thought a moment. "Rubble."

"Thanks."

"You know as well as I do, you're not a model citizen. Not in Michigan. This is a headquarters for the KKK. And they passed a fucking amendment against gay marriage. What an idiotic waste of time! Global warming and the oil shortage, that's what's going to hurt traditional marriage more than anything else because they're going to destroy the economy. And what the hell is wrong with gay marriage anyway? Think of all the bands that would get extra work, the florists, the caterers, the tuxedo rental shops. And then the marriage counselors and divorce lawyers! Gay marriage could be the economic boost Michigan needs, because it sure as shit isn't coming from the Big Three."

"I thought you didn't like domesticated gays."

"I don't like anything overly domestic. It's what D.H. Lawrence wrote in *Women in Love*, the world divided into couples, stewing in their little intimacy. Disgusting!" She shuddered and I thought of randy, freedom-loving Samantha on "Sex in the City."

"But I think you should be able to get married, because—" She leaned forward and laid the words out like a mason setting a course of bricks. "Because—those—fuckers—don't—want—you—to. How could they possibly think gays getting married threatens anything at all?"

"It won't happen here."

"You're right, too many fuckwits."

"Wait—every country has them."

"Oh, yes, only yours are more vocal, yours are on TV, yours

get elected. You should move to Canada. It's colder and quieter, and we're taxed to death, but at least you'd be free."

"My parents came to America for freedom, they saw what was happening in the Thirties and they were afraid, so they left Europe to come *here*."

"Darling, that was then and this is now. Europe is a million times more liberal and sane than this miserable country. You're turning into Argentina under Perón. It's eerie. Last night I read that your FCC wants to put people in jail for indecency on TV or the radio. In *jail?* Why not brand them and whip them and put them in the stocks while you're at it? You've all gone bonkers since 9/11. You're like mad dogs running down the street of a hot Mexican town biting their own butts."

Suddenly I felt embarrassed about having gotten that second cell phone in a panic. We'd never actually had an emergency that required being instantly in touch.

Juno wasn't exaggerating about the state of the Union, not much, and I knew my parents would agree with her. They were horrified by the Orwellian Patriot Act, by George Bush's cavalcade of lies, and a whole administration that stank of mendacity. My father had recently quoted Yeats to me over the phone: "The best lack all conviction, while the worst / Are full of passionate intensity."

"Really, Nick, you're young enough, you speak French, think about it."

"Stefan speaks French. I stumble along."

"But aren't your parents from Brussels?"

I nodded miserably. It was a deep source of shame that I not only had never become completely bilingual, but that Stefan, whose parents were Polish Jews, for God's sake, could speak French like a Francophone—with just the right rhythm, accent, and intonation. Even his body language changed when he slipped into French as smoothly as a diver entering a pool.

I sipped my espresso, feeling even sorrier for myself, then sighed and tried to get myself focused. "Where do we start?"

Juno squinted at me, as if she were a hardened veteran and I were the stereotypical raw recruit. "His wife, I think. She would know who hated him."

"Are you sure? What's she like?"

Juno shrugged. "Small, mousy, drab. I've seen him with her, and when they meet someone he knows, he doesn't introduce her. She just stands there."

"Not a trophy wife."

"Beautiful men marry their equals, or they marry women who can set them off like a picture frame."

"But she might not know anything about his private life."

"Don't you believe it, Nick. She had to know, they always do, whether they admit it to themselves or not. Now that he's dead, she may open up. Mudslinging can be cathartic."

"Or she may never say anything, not even to the police. So why talk to me?"

"Because you were there when he died. She'll want to talk to you. Let's look up their address in the phone book." Juno started to get up, but I told her not to bother.

"I'll do it. I'll go see her alone. I was there, right? It's more natural for me to show up."

"Well..."

"And you'd only intimidate his wife." I waved at Juno's array of unmousy, undrab assets.

Juno gave me a silky grin. "That's so sweet of you. I'll start asking around to find out exactly who Vlado was shtupping."

"How do you know that word?"

Juno reached over and patted my cheek. "You Americans always underestimate us Canadians."

I had to agree, and I remembered a comedian from the Canadian group the Kids in the Hall saying that Americans knew as much about Canada as straight people knew about gays.

"So if you didn't kill him," Juno said rhetorically, "who did?"

"Who would hate him that much?"

"My best guess is a jealous husband. Someone who found out his wife was sleeping with Vlado, and he snapped. Killing someone in a steam room sounds very spur-of-the-moment to me. And what weapon could you use?"

I shrugged. Then something occurred to me. "What if some guy really did make a pass at him in the steam room? What if that detective's scenario is right?" She looked blank so I explained what Detective Fahtouzi had said.

"Does that happen at the club?" she wondered.

"I've heard about it."

"Then it could be anybody. We'd never figure it out because they check you in when you enter at the club, but not when you leave. There could have been hundreds of men there when he was killed. Or at least dozens if they were between crowds."

"It would have to be somebody really strong," I speculated, "to overpower Vlado. Was there a struggle? Did your, uh, friend, say?"

Juno shook her head.

I asked her if she thought Vlado was popular with other trainers.

Juno considered that, licking her glossy lips. "He seemed to be. I've seen him with other trainers around town drinking, partying. It's something to explore, but with anyone that randy, falling afoul of a husband seems most likely, eh?"

Juno said she would go home and make some discreet calls; in her case I thought that was oxymoronic, but maybe she had reserves of caution I wasn't aware of. I stayed and got the phone book from a staffer dressed all in black who had some kind of runes tattooed on his forehead. Bizarre, but at least he wasn't multiply pierced in his eyebrows, chin, and tongue, a fashion that was still popular locally and made it hard for me to look some of my students in the face. When I'd been young, wearing my hair long, and wild colors had been rebellious. Now it was tattoos and piercing–what was next?

While I looked up "Zamaria," it struck me as almost surreal

that Juno and I had been talking about launching a private murder investigation, with students all around us innocently abusing caffeine and clacking away at their laptops.

But was that any more bizarre than quietly relaxing in the steam room and ending up involved in a murder? At my health club? Could there be any place more incongruous, except a hospital? People went to health clubs to stay fit, to shape up, to live forever, or at least to live well, not to stalk someone or be felled in the dark. Neither a murderer nor his victim made any sense in that setting.

I found Vlado's listing and was surprised that the address wasn't that far from my own house. But when I got there I realized it was another pretty slum, like other such pockets near the university. Nice houses gone to seed because they were constantly rented and had suffered too many change-overs and too many parties. This little white Cape Cod needed paint, new windows, a new roof, a new everything–and that was as much curb appeal as it had.

As I got out, an elderly woman walking a West Highland White Terrier in a red flannel dog coat passed me and headed to the house next door, turning back to smile at me as if we'd met before but hadn't spoken. Where did I know her from?

I walked up a heavily cracked concrete path and knocked on the rain-stained front door. "Hold on!" a woman called from inside, and in a minute I was looking at a short version of Betty Crocker.

"Mrs. Zamaria?"

She nodded. This was not at all the woman Juno had described. Vlado's wife was petite, but not at all mousy. She had the creamy, serene, oval face of a van Eyck Madonna, with her reddish gold hair pulled back into a thick, long braid. The face didn't quite match her outfit: she wore a frilly pink apron over lime green jeans and blouse, and her tennis shoes were bright yellow. From behind her wafted the smell of something delicious.

"I'm Nick Hoffman."

"And?" Her voice was larger than her frame prepared me for, more resonant.

"I was there. In the steam room. When your husband died."

"You were?" She shook her head as if someone behind me had asked her a silent question, and I almost turned. She beckoned me in and told me her name was Barbara.

Inside the tiny, bland house, I recognized the sad, featureless rental furniture you see in student digs, though the lack of color or style was overcompensated for by a huge flag hanging over the dilapidated couch. Horizontal bands of red, white, and blue were centered by a red-and-white checkerboard shield with five colorful spokes forming a kind of crown arching over the shield.

"Vlado was very patriotic," she said, watching me study what I recognized as the Croatian national flag. One small bookcase stood nearby, well-stocked with Stephen King, David Baldacci, Tom Clancy, Jeff Deaver books, along with some surprises: Alice Walker's *The Color Purple*, a biography of Sylvia Plath, and Anna Quindlen's *Black and Blue*.

She led me to the cramped kitchen, which looked like it hadn't been updated since the '70s: the counters were Brady Bunch–orange Formica and the appliances were avocado. Café curtains at the window were a determined plaid of both those colors. Cookbooks crammed one counter, and shoved in on top of the books was a pair of those bright blue silicone "lobster claw" mitts you used for handling very hot dishes. Trays of petits fours iced in the traditional pastel colors covered every surface. Barbara gestured at the sweets. "I've started my own business. I sell these to stores in town, coffee shops."

"I haven't seen them at Noir."

She smiled briskly. "Not yet." She poured me a cup of coffee and set it down at a battered white table that was small enough to make me feel out of scale. I was so startled by her not being

what I'd expected, all the questions I wanted to ask had fled like backyard birds startled by a slamming door.

"Would you like to try–?" She seemed shy, suddenly, and I nodded enthusiastically. She brought me several petits fours on a plastic plate. I bit into the pink one and it was as perfect as anything I'd ever had from a New York bakery. The taste of marzipan, raspberry, and chocolate more than compensated for the weak coffee.

"Delicious." I'd loved petits fours since I was a little boy and my parents had served them to friends at high tea. Watercress sandwiches, however, became a source of aversion.

Barbara Zamaria beamed. "Thanks." It came out almost shyly, and she watched me slowly demolish more of the little cakes, making me feel like she was my mother and I was a school kid just off the afternoon bus, having my milk and cookies and discoursing brokenly about the day's many adventures.

That's when it hit me that she was preternaturally calm, as if her world were bounded by mixing, stirring, decorating. I guessed that working in the kitchen was the same for her as it was for Stefan–a haven of sanity. And with Vlado dead, more necessary than ever. I could half picture Stefan cooking something elaborate on hearing that I had died....

"It upset you," she said softly. "Being there with Vlado."

I nodded, taking a deep breath.

"It was a shock. A terrible shock."

As if she were a therapist pushing just the right button, I felt myself on the verge of tears and I gulped some coffee to hide that.

"It's okay," she said, coming forward to pat my arm.

"No, I'm here because of you," I blundered.

She backed up to survey me, as if she'd missed something. "It's nice of you to worry about me," she said tentatively, as if testing my motives for being there. "We don't even know each other."

Was that a subtle dig?

"You were Vlado's friend?" she asked. "No? You trained with him? Not even sometimes? Oh."

Now she looked puzzled, as if I really were some kind of fraud, and I struggled to think of some way I could turn the conversation around without being obvious. But how was I supposed to find out if she thought there was anyone who might have wanted Vlado dead? Then it hit me that just because I knew Vlado had been murdered, thanks to Juno's inside source, his wife might not know yet. I didn't know how these things worked, how quickly the autopsy results would get to the police and when they would inform her. I flushed.

"I feel involved. I mean, I was a witness."

"A witness? What did you see?"

"That he was dead, I mean, or dying." I almost dumbly added "whatever."

She nodded. I wondered if I was beginning to sound like some morbid freak who was glomming on to her tragedy because my life was empty. Yikes.

"What's the matter?" she asked. "Are you all right?

"I don't know CPR. I couldn't do anything for him, or even try. I just called the main desk."

"You did what you did," she reassured me. "You did fine. It was too late."

I wondered if bringing Juno along might not have been more effective, since I wasn't accomplishing much more than making Vlado's wife feel sorry for me. Desperate to salvage something from this ill-fated interview, I asked if there was going to be a memorial service.

She gave me a look that clearly said, "Why should you care?" but she shook her head after a moment. "He was very patriotic. He'll be buried back in Croatia. He has deep ties there."

Me, I felt buried in my own incompetence.

My cell rang just then and I snatched it out of my pocket, thankful for the interruption. It was Stefan and he said, "Where have you been? Why haven't you answered your phone?"

I told him I'd call him right back, and then I thanked Barbara for the coffee and dessert. Just then, I heard whining and scratching from what I took to be the bedroom, and some metallic rattling. It sounded like an unhappy, crated dog.

Barbara frowned. "Quiet!"

That didn't work. "Vlado's dog," she explained. "I don't let him in the kitchen when I'm baking," she said darkly, and I didn't ask why.

As she escorted me to the door I was furious at myself for not having been better prepared. How the hell would I get to talk to her again to find out what she knew?

"You work out at the club?" I asked a bit desperately, as she opened the door. Like most of the other members, we referred to it as if there weren't any other health clubs or gyms around, since ours was the biggest, the best equipped, and the most expensive.

She shrugged. "Fitness was Vlado's thing, not mine. I don't go."

Barbara must have been one of those people who were naturally fit because she not only looked tight and trim, her biceps and triceps in the short-sleeved blouse were very firm.

"But trainers get free membership," I said. "Doesn't that include spouses?"

"Too many snobs there," she said, and I suppose it was a good enough explanation for not taking advantage of being able to use the city's most deluxe health club for free.

"Well, maybe I'll see you," I said hopefully. "At the club."

Her face clearly said it was unlikely. And then I couldn't believe I suggested she would want to go and exercise in the gym where her husband had died.

"The women," she said, sounding upset for the first time. "They're all bitches. They brag about their jewelry, their cars, their vacations, their boats, the 'house up north.' Their boob jobs. It's sick. I can't stand being around them."

I nodded sympathetically, but as I got into my car, I thought of boob jobs. I was sure then that Juno would have better luck with Barbara than I had–but how would we get them together if Barbara was not going to go to the gym? What could we do, stalk her?

6

IT WAS MY TURN to bring the Sunday papers up to our bedroom the next morning, while Stefan lolled in the sleigh bed, drowsy-eyed, a perfect *Vanity Fair* advertisement for designer sheets or cologne.

I didn't have to say anything—he knew me well enough to read the news on my face. Suddenly more alert, he reached for the *Michiganapolis Tribune*, a paper that had a long way to go before it deserved the designation of rag sheet. He never read it before the *New York Times* on Sunday.

GYM DEATH: MURDER the graceless headline read, and Stefan sat up, quietly absorbing the story as if it were brand new to him, taking sips of coffee now and then, but never shifting focus. I sat opposite the bed in the chair he'd been sitting in the previous morning and tried to read some *NYT* Arts and Entertainment encomium of a new rap group, but I couldn't get a grip on the words, and not just because the murder story had distracted me. It had to be my getting older: articles about the hot new thing—whether wasabi or thongs for men—were beginning to seem like much ado about boring.

I'd checked out the murder story on the way upstairs. It had photos of Vlado and the front of Michigan Muscle, with a sidebar about the club's new ownership and some empty quote from the new manager, Heath Wilmore, about tragedy and fitness.

"Heath Wilmore is the new manager?" Stefan asked when he was done. "Did you know that?"

I shook my head. Surprisingly, Juno had not mentioned this bit of unwelcome news, and I would have thought she'd be au courant on every aspect of the ownership.

Stefan and I had run into Wilmore last week on vacation in the Caribbean. He was an assistant to Franklin Pierce, the president of ultra-conservative Neptune College an hour south of us, which sort of explained his new job, given the Pierces' having bought Michigan Muscle. But if he worked in academia, how would that prepare him for managing a health club? Aside from there being dumbbells in both milieus.

Heath was a very odd character, a man with the robotic unctuousness of Mr. Smith in *Matrix*, and some of our interactions had been quite disturbing. He'd reminded me of the gunsel in *The Maltese Falcon*, someone with a chip on his shoulder that he would be happy to shove down your throat.

"So we'll probably run into him when we work out," Stefan mused, eyes down.

"Maybe, maybe not. I don't remember seeing a lot of the old manager. But we're members in good standing."

"I wasn't thinking about our membership, I was thinking about—" He shrugged. "I don't know."

"Yeah, it creeps me out, too." We'd met him and knew that Heath's boss, Franklin Pierce, hated gays, and no doubt Stefan wondered as I did what one of his operatives at the club might do or want to do. What kind of atmosphere would he create?

Now Stefan put down the newspaper and said, "How deep are you in this?"

"In what?"

"You know what. You're investigating already, aren't you? You've got that furtive look."

I shrugged disingenuously.

"Nick—"

"Okay, okay." There wasn't any point in temporizing. I filled him in about my conversations with Juno and my visit to Barbara Zamaria.

He frowned and closed his eyes, as if counting to ten in an effort to contain himself.

"Her husband died and you barged in on her?"

"I rang the bell. She let me in. She gave me petits fours."

"You can't do this. You can't run around with Juno playing detectives. It's not a game."

"I never said it was."

"Nick, you're a bibliographer, you're a college professor, you're not Phil Marlowe."

"Philip Marlowe," I corrected.

"Whatever. You've gotten into so much trouble up to now, why can't you just walk away from this murder and let professionals handle it?"

"Because I was there."

Stefan shook his head. "That's not enough of a reason."

"It is for me. But there's more. I like it."

"It's exciting," Stefan said, with quiet concern, as if preparing to do an intervention with an addict. "But it's not your job."

"Listen, there's no way in hell I'll get tenure. We both know that. I have too many enemies at SUM. And being in my forties doesn't help, either. They'd be happier hiring someone right out of grad school to take my place, or even stuff some adjuncts into the gap."

I'd needed a full five years to earn my Ph.D. and Stefan and I had both taught elsewhere before he was offered his position at SUM. I was the negligible "spousal hire," taken by SUM because they wanted Stefan. Added to this obloquy was my anomalous behavior and background. I enjoyed teaching, and worse still, teaching composition to freshmen. I had also never written any abstruse articles or books, but had concentrated on work that could be helpful to students and researchers, clearly a sign that I myself lacked scholarly gravitas and rigor. On top of that, I'd had the misfortune to find myself involved in my own little crime wave, and though none of it was my fault, the university judged me as blameworthy.

"So what are you saying?" Stefan asked gloomily. "This is a career choice? You want to be, what, a detective or something? A private investigator?"

"What if I do?" We'd never really had this discussion seriously before, and I found it exhilarating and a bit scary, like diving from a great height with my eyes closed. "I could– I could take criminal justice classes–I could, I don't know, intern with a PI and see if I can make it."

"You're a middle-aged, gay, Jewish comp teacher from New York–what private investigator in mid-Michigan is going to think you've got the right stuff? Because you're not planning on moving, are you?"

"If you told me you wanted to make a career change, I wouldn't make fun of you, I'd try to be supportive. No, I wouldn't just try."

He was suitably abashed, so I didn't need to say anything about having been everything from a cheerleader, handholder, to psychic advisor through the miserable labyrinth of his writing career. After enough years together, some accusations and admonitions don't need to be stated; at the right time, the air bristles with them. It certainly saves time.

"So that's why you went to that gun shop a few weeks ago. It wasn't just personal safety you were thinking about, you were planning ahead."

After having been attacked twice at SUM, and seen Juno attacked as well, I'd gotten fed up and followed her advice about getting a gun. Well, followed it up to a point. I'd gone to an upscale gun shop, read some materials, hefted a few firearms, but hadn't made a decision yet.

I nodded and he flung the sheets aside and sat on the side of the bed, hands gripping the mattress. "Your parents will love this," he said, before stalking off to the shower, looking hotter than ever in his loungewear and his annoyance. I suppose he thought his riposte might disarm me, but the warning made me grin. I could just hear my folks inquiring, with a massive

display of baffled tact, if I planned to be a security guard at Wal-Mart.

God, was there something wrong with me that the idea of defying my parents in my early forties felt bracing?

We had a strained kind of breakfast. Stefan made scrambled eggs with white truffle powder and we ate that with very dark rye toast, grapefruit juice, and heavy doses of silence. Stefan wasn't trying to manipulate me by being quiet; he wasn't passive-aggressive. He had just retreated deep inside as he did when he was puzzled or hurt. I didn't feel offended, and I didn't try to lure him out by reading bits of the *Times* to him for approval or disapproval. He'd return when he was ready.

"I have some errands to run," he said, checking his watch when the dishes were in the dishwasher, and I didn't ask what or where. I was glad he was gone because Juno called me ten minutes later: "She's here!" and ordered me to meet her at Noir right away.

She could only mean Barbara Zamaria. I hurried upstairs to finish getting dressed, and as I snatched up my car keys from the kitchen counter, I couldn't help thinking, "The game's afoot."

When I got to Noir a few minutes later, Jane's Addiction was on the sound system: "The Wrong Girl." I liked that song and the whole album it was on; Stefan didn't. He called it "U2 lite." The last thing I needed right then was to be reminded of a difference of opinion between us, but there it was. Just as I eyed Juno, the chorus came on: "You've messed with the wrong girl, she's small but she's fierce...."

Juno throned near the door at a table for two, wearing jeans and a black-and-white hound's-tooth Chanel jacket, with a black leather rose in her lapel. I guess the jeans were her nod to camouflage, though she looked grossly out-of-place in that roomful of about two dozen pierced, tattooed, and soul-patched SUM students. Not that I fit in any better.

"Barbara's over there," she said out of one side of her pouty, glistening mouth, lifting her chin to a corner of the coffee shop. Her hands were demurely crossed on the table next to a steaming double-sized black mug of coffee.

I looked over to where Barbara was sitting alone. "Juno, I don't think whispering makes a difference. How could she miss us? We're twice the age of everyone in the room."

Juno looked momentarily offended, but the thrill of the hunt obviously took precedence and she hissed, "Come on! Let's go over there!" Before I could tell her to slow down she was up and weaving through the crowded tables to Barbara's. I followed somewhat reluctantly, not knowing what our reception would be like.

Today Barbara was dressed in a thick pink cowl-neck sweater and burgundy cords and seemed a bit fragile or tentative. Juno introduced herself and burst right into a monologue about how sorry she was, and what a great loss Vlado's death was to the health club. Barbara was even cooler to Juno than she'd been to me, but Juno pulled out a chair and joined her without even asking, and waved me to sit next to her.

"You're friends?" Barbara asked flatly, looking from Juno to me and back. I couldn't tell if she thought this was improbable or incriminating.

"Absolutely!" Juno said, grinning, as oblivious to Barbara's mood as someone saying to a pregnant woman, "May I touch your belly?" and going ahead before getting an answer. I supposed death was like pregnancy in that it made you a public figure and left you exposed to comments and collisions you couldn't avoid. That seemed to be Barbara's attitude, that we were the inevitable privacy crashers. Of course, this was not a town of raised voices, except at football games. People didn't even honk their car horns much in Michiganapolis. (Once at a major intersection, I'd been stuck in a turn lane behind an elderly man who was not turning on the flashing red light, despite there being no oncoming traffic at all, and I honked and

honked with no effect. Days later, two people at the health club mentioned having seen me there, futilely pounding the horn. My frustration had cracked them up.)

Juno now tamped down her ebullience and gave Barbara a wide-eyed look of sympathy that made her look a bit cross-eyed.

"So?" Barbara asked, surveying both of us coolly, waiting.

"Vlado was a very good trainer," Juno said, clearly feeling her way.

Barbara nodded. "He had lots of clients." I couldn't tell if the thought gave her satisfaction or not; she was pretty hard to read.

"And lots of friends?" Juno went on.

"Many." Barbara shrugged. "Enough."

"Enemies, too?"

Now she hesitated. "Why not? He was so handsome and strong. That makes some people jealous."

"Like other trainers? Or someone else at Michigan Muscle?" Juno asked, and I winced not at her heavy-handed questioning, but at the similarity between the possibility she'd raised and what Detective Fahtouzi had suggested about me.

"How would I know? Who would be that jealous of him anyway? And the trainers, he was their boss, but the trainers were all buddies, they worked together, they went out together, they worshiped the same thing."

"Fitness," I said.

She nodded an "of course."

Juno pressed on. "Were you jealous of Vlado?"

Barbara almost snorted. "He was my husband."

I was dying to ask her if it was true he slept with some of his female clients, but it was such a crude and embarrassing question I couldn't get it out. Even Juno wasn't going to bring it up, though I sensed she wanted to. Instead, she said generally, "Can you think of a reason why anyone might want to hurt him?"

"He was Croatian, maybe somebody didn't like that."

"Because of the wars?" I asked. I wasn't just thinking about the dissolution of Yugoslavia and the fighting between Serbs and Croats, but also World War Two and the notorious camp of Jasenovac where hundreds of thousands of Serbs, Jews, and Gypsies were killed by the fascist Croatian regime, the Ustashe. The new Croatian flag itself was controversial because its red-and-white checkerboard had been on Ustashe uniforms and the fascist puppet-state's flag. What if somebody had seen the flag hanging in Vlado's living room, would that be enough to inspire a murder?

"I don't follow politics, but those people over there–" I assumed she meant the Balkans. "They have a long memory when it comes to disasters."

And revenge, I thought. I'd read a number of books like Robert Kaplan's *Balkan Ghosts* that showed the unique power of memory to keep hatred alive over centuries in that part of the world. "Was Vlado political?"

Barbara shrugged. "I didn't pay attention to that. He sent money home; what it was for, who knows?"

"You mean he contributed to groups back there?"

Barbara shrugged again.

Juno started to ask something, but Barbara cut her off. "I have to go," she said. "Arrangements." She stood and slipped into a black down parka, and left us as calmly as she'd answered Juno's questions.

I wondered what arrangements she meant. I knew she said something about his being buried in Croatia, but since her husband's death had been ruled a murder, the body wouldn't be released yet.

"You think something about Croatia is behind this?" I asked Juno as we headed back to our previous table.

"But he's not Croatian-born, is he? And he was too young to have been involved in the war when Croatia became independent from Yugoslavia."

Seated opposite her again, I said, "Right, but maybe his father was, or his grandfather, or something like that. And she said he sent money to Croatia—what if he was into fascist groups or something and it got him killed?"

"A vendetta," Juno said thoughtfully.

"Unless it's not even personal, just his ethnicity."

We mused on that for a while. Milosevic was still being tried for war crimes in the Hague, but I'd never heard anything about Croatian and Serb animosity in our city, never heard of demonstrations or attacks or any kind of agitation connected to the wars in the former Yugoslavia. It did seem a strong possibility, though, given that flag in his living room. And Barbara had left as soon as it came up. If there was some kind of connection to his death, how would we find out?

"What did you think of her? I thought Barbara was quite cool," Juno said with a grimace.

"Well, maybe she's in shock."

"And maybe she killed him." Juno had lowered her voice, but a few people around us did seem to hear her, and they shifted around in their chairs uncomfortably. "We got too close and she couldn't handle it. That's why she left."

"Maybe she felt invaded."

"Your husband's murdered and you go out for coffee?"

"Being alone might have felt bad for her." I tried to think what I might do or not do if Stefan had been killed, but the idea was too overwhelming to lead anywhere.

Juno sighed, but not with acceptance. "Nick, she was too unemotional."

"Did you think she'd be falling apart here in public?"

"Why not? Sometimes that's the best place for it."

"She left because—"

Juno cut me off. "Why are you being so bloody-minded? Why did you even come here?"

"You called me."

"Well, you're not exactly Batman."

"And you're not Commissioner Gordon." It was a dumb reply to an even dumber critique, but it made us both laugh. "No, I'm not," Juno admitted with regal good humor. "No I am not."

"When you called, Juno, you didn't say I had to agree with everything you said, you just said to get over here right away."

She relented. "That's true. It was just luck that I walked in and found Barbara here. We need a plan now."

"I don't think she's going to talk to either one of us anymore, do you?"

She nodded. "So we have to find people who *will* talk to us."

When I got home, Stefan was playing some bombastic Shostakovich symphony I couldn't identify by number, but I didn't ask. He was drinking coffee in the kitchen and reading part of the *Times*, but just as he had said I'd looked furtive that morning, that's how he seemed to me now. I told him I'd been having coffee with Juno and he nodded, but didn't ask for details. I didn't supply any. He didn't offer up anything about where he'd been and I didn't probe because I had the distinct impression he wouldn't have told me the truth. We planned dinner instead.

7

MICHIGAN MUSCLE sprawled over some ten acres. An un-
distinguished and rambling mélange of red brick, concrete,
steel canopies, and glass brick, it looked like an overgrown
high school or a midsized suburban corporate headquarters.
Unimpressive, but that was just the meagerly landscaped exte-
rior, enveloped by parking lots. Inside, built on several levels,
and rather randomly organized, the club was a staggering facil-
ity, crammed full of racquetball, squash, basketball, and tennis
courts; swimming pools; running tracks; conference rooms; a
restaurant; a pro shop; multiple yoga and Pilates studios; car-
dio exercise rooms; rooms for stationary biking classes; and
several enormous areas with free weights and the latest weight
machines. It was so scattered, vast, and brooding–despite the
fluorescent lights–that it seemed to be perpetually on the
verge of expanding in new directions all on its own. Inside it
was filled with mirrors and glass walls between sections, so
that all the physical effort expended by its members seemed
multiplied and theatrical.

For a newcomer to fitness, it could be overwhelming. For a
veteran, it was as inviting and comfortable as a cruise ship
offering nothing but pleasure 24/7.

But I wasn't there that Monday morning, the day after I'd
had coffee with Juno at Noir, just to work out. I was on a mis-
sion to gather as much information as I could about Vlado,
from any source possible. It was as broad a portfolio as the one
given to Marco Polo when he went to China, I suppose, and

there was certainly an Oriental profusion and richness to Michigan Muscle. Stefan and I had friends from other parts of the country who came through town and marveled at the club, wondering what it was doing *here*.

That morning at home I'd played one of Haydn's dazzling *Paris Symphonies*–"The Bear"–and felt sufficiently buoyed and even martial to take on this mission. I might cross paths with Juno there, since she was going to start working her contacts among Vlado's clients and their friends. For the moment, that was the extent of our plan, since we had temporarily, at least, exhausted Barbara Zamaria as a source.

I passed through the enormous gray-and-blue-tiled outer lobby to the inner one where the scale was smaller but the colors no more inviting. Various doors and corridors led from this rectangular high-ceilinged space to the restaurant, day care, the pro shop, and the administrative offices, with others leading around to different parts of the facility and a wide L-shaped staircase taking you down to the locker rooms.

It was strange to show my member's card to the stagily cheerful young woman at the main desk who was also answering a phone call, and get waved through just as any other day. Here was the old disjunction in my life, in anybody's life if you've experienced a shocking event. The world goes on around you. And the simple dailiness of it all makes you feel out of kilter, as if you've been clumsily Photoshopped into a picture and everyone can see the fakery.

Down in the locker room, after I'd changed, I ran into one of the trainers, Fred Gundersen, in the bathroom area. We were five urinals apart and I waited till we were both done before saying, "Hi."

"What's up?" he asked, chewing gum as he strolled past me to the sinks where he washed his hands and modestly surveyed his Nordic good looks. He was tall, lean, blue-eyed, and so blond his hair looked dyed. All of the trainers, men and women, were young and handsome, and could easily have passed for

actors or models. A few of the men were on the edge of being overdeveloped, with the lumbering, elephantine walk of power lifters, but they were the exception.

Side-by-side at one of the steel blue sink counters, I said, "That was pretty bad about Vlado."

"Hey, yeah, that's right. You were in the steam room." And he drew back a little, drying his hands with a tan paper towel as if inspecting me for some trace of the event, or maybe some sign that I'd been changed by it.

"I didn't know him," I said as we both moved towards the exit.

"Dude loved to party," he said somberly. Was he thinking of some specific time? And what did that have to do with his being dead in the steam room? "I can't believe he's gone." Was Fred imagining himself, as young and vital as Vlado, lying dead somewhere? I often wondered what it was like for the trainers, all of whom were at the peak of physical fitness, to work every day with clients who often were the opposite. Did it shake their unconscious ease in their super-performing bodies to see people struggle to merely stand straight, to lift even light weights correctly, to perform any of the workout maneuvers they were being taught?

We strolled companionably down a long empty hallway past office doors, though I never was one to overestimate anybody's friendliness at the club, especially the trainers' who were–after all–supposed to be sociable. What they thought about me, given that I was gay, was anyone's guess.

"Yeah, I heard he liked to party," I said, trying to sound knowing but casual, and I could feel Fred study me warily, as if suddenly remembering that Vlado had been his boss and not just his peer.

"He worked us hard," Fred said, apropos of nothing. And another non sequitur followed. "The paper said he was hit on the head," Fred brought out, as if he didn't believe it. "But what if he, like, fell, or something?"

"Because he was high?"

That was too direct a question and Fred peeled off down another hallway, saying, "Later, bud."

Had I learned anything? I wasn't sure. Passing one of the basketball courts, I surveyed the enormous weight room that seemed to stretch as long as a football field. Its many dozens of machines were arrayed in no discernable order, so that the unwary patron could very easily get clobbered or brained by backing up suddenly into a machine, or turning into the end of a barbell hanging on a rack. There were only a dozen or so people there midmorning, a time between the early-morning maniacs and the lunch-break crowd, but I heard AC/DC blasting from a stationary biking studio off in the distance, the pounding of a basketball and cheerful taunts from another one of the courts. The club did not have a general sound system, thankfully. If you wanted music, you brought your iPod, or tuned into stations set up in the rooms of treadmills, stair-climbers, bikes, and elliptical steppers. I nipped into the nearest cardio room where there were only a few pre-anorexic women on various machines and after ten minutes running on a treadmill, I dutifully worked out my legs and shoulders, mixing free weights, bands, and machines, always on the lookout for someone I could pry some information out of. But I didn't see anyone in the half hour I was on the floor, so I headed back to the locker room to shower and change.

While showering I mused about Fred's few comments. Was talking that openly about drugs a warning bell for Fred–did he think I was implying Vlado might be on steroids? But that didn't make sense because steroids didn't make you high, they helped build your body, and not only did Vlado's body look natural, he also apparently had a strong sex drive, which steroids suppressed. Was Fred saying anything meaningful, did he even know Vlado well enough, or was it a rumor? I tried to come up with ways I could get to talk to Fred some more, but none of them added up. I couldn't exactly suggest we have a

beer sometime because we'd never gone beyond chitchat. If only I were a writer! Stefan could get away with it because he could always pretend he was doing research for a book, one set in a health club. I hesitated when I was done showering, because I wanted to sit in the hot tub, but that would have meant passing the steam room where Vlado had lain dead or dying. Then I heard loud voices and splashing as a couple of guys entered the hot tub from the other side of the shower room and their blustering noise relaxed me enough to head their way.

The hot tub was big enough for about a dozen men, but these two sat as far apart from each other as possible while they ragged each other about some tennis game they'd been playing. Most guys went into the hot tub nude, and I had noticed that straight middle-aged men talked the loudest, as if the idea of each other's family jewels bobbling just below the surface of the water crisscrossed by jets made them uncomfortable. The heartiness of their speech was apparently a shield against embarrassment–or worse.

I nodded minimally to both as I stepped down into the hot tub and headed for the spot midway between them on the circle, following the same social rules that governed placement in an elevator. So I was at midnight, and they were at nine and three.

"Hot today," one of them boomed.

"The jets," the other guy said, as if there were any doubt what his friend had meant. I nodded. I'd seen them both before, possibly exchanged a few remarks about the weather or our workouts, and I thought the one to my right was Dave, the other one Robert. They were both pushing fifty, in real estate, I thought, with full heads of salt-and-pepper brush-cut hair, incipient jowls, flabby shoulders and chests. I'd heard them at the lockers once haggling over some multi-million-dollar real estate deal that involved a complicated swap of some property I couldn't follow.

I closed my eyes and settled in for a ten-minute soak, enjoying the jets on my lower back, but then Dave, the guy to my right, piped up. "I'm telling you," he said, obviously continuing a belligerent conversation started elsewhere. "It was terrorists."

"Bullshit. What the fuck would a terrorist want to kill some trainer at a gym for?"

I opened my eyes.

That caught their attention and suddenly I was being appealed to.

"Dave thinks terrorists are behind most of the unsolved murders in the news."

What did that have to do with Vlado—his murder was too recent to be considered unsolved. But I didn't bring that up because I was too surprised at the theory.

"Rob's clueless. Why should they go after big, obvious targets? They could kill people here and there, one-by-one, and who'd know what they were up to?"

"You're nuts, man. What kind of sense does it make to kill one person at a time if you're a terrorist? Where's the payoff?"

Dave grinned malignly, as if pretending he were a terrorist. "They've got plenty of time. They don't think like we do. They'll take us down even if it takes a hundred years."

"It's gonna take a hundred *centuries* your way."

They glanced my way to see whether I had an opinion, but I held my hands up in a "leave me out" gesture. Why couldn't they be chewing the cud of some game on ESPN last night—that would be easy for me to tune out.

Rob asked, "So you think some Arab nut from al-Qaeda snuck into the gym and went after one of the trainers. Okay, why him?"

"He was a real stud, he was a real American."

"How do you know?"

"Shit, Rob, his car bumper has all kindsa stickers about Iraq and the troops. That's the kind of guy they'd go after. A real

patriot. And–" Here he leaned forward conspiratorially. "Who says they snuck in? They're already here!"

I assumed he was referring to Michiganapolis's sizable population of Arab Americans. Great, I thought, a conspiracy nut and a bigot, just what I needed right after a workout.

Dave said, "So, who do *you* think killed him, smartass?"

"Obvious. Guy like that stud, he had to be gettin' it wet where he shouldn't be. You wave your dick around that much, somebody's gonna cut it off or cut you down. I figure it was some poor schmuck whose wife he was banging."

That seemed to dampen Dave's vision of personal apocalypse, but only momentarily. Both of them stood up and started to draw a bit closer to the middle of the hot tub and seemed prepared to launch into another rhetorical tussle, so I exited and showered off to the sound of their arguing, trying not to laugh at the bizarre and ugly theory I'd just heard. Terrorists? Why not an alien abduction that had gone bad?

I dried myself as quickly as possible lest they follow and start arguing in the showers, wrapped the towel around my waist, and headed out into the main body of the locker room to change and figure out what I could possibly do next to learn more about Vlado. Something about the bumper stickers bugged me, but I wasn't sure what or why.

The locker room was almost empty, as far as I could tell, with even the attendant who handled the towels–collecting, laundering, folding, distributing–out of sight. Thankfully, someone had turned the plasma TV facing a U of armchairs down low, so I didn't have to listen to the inanities of the news. Whether it was Fox or CNN or MSNBC, there was always some story about a disaster that had nothing to do with me, but made for colorful and cheaply sensationalistic viewing: fires at chemical plants, missing kids, highway pileups.

I padded over to my locker in a corner down and off to the right, at the end of the first of four rows of lockers. I took off my towel, laid it out in front of the locker, stepped onto it, and

reached out for my lock but before I could start spinning the combination someone behind me said, "Nick Hoffman."

I whirled around as if greeted by Dracula.

It was Heath Wilmore. Where had he come from? Had he been waiting in another aisle for me?

"I didn't see you," I said, and he made no comment. He was dressed in business casual: loafers, black slacks, blue silk shirt and black-and-blue striped tie. But even without a suit he seemed armored, and he had the spooky intensity of Christopher Walken about to burst into one of his tirades.

"I need to talk to you," he said quietly.

"How about after I put on my clothes?" I resisted the impulse to sit down or cover myself in some way. I didn't want him to know how exposed and cornered I felt. But at a time like this, where was I supposed to put my hands?

He nodded. "I can wait."

Was he going to stand there while I got dressed? What the hell for? He didn't give off any voyeur vibe. Then I remembered when we'd seen him on vacation being bossed and bullied by Franklin Pierce. Somebody like that would need to play little power games on a daily basis to keep his self-esteem from puddling.

"I'll come up to your office when I'm done," I said, firmly, wanting to turn and moon him, though I don't know if it counted when you were nude.

He met my eyes briefly, then nodded in that way of his that was so affectless it was vaguely threatening. As he walked off I was glad to see he cast a bit of a shadow.

I made the mistake of calling to his back, "What's it about?" and of course I didn't get an answer. Fucker.

When he was gone, I smacked the bench. I was an adult, but his one request somehow triggered that I-didn't-do-anything-wrong response that went back to elementary school. I was instantly on the defensive—being undressed while he was clothed didn't help—and stopped thinking clearly.

Speaking of an end to clear thinking, Dave and Rob had emerged from the shower area and I could hear them arguing their rival explanations for Vlado's murder an aisle over.

"It's pussy," Rob was opining. "It's always pussy, man, there's no other reason." Locker doors banged open and they seemed to be making as much noise as if they wanted to break something more than the silence.

Dave said, "Muslim terrorists, you wait and see."

"You Serbs are whacko, you got Muslims on the brain."

Dave laughed bitterly. "You don't know what they're like. They destroyed Yugoslavia, and now they're headed over here."

He was delusional. Milosevic had destroyed Yugoslavia with his revival of Serbian nationalism. Dave was clearly a fanatic.

"Hey, Doc, how's it goin'?" Dave called to somebody who was apparently joining them in their aisle. "Good swim to-day?"

"Not bad, not bad," came the reply, and I recognized the voice. It was Alfred Aftergood. I was suddenly transported right back to the steam room door, watching him attend to Vlado, and ordering me to keep people away. I finished dressing, grabbed my parka, and fled into the hallway. I hesitated at the stairs leading up to the lobby and the manager's office, standing there for a while, breathing deeply, trying to calm down as people passed and nodded. One of the club's minions, head down behind a pile of towels, scurried by so quickly I couldn't tell if it was a man or a woman. But if Heath Wilmore was the new manager, it made perfect sense that he was intimidating the lowest people on the club's totem pole.

I headed up the stairs but sat on a bench when I got to the main level; I needed a time out. It was only a few days after I had witnessed a death or discovered one, however you wanted to describe it, so I couldn't imagine a time when I wouldn't still be shaken and oppressed by it. And even in the short term, I wasn't anything like the amateur sleuths in far too many

mysteries who found a corpse in one scene and went off to Denny's in the next, unmoved, unchanged. That was one reason why I preferred more hardboiled writers like Loren D. Estleman, because his protagonists didn't slough off the reality of dealing with death. It made them tougher, as a defense, and that seemed logical and human.

Stefan had said that sleuthing was exciting, but the deeper truth was that it had helped me feel moderately more in control of my life. After all, I'd grown up in New York City and never been mugged or even pickpocketed, and yet here in bucolic mid-Michigan, I had learned too well the power of that Latin tag: *Et in Arcadia ego.* Death found its way into Paradise, too.

I hadn't seemed to be able to propel my career forward, and not just because of the bad publicity for the university I'd contributed to. My work as a bibliographer was not taken seriously in the department; neither was my teaching, which earned rave reviews from students. Doing a bibliography isn't daring, controversial, or especially noteworthy–it puts you in the ranks of the academic plebeians, and you're widely viewed as a glorified clerk or librarian. As for teaching, most parents spending thousands on their kids' education would be appalled to know that universities tend to value the professors who bring in grant money, not the good teachers, because there isn't much profit in it.

What did I have to offer SUM? I'd published some articles in the last few years, but I hadn't been able to write another book because the Wharton bibliography had burned me out, and so my CV just wasn't impressive enough. Yet I'd had moderate success investigating crimes, so why shouldn't I be drawn to exploring what that meant or could mean? It's not as if I wanted to do something I'd never had any experience with or shown any talent for, like opera singing, architecture, or public relations.

Thinking of the future snapped me out of my state and I marched down the hall to the manager's office. The door was

open and I didn't bother knocking. Why should I be polite when he'd snuck up on me? I just dropped my gym bag inside the door and said, "What's up?" I didn't even move towards a chair, determined to put him at a disadvantage.

Heath Wilmore sat behind a standard-issue, shiny, Office-Max kind of desk. The whole office had the same cold, pre-fab look, as if it were a stage set or rented for the day, something without history or meaning. The only human touches were a small collection of trophies on a side table and what I assumed were family pictures facing him on the desk. Was the room virtually devoid of decoration and clutter because he was new, because he was obsessive, or because he didn't want anyone to figure him out?

There were two chairs, but Heath pointedly did not ask me to sit down, and I felt out-maneuvered. If I sat now, was that giving in or taking over?

"Tell me about the other day in the steam room," he said.

"What?"

"What happened in the steam room," he explained. "I want you to tell me about it."

"Haven't you read the paper? Didn't you talk to the doctors?"

Heath nodded dismissively, hands folded in his lap. "I want to hear your version."

"My version? What are you talking about? I don't have any *version*. And why are you asking anyway?"

"I'm the manager, I want to be informed about what goes on in my club."

I didn't know what he was implying, but it definitely sounded hostile. "You want the story, ask the police." I zipped up my parka and turned to grab my gym bag and leave.

He sighed. "I've gotten some complaints about you."

That stopped me, of course. "What?"

"You're bothering members, asking them questions. You need to stop."

"Who am I bothering?"

He rolled his eyes a bit as if I were a real troublemaker. "My job is to protect the members, so I'm not at liberty to say." It didn't just sound stiff, it sounded mean-spirited. He enjoyed withholding the information.

"But you're at liberty to make false accusations."

"You're denying it?"

"Denying what? This isn't a courtroom."

"I don't want to hear any more complaints about you. That's not the kind of club we want to run. We want our members to get along. Harassment is not acceptable."

Harassment? Bothering members? What the fuck could he be talking about? I'd only talked to Barbara Zamaria, who said she didn't go to the club, and Fred Gundersen, who was on the staff. Flabbergasted and offended, I was unable to hit him with any kind of comeback. He clearly enjoyed my confusion, because he smiled and said, "Have a nice day" as if it were a dagger he was slipping between my ribs.

God, he was insidious. I marched out of there wanting to kick someone or something. On the way through the lobby I passed Alfred Aftergood and Dave from the hot tub speaking in low tones. Just as I stepped into the slow-moving revolving doors, I heard Aftergood very clearly, perhaps because there was something of an echo where he stood.

"That wasn't murder," he said. "That was a gift."

8

WITHIN FIVE MINUTES I'd had two virtual smacks in the face: one from Heath Wilmore, the other from Alfred Aftergood. The cold air outside was a third. I hunkered down and headed for my Lexus, wondering what the hell they were both talking about.

How could a doctor say someone's murder was a good thing, especially the doctor who had tried to save him? If Aftergood was truly glad Vlado was dead, and had trained with him, then there had to be something personal behind it.

And what was up with Heath Wilmore issuing pronouncements about the club and its members? Could Barbara Zamaria really have complained to him? And Fred Gundersen, too? Had I been that out of line?

The parking lot was starting to fill up with the pre-lunch and lunchtime crowd, just like any other day, and I drove off feeling totally disoriented. I called Juno on my cell and got her at home, asked her to meet me at my house to confer.

She showed up only a few minutes after I arrived, and dressed to kill in brown leather boots, calf-length blue wool dress with hood, and a short, very fitted brown leather jacket. It was cinched tight with a matching belt and topped with a brown fur capelet. I was sure I'd seen a Ralph Lauren ad for this outfit only a week or two before. She looked wildly glamorous, but tightly wrapped, a cross between a super-vixen and a sci-fi vestal. On her wedding band finger, she wore a fierce-looking

Cartier ring: it was a gold panther head with onyx for the spots and what looked like emeralds for the eyes.

She greeted me with a high-five that I returned automatically, and marched into the living room, which she surveyed with her eyes half-shut as if imagining what she could do with the room. I'm sure she thought it was too staid, too composed.

Sitting at the other end of the couch, I asked her about the high-five.

"You must be making progress, or why else call me?"

Was it progress? I told her first about my strange conversation with Heath Wilmore.

Juno considered. "He could be involved somehow."

"But he just got to the club, what connection could he have with Vlado?"

Juno shrugged. "Perhaps he's just a bully."

"He also doesn't like me," I said.

"Immaterial. Who does?"

"Wait a minute—"

Juno karate-chopped the air between us. "Stop. I'm not being insulting, just honest. Most people don't like me either, Nick. And who the fuck cares? We go our own way, and that's that." Was she about to burst into song?

Her blasé attitude seemed very un-Canadian, not to mention un-American. Being liked is as important to Americans as saving money at Wal-Mart. My mother often mocked this craven side of our culture. "You chat up your waiters," she once pointed out to me. And she meant, You Americans. "You want them to think you're discerning, that you make the right choices, that you know about wine, but also that you don't think you're better than they are because you're sitting down and they're standing. *Mais, ç'est ridicule!* When I go to a restaurant, I look for good service, not a new friend. I don't need the approval of strangers."

"So. Is there more?" Juno asked, prompting me.

"Yeah, a lot more." And I repeated what I'd gleaned from

Fred Gundersen and then what Alfred Aftergood had said in the lobby of Michigan Muscle.

"Aftergood? That's amazing."

"He was down in the steam room," I pointed out.

"I know, I know. I've been talking to his wife. We run together. She trained with Vlado. And there was more between them, I bet." Juno pursed her lips. We were silent, and then she said it first. "Her husband could have killed Vlado while pretending to save him. What do you think?"

"I wasn't standing that close," I said, "and I'm not a doctor."

"Right. Who knows what he did, or didn't do, when he got down there. I don't know for a fact that she slept with Vlado, but if her husband knew, there's your motive. Oh, well, we'll find out. She said she'd talk to us about it."

"When?"

"Whenever. Right now, if you want. We could have lunch there."

"How can we barge in, she might be busy. And why would she talk to me, she doesn't know me."

Juno smiled sadly. "Nick, she's rich, she's bored shitless, we'd be a break for her, trust me. These women are as pathetic as Marie Antoinette dressing like a shepherdess and milking goats. They have three homes and a boat and too much jewelry and no bloody life. They try to hide it with little yoga classes and book groups and power shopping and lunch with the girls, but it doesn't work."

"So they have affairs?"

"And that doesn't work either."

For some reason I thought of a Joyce Carol Oates story whose content I couldn't remember, but whose title I'd never forgotten: "The Heavy Sorrow of the Body."

Juno called her friend, and so we drove off in my car ("Very nice," Juno purred) to interview, interrogate, or maybe just entertain the wife of the man who had apparently tried to save

Vlado's life, but also–apparently–hated him. Enough to kill him?

But in the car, Juno made a switch. "You know, Nick, it doesn't matter if Aftergood wished Vlado were dead, he's a doctor, he couldn't do something like that. Haven't you read Ian McEwan's new book?"

Yes, I had read *Saturday*, in which a doctor operates on a man who's threatened him and his family, and doesn't let him die. "But that's a novel," I objected.

"And you live with a novelist and I've written a bestseller. Q.E.D." I liked that she wasn't pretentious enough to call her anonymously published Ancient Egyptian Western a novel. Almost nobody on campus but me and Stefan knew about her authorship; it was a rare instance of Juno's taking a low profile.

She directed me to a neighborhood about ten minutes north of mine that was also filled with mid-century Colonials, split-levels, and ranch houses, though many of the trees were older, and I think I'd read once that the area had been a 500-acre farm at the turn of the previous century. We wound our way through the gently curving streets, staying at 25 mph because Michiganapolis cops loved catching you speeding in subdivisions. Eventually we drove into a shady, heavily treed cul-de-sac dominated by an enormous, shake-roofed, newly built Tudor.

"Wow," I said, as we pulled up to a paving-stone driveway whose base was flanked by two antique lampposts. The driveway ended at a two-story four-car garage, itself as big as a starter house. "We'll go in the side way, to the kitchen," Juno said, and when we got out of the car, the house loomed above us like a ship in port.

"How big is this thing?" I muttered.

"Oh, twenty thousand square feet," Juno said. "More or less."

We knocked and were greeted by what I would have expected. I'd come to think of women like these at the club as "the doctors' wives" whatever their husbands did, since many of

them seemed to be married to physicians. She was in fact the wife of a doctor, but even if she weren't, she fit the standard: petite, thin, perfectly groomed and made up, hair dyed blond and worn short, and enough discreet plastic surgery to make her look shrink-wrapped.

"Celia Aftergood," she said neutrally, and waved us into a stupefying, gargantuan kitchen. Two stories high, it seemed as big as my whole house, and it didn't just have a kitchen island, it had an archipelago. No kidding, there were four islands of varying sizes: one flanked by bar stools, one boasting three sinks, one with an elaborate stove top and grill, and one just for preparing food, I guessed, or maybe it was the spare. The room was floored and countered in deep green marble, with the kind of gleaming cherry cabinets you only see in magazine layouts of kitchens to die for.

Half a dozen antique globe lights punctuated the length of the ceiling, reminding me of a library. Set into one wall of cabinets was a refrigerated wine cabinet with double doors; through the glass I could make out hundreds of bottles. I also noted two computer workstations, a B&O sound system, and two under-counter flat-screen TVs, but we weren't stopping there. Celia took my parka and Juno's jacket, and waved us down to the far end of the kitchen where green-and-rose chintz-covered couches and chairs formed a seating area in front of a fireplace with a French marble mantel. It was either from a real château or an excellent copy.

As we neared that end of the kitchen, I saw it wasn't a gas fire, but the real thing. Celia just managed to have logs arranged so beautifully that they looked fake and the flames looked made to order. Plates of sushi and two bottles of Vouvray waited for us on the polished granite table, and the air was scented by a three-wick fig-scented Henri Bendel candle, which was Sharon's favorite kind. I recognized it from the label.

The *Goldberg Variations* were playing softly in the back-

ground, and I could smell very strong coffee. The napkins were linen, and a wall of windows and French doors framed the view of a snow-covered lawn punctuated by a gazebo, a three-tiered fountain, and copies of classical statuary. I was tempted to ask if we might find peacocks there in the spring. And I wondered if somewhere in the house there was a bedroom as mammoth as Rebecca's in the Hitchcock movie.

"I love making sushi," Celia called from the other end of the kitchen, where she was hanging up our coats in what I could see was a closet but had assumed was a pantry. "I was bored and made some this morning, before you phoned."

I wondered what else she did when she was bored.

"You weren't going to eat all of this yourself, were you?" Juno asked, and Celia shrugged. I didn't know if that meant she didn't care if it was wasted (day-old sushi is grim), or perhaps she'd intended to eat it all and then barf it up in what was presumably one of many palatial bathrooms.

"Sit, sit."

Juno did and dived right in, filling a square green plate with sushi. The wineglasses were gold rimmed and etched and definitely not from Pier 1. Juno picked up chopsticks from an alabaster vase and started sampling. She was a woman born to eat. It didn't distort her face, it made her look more herself. It made her look hot.

I joined her, and Celia beamed; not a high beam, though, but a low beam. In a graceful but lordly way, she opened both bottles of Vouvray with one of those "rabbit-eared" openers and then settled down into a chair and fussed idly with one of her diamond-heavy rose gold rings. She had matching earrings and seemed dressed–in her black-and-white striped Capri pants and matching velvet top–for a party more than an impromptu lunch at home. The sushi was fantastic and I told Celia that.

She nodded thanks. "I took a class...." In her vague ellipsis I sensed the truth of Juno's conviction that Celia and women in

her income bracket were tragically bored, and I imagined there had been sculpture classes, wine-tasting classes, Portuguese language classes, and on and on.

Juno and Celia chatted a bit about their upcoming Christmas vacations. At the club, people were always talking about their Christmas, spring, and summer vacations, either before or after, and the more elaborate or exotic it was (sailing down to Panama and through the Canal; hiking in Peru; a private yacht up the Yangtze River), the more offhand the tone. I had not seen Juno interacting like this before; she seemed much more laid back and companionable, not at all like someone who might set a conversational fire.

Celia said she and her husband were taking their twin college freshmen to Hawaii again. "They already have everything they want," she said offhandedly, "so we've been doing family trips." I wondered what "everything" meant.

"How long will you be gone?" Juno asked.

"Three weeks." Celia turned to me and asked, "Which is *your* favorite island?" In a flash, I saw her and her circle of friends debating the varied merits of one Hawaiian island over another, a debate based on years of experience staying at the finest hotels. It was a very different world than the one Stefan and I lived in, despite how comfortable we were.

"We've never been to Hawaii," I said, thinking I should have made a joke about her four kitchen islands.

There was a minuscule shift in her physiognomy as Celia evidently downgraded my sophistication quotient, or her assumptions about my income.

"My partner and I tend to go to Europe. We love Venice," I said. "And Paris, of course. We go there a lot." It wasn't strictly true, but I felt defensive. I'd had a very well-heeled life growing up in New York, but it was nothing like this, and maybe it was being the son of immigrants that made me feel a little intimidated, or at least off-center.

"You speak French," she said, admiringly.

Since it wasn't exactly a question, I just smiled and let it drop.

Celia was surveying me over the edge of her Vouvray glass. "We must work out at different times," she said. "I don't think I recognize you."

"Well, we all look different with our clothes on," Juno said, echoing what most people at the club said when they met each other outside of it. Celia and I chuckled dutifully.

"But wait–I do recognize you from the newspapers," she said brightening. "Didn't they call you the Male Miss Marple?"

I winced. "That was the *Chicago Tribune*."

"So that's why you're here, you're *detecting*? Will you dust for fingerprints?" She slurred the last word and I suspected there might be a third bottle of Vouvray somewhere, already poured from.

"Cee," Juno said, "we're just curious."

"Okay. So what do you want to ask me about Vlado?" Celia leaned back and waited for our interrogation to begin, but I wasn't sure where to start. Like Vlado's wife herself, Celia seemed fairly unmoved by his death, or at least was laboring to hide any feeling she might have. Perhaps that explained her having almost finished her second glass of wine, unless she was working hard to anesthetize herself and was really broken up.

"How long did it last with Vlado?" I asked her, putting down my plate.

She glanced off to the fireplace, held the wineglass to her cheek as if it aided reflection. "Oh, typically an hour. We didn't have time for more. Omigod, you're blushing! Isn't that what you meant?"

Juno was smirking, and I thought of Missy Elliott's song about not wanting "a one-minute man."

"I meant how long...how long did your affair last?"

"It's not– It wasn't over. And we started a year ago." She smiled. "I think that day was his thirtieth birthday and I said I'd buy him a drink, we were going to meet in town, he was

running late, I said drop by here instead, and there you have it."

I wasn't sure what to ask next, but it didn't matter, because the spirit of confession was animating Celia.

"He wasn't a very nice person, of course. I knew he cheated on his wife with lots of women, not just me, and he didn't have much to talk about besides fitness, but who needed to talk? He was an exceptional lover, he was exciting. Lovely skin, a perfect body, and the weight of those thighs..." Her eyes widened. "People think it's other things, but it's really legs that make a good lover," she said. "You've got to have strong legs, that's where the stamina comes from."

She could have been talking about the right ingredient for a recipe.

"Anyway, we had lots of fun, so who wouldn't want to help him out?"

"Help him out?" Juno prompted.

"With his plans. Didn't you know? He wanted to open his own personal training studio."

"What's that?"

Celia frowned as much as her Botox would let her. "Private sessions, lovely well-stocked studio, flowers, your choice of music, massage therapy afterwards, private hot tub, meals."

"Meals?"

"Whatever you like. Breakfast beforehand, lunch afterwards, whatever. It's all designed personally from start to finish. You buy packages of sessions."

"That sounds expensive."

Celia regarded me impassively, and in her silence I read: "Of course, why not, it should be."

Juno piped up. "It's big on the coasts, so why wait ten years for the trend to get to Michiganapolis? I read about one where the sessions ended with a Kir Royale."

"That's so tame," Celia brought out. "I'd rather have a Ruby Red. We drink those all the time when we go to Chicago."

Even Juno hadn't heard of that drink and she was clearly miffed, but didn't ask what was in it. Since I was obviously the group's peasant, I did.

Celia thought a moment, then diffidently reeled off the ingredients: "Grey Goose L'Orange vodka, Hpnotiq, orange juice, pomegranate juice, and then it's topped off with Dom Pérignon. Oh, and the stirrer has a one-carat ruby."

The only thing it seemed to be missing was sprinkles of edible gold. I didn't bother asking how much the Ruby Red cost–it was obviously the bar equivalent of a yacht: if you inquired about the cost, you obviously couldn't afford it.

But I did ask, "What's it taste like?" at the risk of sounding like a hick.

Celia deliberated. "It's memorable." And she seemed momentarily lost in beverage nirvana.

I tried bringing her back. "Would there be a market for an upscale personal training studio here? You think Vlado would have made it?" I asked. "He was pretty young."

Celia mulled it over. "He was smart, he was ambitious, and he had lots of clients, and then our club is too big for some people. It intimidates them to be surrounded, exposed. Besides, Vlado wasn't just a trainer, he was the head of personal training, he had a lot of responsibility. So why not?"

I thought of de Tocqueville's acerbic observation that "every American is eaten up with longing to rise." I saw that in myself, longing for tenure, Stefan dreaming a hundred different dreams of success as an author. Was Celia beyond longing?

"How did you help Vlado?" Juno asked.

Celia smiled as if it were a foolish question. "Financially," she said, slightly reluctant to use the word.

I asked her, "What did your husband think of that?"

"He admired Vlado, he wanted to help, too. Why wouldn't he?"

I had to point out the obvious: "You were having an affair with Vlado, didn't that bother your husband?"

"Not really," she said. "It's very simple. He got too much out of training with Vlado. He swore by Vlado, was always telling me about their training sessions, how much he learned, how grateful he was. When he started with Vlado, he was twenty pounds overweight, he had back trouble, shoulder problems, and he's in great shape now, the best shape of his life. When you find help like that, you don't give it up."

She could have been Maggie Smith in *Gosford Park* talking about a maid.

"How often did your husband train with Vlado?"

"Once a week, and they sometimes played racquetball, too. I trained two or three times a week, depending on vacation schedules."

"Who do you think killed Vlado?" Juno asked abruptly, and for the first time, Celia seemed less than completely at ease, but the question itself didn't startle her. I suppose she'd been expecting it.

Celia sighed, the way you'd take a puff if you were a smoker and needed to give yourself time to come up with an answer. "Who do I think killed him?" she asked. "One of the trainers, obviously."

Juno and I both asked, "Why?" at the same time.

"Oh, they hated him, and not just because he was their boss. He was always complaining about their attitude. He had so many clients, he had big plans, he was larger than life. People despise that, they want to cut you down."

The American Sickness, my parents called it: envy of success in a culture where the myth was that everyone could make it to the top, despite the fact that there wasn't enough room up there, and most people didn't have the skill or luck to rise very high.

"It had to be a trainer. Whoever did it was strong," Celia said. "Only someone strong could take him by surprise. Isn't that what happened?"

"We don't know," Juno offered.

Celia shrugged, still not showing any regret or grief or even annoyance that Vlado was dead–and she and her husband would have to find a new trainer. But she'd just finished a third glass of wine, and maybe she was beginning to blur around the edges.

"I do think it was a trainer," Celia insisted.

"It's possible. What if he was sleeping with one of the trainer's wives or girlfriends?" I suggested.

Celia surprised me by shaking her pretty head. She poured some more wine for all of us. "Not a chance. He wasn't desperate."

I assumed that meant he had the pick of the club members in women like her.

"There was someone he fired," Celia mused. "One of the trainers. I don't know why, don't recall the name."

Juno and I exchanged a glance: this was something to look into.

"When's the last time you saw Vlado?" I asked.

She shrugged. "At the club, I think. Last week. He was training someone else. We said hello, that's all. He looked busy. Do you want some coffee? I have marvelous petits fours from someone here in town."

Juno accepted for both of us and Celia rose and sauntered to the other end of the kitchen. Watching her, I thought an airport-style moving sidewalk would not have been out of place in that gigantic room.

"Barbara," I mouthed to Juno, who held her hand to her ear. I said it louder: "Barbara Zamaria makes petits fours." It was evidently loud enough for Celia to hear, or the acoustics in the kitchen were exceptional, because she called over to us, "Yes, Vlado's wife made these. She's very good. He asked me to give her a chance, and I've had her bake for teas, parties, you know. It's nice to help someone out."

Celia had loaded up an antique wheeled tea cart and rolled it down to where we sat. There was a silver coffee thermos, china

cups and saucers, and a porcelain cake stand laden with pink, green, and gold petits fours, all of them flawlessly decorated with tiny butter-cream rosebuds. Celia served us and we spent a few minutes *ooh*ing and *ahh*ing over the petits fours and trading notes about favorite desserts in restaurants around town.

I was feeling sated and a bit buzzed by the wine when Celia asked, "Was he dead when you found him?"

"I think so. I'm not sure."

"Uh-huh." She took that in, but I had no idea what she was making of the information, and I thought Juno and I should head out now and go over what we'd heard.

Juno was clearly on the same wavelength because she rose and went over to kiss Celia on the cheek. "This was lovely," she said.

Yes, I thought. If you're going to talk about murder and adultery, the setting might as well be luxurious.

On our way out, Juno and Celia made a date to go running at one of the indoor tracks at Michigan Muscle. I took my coat from Celia, thanked her for her time and for lunch. As I reached for the door handle, she said, "Aren't you going to ask me something?"

"What do you mean?"

"Columbo always turns around just before he leaves and asks some kind of trick question." She suddenly seemed far less clouded by wine than I'd thought she was.

PART THREE

*Nothing is ever black or white, time turns
everything to gray.*

—*Sebastien Japrisot,* A Very Long Engagement

9

JUNO GAVE CELIA a parting hug and we went out to my SUV.

As we got in and I started it up, Juno declaimed, " 'Oh! Celia, Celia, Celia shits!' "

She wasn't freaking out; I recognized the quotation instantly from a class I'd taken in eighteenth-century English literature way back in college–who could forget a line as bizarre as that? It was from a gross and funny Jonathan Swift poem called "The Lady's Dressing Room" in which a lover, seeking a token, slips into his mistress's private chambers when she's gone and uncovers the reality behind her fashionable beauty in all the detritus her regimen creates. Ultimately, he unveils her brimming chamber pot, and the realization that she's human crushes him.

I took Juno's quotation to mean she thought the public and private Celia were very different, and I said so.

Juno had her eyes closed and was shaking her head as if to clear it, but didn't get to dilate on her views just then because a knock on the car window made us both bolt around. Celia stood there with a small bakery box, tied up with green and blue ribbons. I lowered my window and she handed the box through. "Some sushi," she said. "For your dinner."

We thanked her and I swear there was something mildly malicious in the way she walked back and opened her door. Window closed, we drove off. When I tried to press Juno about what she thought, she held up her hand like Dianne Wiest in *Bullets Over Broadway*. The message was clear: "Don't speak."

But I resisted the admonition, because I was still stunned by the luxury of her home, and said so. Juno dismissed it. "I know women in town with houses twice as big, so big that if they forget something when they're leaving from the garage, they don't go back in because it's too much of a walk."

As we pulled into my driveway ten minutes later, Juno said, "I need a drink, a *real* drink." I offered her some single malt, and she practically bowled me over heading into the house. She strode down to the kitchen, stripping off her jacket and capelet as she walked and dumping them on a chair. She plunked herself down at the island with the ferocity of a prisoner about to start running his tin cup back and forth across the bars of his cell. Before she could launch into more poetry, I got her some of The Macallan.

"Ah," she breathed. "Eighteen year." And she took a gulp. The hood of her sweater dress was down and with her legs crossed, she looked sexy but less severe.

"Would you prefer it with some water, to release the esters?"

"Water doesn't release shit, it just slows down the scotch." She set her drink down and I poured one for myself, though I didn't really need it. I glanced around our recently remodeled kitchen, and though it was gorgeous it seemed cramped suddenly, and claustrophobic at being only one story high. Even our lone island seemed oddly pathetic.

"What bull! She may be bored," Juno said. "She may even be a desperate housewife, but she's not that hip. I don't believe her husband knows, *knew*, about Vlado."

"Maybe he does know about the affair," I said, walking back and forth, trying to put it together, or tease it apart–or both. "But I don't think he approved, or that he sloughed it off because Vlado was such a great trainer."

"I agree. That wasn't real. There are plenty of great trainers around. Besides, you heard Aftergood say it was, what, a gift that Vlado was dead?"

I nodded.

"No possibility that he said something else, something that *sounded* like 'gift'?"

"Like what? There's always a chance I completely misheard him, but I don't think so." Then something else that was bothering me jumped the queue of my thoughts. "Why did she volunteer to talk to us at all? She didn't have to. And lunch, and wine–what was all that about?"

"It was a show. She was pretending to be honest."

Playing devil's advocate, I said, "But you told me that I'd be surprised by what women say to each other in the locker room."

She raised her already dramatic eyebrows. "And you would. But this wasn't a locker room, she didn't say anything juicy. Really juicy, that is. She didn't tell us what he looks like when he comes, did she, or what kind of noise he makes when she massages his prostate, eh? It was all an alibi. A general alibi," Juno explained. "She thought Vlado was great, her husband thought Vlado was great, they all got along well, shit, she even used Vlado's wife to cater, isn't that cozy and mature?"

I stopped pacing. "You're not thinking that–"

"A four-way? A three-way? I can't picture it, she'd have to work too hard."

"Did you notice she didn't seem upset that Vlado was dead?"

Juno nodded fiercely. "Hell, he was a good fuck, and if she was getting it on a regular basis, she'd miss that even if she didn't miss him."

"So she invited us to show she had nothing to hide?"

"That would be my guess. Unless she thinks her husband did it and she's trying to protect him."

"But why protect Alfred? If she had an affair, she's probably tired of him, so why not let whatever happens, happen."

"You're kidding, right? She's probably been tired of him for years. But if she protects him she protects herself, her lifestyle. Nick, did she strike you as somebody who wants to take care of herself? She wants to be pampered, coddled, cocooned–and

her husband makes all that possible. I'm sure she's the kind of wife who doesn't know anything about where or how their money is invested, where the bank books are, none of it."

"But she risked everything having an affair, didn't she?"

Juno grinned. "What's the point of being safe?"

"Okay, I'm confused. First you say she wants to be safe, then you say she flirts with the opposite."

"Nick, you're so naïve. Are you really from New York? It's like sexual asphyxiation, being tied up and almost choked when you come, it's going to the edge, it's teasing Fate. When you're bored, taking that kind of risk can make you feel twice as alive as just any old affair. And it's with her husband's trainer at the gym? So low-rent."

"It's murky, too, isn't it? And maybe vindictive?"

"Yes, I would put it high up on the murk scale."

We both drank some more scotch and I joined her at the counter. Focused so heavily on Celia and Vlado, I felt less drawn to Juno and less perplexed by my attraction. Puzzling things out with her, or trying to, might make being around her less conflicted.

I kept at Celia's motives. "Then talking to you and me was a calculated risk for Celia and part of the game?"

"Exactly. This is fun for her, throwing sand in our eyes."

"More like sushi."

Juno took a whiff of her scotch.

"And those petits fours!" I said. "There was something creepy about that. I bet she would serve those if Barbara's body was in her freezer."

"No doubt."

"Okay," I summed up. "I'm with you that Celia is hiding something, so how do we find out what she didn't want us to know?"

"We keep digging."

Yes, that would make a good motto for my PI business, I thought, fantasizing a successful–or at least sane–future very

different from my present, imagining my business card emblazoned WE KEEP DIGGING.

But where did we start?

We both fell silent on the same question, and then it hit me: "Have you ever heard anyone else talk about Vlado opening his own gym, studio, whatever?"

Juno shrugged. "It's probably like actors wanting to direct. They all want to do something, open a gym, write a book, do an exercise video, direct a training program somewhere—"

"—but wasn't it strange how Celia just popped out with the information? As if she was brooding about it while we were talking about something else, and couldn't keep it to herself."

Juno frowned, apparently trying to recollect the moment. She sipped her scotch pensively.

"I mean, we didn't even raise it, but there was almost a defensive edge in how she brought it up."

"Which would indicate that...?" Juno looked sideways at me.

"It could mean a lot of things. That her husband doesn't know she gave Vlado money. That maybe she regrets she helped Vlado out. Or that she gave him too much money."

"Or there could be some problem with Vlado's plans." But as she said it, she seemed disenchanted with the possibility.

"Sure, why not? But it has to be important, it bothered her more than his being dead, I thought. And didn't she say her husband wanted to help, too?"

"More family values, eh?"

"Well, let's see what we can find out about Vlado's plans for his own club. Why don't you call Celia and see if you can get any details out of her, okay? And I'll see if I can find out which of the other trainers was a good friend of his and might know what he was up to."

"Plus we need to find out who Vlado fired and why. I haven't heard of anything like that."

"Maybe it was hushed up."

"It won't stay that way. Nothing ever does." Juno downed

the last of her scotch, slipped into her caped jacket, and belted it as if she were ready to rumble.

As I followed her to the front door, unable not to notice her muscular haunches, the door opened. It was Stefan and I knew right away he was drunk because he greeted Juno with warmth, asked her why she was leaving when he'd just got there, but she slipped away from him before he could hug her. She marched down the driveway to her new silver Cadillac CTS-V, the luxury sedan that looked like a cross between a tank and the Batmobile.

"Have you put anyone in jail yet?" Stefan joked, hanging up his coat without a trace of unsteadiness. Where had he been, and why was he drunk?

"How about some coffee?" I suggested.

"Not for me, thanks, I don't want to be wide awake ever again." That gnomic comment was a clear warning that some bad career news had hit him. I trailed after Stefan into the kitchen, where he was uncorking a bottle of Veuve Clicquot he'd taken from our small wine refrigerator (which I'd never thought of as small before seeing Celia Aftergood's wine behemoth).

"Un bon verre du vin," he said jovially, *"enlève un écu au médecin."* It was a French version of "an apple a day keeps the doctor away," but predictably, it involved wine and money. And of course it just rolled off his tongue as it never could from mine.

"Why should people just toast good news? You raise a glass of champagne at a wedding, but nobody celebrates divorce. Doesn't make sense. I say, celebrate everything, creation and progress, decay and ruin."

I was glad Juno had left or she might have started quoting from Ecclesiastes about a time for this and a time for that. I thought of the character in the '30s Cary Grant movie *Holiday* muttering, "Head for the nearest exit."

"What happened?" I asked.

"I got a call from my agent while you were out playing *Miami Vice* games with Junebug."

Stefan opened a few cupboard doors fruitlessly, looking for a champagne glass I figured, then grabbed a juice glass and filled it with champagne. I didn't comment or point out where the champagne glasses were; let this play itself out, I thought, waiting.

"Heard from my agent," Stefan said after a big gulp of champagne. He hadn't even bothered to wipe any from his lips. "It's over." He gave me a sickly smile. "Three of my books are going POD. Two more are en route."

"Did you know this was coming?" I asked. "Is that why you were acting strange on Sunday?"

"Strange."

"You know, going out to do errands..."

He shrugged.

POD, I thought. Crap. It stood for Print On Demand, the burial ground of thousands of books whose sales history had gone from dim to dismal. It meant copies would only be printed if someone ordered them. They'd disappear from bookstores as if they'd never existed. It saved publishers money and it was like a nail in the coffin for writers. There was no redress, and unless something miraculous happened to make a book a saleable commodity again, it was like watching a book die. A novelist friend of Stefan's had once told him that every book had two lives. First there was its own dreaming, outlining, slow and steady progress, and triumphant weary finish. And then there was everything that happened around and through it– the places where it was written, the people who influenced it, the weather of each day of creation. The hidden life. It was hard to say, he concluded, which was more beautiful. But when a book went POD or worse, completely out of print, both lives were really over.

Sympathy would probably have made Stefan feel more humiliated, so I went to get my own tumbler, and held it out

for some Veuve. I didn't care what it would feel like on top of the wine with Celia and the Scotch with Juno. Stefan had suffered a great loss, and attention must be paid.

We toasted each other silently, and I slugged back the champagne as if I were at a wake and getting myself ready to keen. Stefan surprised me. Later, after a long nap and a cup of coffee, he was energetic and positive, talking about a new book he'd been thinking of, a thriller about a failed writer. We both laughed with delight when he told me the plot, and I knew the shame storm had passed. I'd once asked my cousin Sharon about his moodiness and she'd reassured me: "He's not manic-depressive, sweetie, he's an artist. Be thankful he hasn't cut off his ear—or anybody else's!"

Sitting in the living room listening to the sublime Susan Graham singing about love in French, I asked, as I had more than once before, "Why's it always postal workers who go nuts?"

He nodded with appreciation. This was one of the things I loved about being together for so many years. You could go back to hobby horses, to memories, and there was always something stimulating about it. As Henry James had written about two friends in *The Ambassadors*: "The circle in which they stood was bright with life, and each question lived there as nowhere else." I felt that way with Stefan and also with Sharon.

"Stephen King got the Kathy Bates part way wrong," I went on. "She should've been a *writer* breaking her *publisher's* legs."

"Amen to that. But one of my editors told me he went to see that movie with other editors and they all cheered when she brought down the sledgehammer."

"Typical."

"How about Bijou tonight?" he asked.

I couldn't think of a reason why not. Half an hour away on the road to the county seat, it was a new French-style bistro,

locally owned and run, and had the best *steak frites* in town. Maybe the only *steak frites*, but who cared. The place was very French in style and setting, with a long mirror-lined room that was floored in black-and-white tile and made you feel you were anywhere but in another one of Michiganapolis's ubiquitous strip malls. We had fallen in love with the menu, which featured classics like *cassoulet, pissaladière, brandade, coq au vin*, etc. Molly was the lean and quiet chef and her delectably named husband Jean-Marie Bourguignon was the host; dining there felt very intimate and low-key despite the bustle.

When we arrived, the place was half-full and Jean-Marie led us back to our favorite table in a corner, passing diners dressed both casually and elegantly in that typical Michigan mix. We had dressed in jackets with no ties, and Stefan was all in black, looking very hip.

"I just put a terrific Cahors on the wine list," Jean-Marie said in his softly accented English, pointing it out to us. He and Stefan launched into a rapid-fire chat about *terroir* and other wine arcana and I sat back, listening as if I were at a Mostly Mozart concert at Lincoln Center, awash in beauty. Jean-Marie was typically French, handsome, slim, big-nosed, with curly black hair just starting to gray. He had the elegantly rumpled air of a French intellectual talk show host, and always paired his stylish black suits with dark blue shirts.

Stefan loved dining at Bijou not just for the food, but to practice his French, which Jean-Marie had complimented more than once. Stefan had even come up with a French expression Jean-Marie didn't know, one that punned on the owner's name: *"Il fait du bourguignon"* was some kind of slang for "the sun is shining." It impressed the Frenchman as an illustration of how much Stefan loved his language, though he told me later privately that he'd checked with his parents and it was rather outdated slang. He'd never heard the expression himself.

Jean-Marie and Molly had met in Paris where she was studying at Cordon Bleu and moving towards the step of owning her

own French restaurant in Michiganapolis, where she'd grown up. It had taken her twenty years in the restaurant business to get to this point, and Bijou was already a success. That was good news because Michiganapolis was not known in Michigan as a town for fine dining, though it had more than its share of national chains. It also had very little in the way of cabaret life, no art house cinema, and in general seemed to be lost behind some kind of cultural Iron Curtain.

Jean-Marie brought a bottle of Badoit and the wine and uncorked that for us, taking our order for the delicious house pâté. "Molly sends her love and she will be out to see you when things calm down." As he walked off, the music on the sound system shifted from Charles Trenet to some Baroque overture that sounded like Rameau.

"This is great," Stefan said, glancing around as if nothing depressing had happened to him in a very long time. "You know, it's a good life," he said, taking my hand and squeezing it.

Indeed it was, despite the professional disappointments for both of us and the weird way that crime dogged us here in Michigan. Our house was so beautiful–and affordable–and both of us loved teaching, and our cabin up north was a dream. If only Stefan could stay centered on moments like this.

We were consulting the menu when I felt someone approaching our table. It was Dr. Aftergood, whom I hadn't noticed on the way in since I was focused on our table at the end of the room. I was about to make some anodyne comment about what had happened in the steam room when he put fists on our table, leaned in, and said with soft menace, "Leave my wife alone. Don't you ever harass her again or I'll have you arrested for stalking." His round, recently shaven face was so genial and placid I felt we were in a badly dubbed movie: How could those words be coming from his mouth? Aftergood didn't wait for a reply, but spun on his heel and headed down the length of the restaurant where I made out Celia, waiting for him, wearing a

black leather pants suit. A waiter helped them into their coats (his cashmere, hers sable) and they left.

I could feel the eyes of diners at nearby tables who might not have caught the words, but couldn't have missed the tone. Shocked, I looked to Stefan for a comment. His eyes were down, scanning the menu.

"Nice suit," he said, evidently referring to our departed guest. "Armani."

And I cracked up, as I was meant to do. Our waiter arrived to pour us some wine and I drank heartily of the lush 1995 *Clos la Coutale*, well aware that I'd have to drink a bucketful of water at dinner to counter all the alcohol that had entered my system that day.

"How about filling me in?" Stefan said warmly. So I did, at length, through the chicken-and-veal pâté, and half a bottle of the Cahors, and on through the *boeuf en daube*, and into the *clafoutis*, all of which was sublime.

"Interesting," Stefan concluded. "I don't see how you ended up studying Wharton. Your period is really the Picaresque, and Juno is right out of Fielding."

I flashed on the movie of *Tom Jones* with Albert Finney and that wild-haired trollop.

"Maybe not so much Fielding as Smollett," Stefan mused. "That's your life right there."

"Well, I do love the sound of his name. Smollett, Smollett, Smollett." I tried to imitate the way Jennifer Tilly, playing a pretentious bimbo in Woody Allen's comedy *Bullets Over Broadway*, met a Broadway producer and said, "Charmed, charmed, charmed."

Stefan was thinking more seriously and he didn't let me distract him. "There are two key questions," he announced after a pause. "Why did Celia tell her husband you harassed her when she invited you, and why did it bother him so much that he had to make a scene, even a quiet one?"

"You're not pissed off that I got involved?"

He considered the question, then shook his head. "How could you avoid it, given who you are, and given Vlado dying or dead right there in the steam room? And how can I stay out of it, now that this jerk is making ridiculous threats? I don't know if it's karma or carcinogens in the water around here, but—"

"You want to help?"

"Sign me up," Stefan said. Then after a moment, he added jovially, "Maybe I should give up writing as a career and we can both become private investigators. What do you say?" He took a sip of wine and winked at me over the rim of the glass. "How do you think I'd look in a trench coat?"

"I saw an ad for a suede one from Gucci that's only about sixty-five hundred."

Stefan raised his glass. "Let's refinance the house!"

We made quite a night of it, and drove home slow enough to be pulled over for attempted speeding, but we weren't too drunk to stop celebrating.

10

IN THE MORNING, I thought that at any other time, I would have called Sharon to consult with her, since she was so logical and calm, and had such a good memory. Stefan had been enthusiastic about offering his assistance, but I suspected his publishing troubles might blur his ratiocination. Unfortunately, Sharon was out of touch for two weeks, having requested privacy while staying at a friend's villa in St. Thomas. Afraid to fly after her brain surgery, she had taken the train down from New York to Miami, and a cruise ship out. She had stayed at Cowpet Bay at the end of the island many times, and from her balcony overlooking the private beach and sapphire water had watched the big ships at night. It would be even more relaxing now. She had said someone would be cooking and cleaning for her, so I doubted she'd go out much to dine or shop, especially since it's so unnerving to drive on the opposite side of the road. Even if someone drove her I didn't think she would be able to stand the jouncing of the road and I doubted she'd want to be among crowds of tourists anyway. I remembered her story of shopping in Charlotte Amalie once when a cruise ship came in and she saw a fat American chomping on an unlit cigar hurl hundred-dollar bills at a salesgirl. "The Quiet American he was not," she observed.

This unplanned getaway had followed a battery of tests to discover why she was suddenly having headaches and insomnia: urinalysis, blood work, a bone density test, a complete body sonogram, MRIs, and a colonoscopy. At the back of her

mind was the fear that she said many victims of an acoustic neuroma have after it's been removed, that they'll grow a similar tumor on the other side of the brain.

I admired Sharon not just for her orderly mind; she was a far more educated reader of mysteries than I was, which had proven helpful in the past. I could mention the most obscure European mystery author published by the tiniest press, and she'd start comparing his first book to his second. Thanks to her, I'd discovered writers like Jean-Patrick Manchette, Carlo Lucarelli, and Chantal Pelletier, whose short books were richer, deeper, and more involving than typical bloated thrillers like the books churned out by America's bestsellers. If my mystery course went well, I wanted to teach it again using only little-known authors of short books. My students would love the latter part, and I'd feel good not playing the publicity game that relentlessly pushes mediocre books to the front of people's consciousness by a barrage of advertisements and bookstore placements.

Stefan had promised after dinner at Bijou to talk to his workout partner Didier, who lived across the street from us, and see if they could come up with some clever strategy for interrogating the Michigan Muscle trainers about Vlado. Didier, who looked like a Québecois Popeye, often hung out in the main trainers' office, gassing about workouts and competitions and sex, apparently. He'd once confided in Stefan, man-to-man, that nothing made him as horny as a really good workout, and that plenty of the trainers felt the same way, so he obviously had some kind of in with them. I could talk to them individually, but en masse, they intimidated me by their youth, their physical edge, and their rampant straightness. They were like some mutant high school club, but middle-aged Didier seemed to be an honorary member.

With nothing to do to prepare for classes in a few weeks, I headed to Michigan Muscle to work out and once again troll for information as best I could. The parking lot was nearly empty,

which wasn't encouraging. On my way in, a little man, bundled up against the icy wind so tightly it was hard to see his face, shouted, "Don't you ever skip a day?"

I didn't recognize him, but given that there were several thousand members at Michigan Muscle, people you didn't know or notice might easily notice you, and total strangers often seemed to have a better sense of my schedule than I did, greeting me with "You're early today" or "Late night?" or "Haven't seen you in a while—have you been gone?" And I'd smile a "whatever" kind of smile and move on. The club offered a strange simulacrum of intimacy: people zipped past you as this guy just had, or grunted nearby while lifting weights or stretching into a yoga pose, or ran on the treadmill next to yours, toweled off in the opposite shower, wallowed in the hot tub, and you'd smile and wish each other a good workout or comment on the weather. Or just nod. But they were still strangers, no matter how many hundreds of times you'd "met."

Speaking of which, Juno had left me a phone message last night and I was supposed to meet her there in the lobby, but didn't see her, so I passed through to the reception area where I saw an easel with a large black-bordered poster announcing a memorial service for Vlado Zamaria—in an hour from now. I studied the sign as if it could tell me why there hadn't been more advance notice, and why anyone would hold a memorial service for one of the club's trainers at 11 A.M. on a Tuesday morning. While I pondered, neither weak nor weary, Juno came bustling up to me. She was in her version of Audrey Hepburn, with a leopard-print scarf tied over her hair, big black superfluous sunglasses (when was it ever sunny in mid-Michigan?), knee-length black coat, and high black boots.

I pointed out the sign and she was thrilled. "We're going, of course," she said. "We have to go. Think of the suspects!"

She was right, and we showed our club IDs to the kids behind the counter whose smiles were painfully white, and headed down to the locker rooms. Juno was ebullient, as if she were a

Canadian Mountie about to get her man, and we arranged to
meet at the service, which would be held in the conference
room adjoining the restaurant, after we worked out and did
some snooping.

I had no luck with the latter since the locker room was an
over-bright wasteland that morning, the one or two guys in it
off in the distance like cows in some eighteenth-century
English landscape. The club itself wasn't much better, whether
in the cardio rooms, any of the courts, or the weight rooms.
There may have been several dozen people working out, but
the club was so enormous, they were scattered very far afield,
and nobody was familiar enough for me to strike up a conversa-
tion about Vlado's death to see where it went. I didn't see much
point in starting this with a total stranger, but maybe I was
wrong.

It amused me, though, to notice that almost all of the wom-
en there that day, whether college-age or middle-aged, were
wearing some combination of lavender, pink, purple, and
fuchsia. It made them hard to tell apart, I thought. Were those
colors hip at the moment, or was it a set of weird coincidences?
Every now and then I'd notice the same thing at the club, and
the last time it had been black workout gear with white stripes,
or the reverse. Other kinds of trends seemed to sweep through
the club as well. I'd notice more and more women who had tat-
toos in the small of their backs and wore their gym pants or
shorts lower to show the designs off, and more young guys than
I could count were showing up in the showers with their pubic
hair either shaved completely off or shaved into a little square
or rectangle.

As I worked out shoulders and back, I tried to figure out why
that guy leaving the club as I came in was still buzzing in my
head like a cartoon character. Something about him, about
how he looked, jogged a memory, or made me feel it could do
that, but I wasn't sure. Was it his black beret? His voice? I
couldn't remember his name, but also wasn't sure I'd ever

known it. I'd been saying "hi" to people there for years without knowing their names, or remembering them. Stefan, whom people also seemed to know, had a much better memory for names than I did, and of course, his having been in the local paper was always because of a reading or a new book–not a murder.

This day, entering the shower area and catching sight of the steam room door didn't bother me as much, which was a relief. Maybe I'd recover from the shock faster than I'd thought I would. But as I showered and studied the door ten feet away with its glass panels fogged by steam, I tried to imagine how it could have happened, and speculating lifted me out of those terrible moments in a strange way, as if I were recording it in a diary.

Had someone been waiting in the steam room for Vlado? How would he know Vlado was there? If it was a guy he trained that day, could Juno and I get ahold of his schedule? But if anyone had followed him into the showers and then the steam room, taking advantage of the timing, what weapon would he have used? The locker room didn't offer anything that I could think of. The sink counters had sterilized combs, hair spray, shaving cream, and spray deodorant–none of which made for a blunt instrument. The only heavy items were garbage cans and chairs by the TV, and those were obviously too large. So it had to be something the murderer had brought with him and stashed in his locker afterwards; throwing it away would have been stupid. Smuggling it out in his gym bag was the only way.

As I speculated about all this, it seemed strangely disconnected from my life, from the very shower I was taking right at that moment–yet I'd been only a few feet away from Vlado when he died, or lay there already dead. Was it healthy to be able to find this emotional distance, or was this a bad sign of being a modern citizen of a world too full of casual brutality?

Toweling myself dry, I wondered if the police had searched

for a weapon and how we could find that out. Even though I had been a witness, of sorts, the whole thing struck me as audacious and crazy. Only someone enraged would dare to try it, or was I being unimaginative? Maybe it had all been somehow planned by a quiet, cunning mind. And maybe in this case, revenge was a dish served hot and steamy rather than cold.

I decided to dash out to the parking lot and stash my gym bag in the Lexus, but Juno was waiting for me impatiently out in the hallway that ran past the locker rooms to the main gym areas. When I told her my plan she said there wasn't time, we had to hurry to get a good seat.

"No. We want to stand at the back so we can observe people," I said.

"Observe what? The backs of their heads?"

Clearly we had some strategic differences. Juno gave me a minute to nip back into the locker room and stash my bag, as she had done in her locker room, and then we headed upstairs, past the reception desk and into the restaurant, where we could hear a low hum from the attached conference room that was typically used for health lectures and presentations by various local groups. En route she said she'd called Celia and left a message inquiring about Vlado's personal training studio.

The narrow rectangular room was surprisingly jammed, with close to a hundred people sitting in uncomfortable plastic chairs, and standing at the sides and at the back. There was no place left to sit and despite Juno's preference, we had to squeeze in to the only vacant spots at the back.

All the trainers seemed to be there in the front rows, along with Barbara Zamaria and Heath Wilmore. Half the glaring fluorescent lights were off, in deference to the occasion, I assumed. But I could still make out the natty presence of Detective Fahtouzi, who met my glance long enough to make me feel guilty for having come. When I was very little, my mother had drilled in to me my address and phone number and the instructions to head right for the refuge of a New York City cop if I were

lost. "You'll be safe," she kept saying. So what had happened to that sense of security I recalled policemen always triggering in me when I was growing up? Now, they made me feel automatically on-stage, obliged to act as if I had nothing to hide, even though in fact I did have nothing to hide—just like today.

Well, nothing really, except for my own private investigation of Vlado's death, and wasn't that within my free speech rights?

Many of the faces in the room were quite familiar and each time I met a pair of eyes I nodded seriously, as befit the occasion, though of course I wondered what connection the person had to Vlado, and if each one might have killed him. The Aftergoods were not present. I'm sure he was at his office seeing patients, but what could be keeping Celia away? Shame, or cooking lessons?

"It's very warm in here," Juno muttered.

Heath Wilmore rose and thanked people for coming, then mentioned there would be a community-wide memorial service later that month. "But we wanted to acknowledge a valued member of our team as soon as possible," Heath said, having adopted the fake solicitousness of a mortician. It didn't suit him at all, because he seemed put out to have to be dealing with a murder so soon after assuming management of the club.

"They're holding this now to get past the bad publicity," Juno whispered, and I agreed.

Wilmore introduced Barbara to the crowd. She looked very different in black, with minimal makeup, almost as inconsequential as Juno had first described her to me, the kind of person you might barely notice if she didn't speak to you. Barbara, too, thanked everyone for coming, and once again, observing her, I could not tell if she was controlled or unfeeling.

I expected her to say more, but she merely introduced Fred Gundersen, who looked very uncomfortable speaking to an audience this size. His eyes darted back and forth nervously, and he blinked like someone with badly fitting contacts.

"I learned a lot from Vlado," he began, and everyone seemed to settle in for a comfortable, feel-good narrative. "He taught me about customer satisfaction, and goals, and the importance of people." Fred went on for ten minutes in that bland, starchy management-speak that's infecting every realm of public discourse. He could have been eulogizing a college professor or a Home Depot worker for all the individuality of his remarks.

Fred was followed by several trainers who were his rhetorical epigones, making the same points, but less effectively. They praised Vlado's strength ("he was a beast"), his dedication, and told some funny-only-when-you're-dead stories about him in various unfunny situations. People chuckled obligingly– what else could they do?

But was this bland recital really what they thought? Or was it a cover for what they truly felt about Vlado when he was alive? Both Barbara and Celia had said the trainers were jealous of him. I felt as suffocated by the empty sentences as by the warmth of the crowded room. Watching people take slugs of water from Evian bottles, I wished I'd planned ahead.

"Vlado changed my life," a fortyish woman was saying, and I realized I'd drifted off. She was runner-slim, poised, wearing a tailored, expensive maroon suit with cream blouse that looked like the unassuming costume of a superhero. Her wheat-blond hair was very Michigan: bowl-cut and unflattering. "He gave me the courage to get off my butt and take up running, swimming, racquetball, biking. I lost twenty pounds, my blood pressure dropped, I've done triathalons–"

"Who is that?" I asked Juno as the list of breakthroughs continued.

"Ruby Strockbine."

"Sounds like a ground cover," I said. I could even see what it would look like: tiny gray-green succulent leaves dotted with dark red flowers.

Juno shrugged, then leaned closer. "She's a divorce lawyer,

and a demon. Vlado was fucking her for sure." Nobody around us seemed to hear that, and I was glad. Making a scene at a memorial service was not a good way to gather information inconspicuously.

Ruby was just getting warmed up, and whereas earlier, people had listened to speakers with amusement or nodding admiration, depending on the tone of the remarks, now I sensed some discomfort in the air as she raved about Vlado's "warmth" and "empathy." I wished I could get a look at Barbara's face during this panegyric, but maybe that was wishful thinking, like this whole venture, which had so far yielded almost nothing. We hadn't hit any dead ends yet; on the other hand, we were totally without a street map.

Then it hit me, and I quietly told Juno I was going out to get some water. "Bring back a bottle," she said.

I made sure not to turn around and check whether Detective Fahtouzi was watching me or not, and I set off through the restaurant, hurrying past the bar and nodding to the barman, moving directly to the suite of offices on the other side of the reception desk. The main trainers' office, with window walls looking out on a basketball court, was downstairs, but Vlado's office was near Heath's, and the door was solid. With everyone at the service, now was the chance to go through his office and see what I could find—if it was unlocked.

It was, which kind of made sense, since it wasn't a crime scene and Vlado had probably left it that way the morning he died. But if someone was supposed to have locked it, there'd been a screw-up.

I quickly stepped inside from the empty hallway lined with bulletin boards layered in flyers and memos. The office was a white-on-white box, but much more personalized than Heath Wilmore's office next door, filled not just with trophies but practically papered in framed photos of Vlado in various sports, from skiing and snowboarding to scuba diving and bungee jumping. It was a small museum to his prowess, and I felt

suddenly chilled. So much beauty and strength, and it was nothing now.

I didn't have time for an Ecclesiastes moment, though, because I had no idea how much longer the service would go on. I went right to his desk under two shelves crammed with books on fitness and nutrition. There were several photographs of Vlado and Barbara—at parties, on a beach, in the mountains—and in each one, she looked much more attractive than I would have guessed she could.

There was nothing of immediate interest on the surface, so I started rifling through the drawers, finding nothing but supplies, clippings about health issues, and his client folders.

Then I got to the bottom drawer on the right.

Like most of us, Vlado could not have imagined himself dead, otherwise this drawer would have been locked. Hell, what was he doing keeping stuff like this in his office?

Under sections of the local paper, Vlado had stashed a thick manila envelope. Inside of it I found dozens of nude photos of himself with various women. There was no attempt to hide faces, and I recognized women from the club whose names I didn't know, except for Ruby Strockbine. I didn't go through all of them, there wasn't time.

The lighting in the photos was what you'd expect, but even amateur digital work could not dim Vlado's incandescence. He was eroticism incarnate and the photos of him very much alive made his death seem even crueler. And then I recalled what Auden had written:

As the poets have mournfully sung,
Death takes the innocent young,
The rolling-in-money,
The screamingly-funny,
And those who are very well hung.

As elegies went, that was pretty good, and remembering it momentarily lightened my gloom. Anyway, I could imagine

Sharon asking how I could feel sorry for someone who not only cheated on his wife but took photos of his exploits, and photos in which he and his charms were usually most prominent. It was, I thought, as if the women were merely a frame to set him off.

Underneath the envelope was a smaller bubble-wrap mailer, and inside that lay a Chopard wristwatch whose dial, bezel, and wristband were encrusted with diamonds–the kind of dazzling, ultra-chic bauble you see advertised in the pages of glossy magazines. The kind of Swiss watch that was probably a whole year's salary for most people–if not more.

A present for Barbara? Unlikely. I was sure that it was stolen. Why else would it be in such an unlikely place? These rocks had to be hot. Whom had he stolen them from?

Before I could speculate further, the door opened behind me.

11

JUNO SLIPPED INTO the room and shut the door quietly behind her. Her eyes widened when she saw the photographs I was holding.

"Put them down," she hissed. "Put them back." She jabbed a finger at the open drawer. Her face was as stiff with rage as if I were rummaging through *her* papers, and for a moment I thought she was going to bitch-slap me. Then I understood she wasn't angry at me, she was angry *for* me. "Fingerprints!" she explained.

I hurriedly stuffed the photos back in their envelope and dropped it into the drawer, but what good would that do now that I'd touched them?

Juno shook her head. "And you're going to teach a course about crime?"

That stung, but I had to defend myself. "It's not a how-to, it's a literature class—"

"I know, I know."

"Wait a minute, Juno, why are *you* here?"

"Snooping, just like you, but—" She showed me a handkerchief balled up in her hand. "I was planning to be anonymous."

"What about your perfume?" It was Angel and it was strong.

That stumped her.

"Okay, so we're both amateurs. What exactly did you find?"

I told her. She asked to see the watch, and I pulled the drawer back open, this time using the handkerchief she passed to me.

She nodded at the glittering watch. "Impressive."

Something about her reaction made me ask, "You knew about the photographs?" The watch was clearly more interesting to her than the photos, which I would have expected her to at least be curious about.

She smiled, apparently admiring my guess. "Vlado asked me if he could take some, in bed. And on the floor. I assumed right away that he had a collection and it wasn't just being driven mad by my charms that had inspired an urge for mementos in him."

"And you said?"

"That I wasn't interested in being on display." Juno spoke without irony, even though on an average day she would have stood out in a Mogul palace.

"What do you think he did with the photos?" I asked.

"Blackmail? Show and Tell?" She shrugged. "I want to know about the watch."

"You think he stole it?"

"Probably. Who'd give him a woman's watch?"

"I don't know, but we should get out of here."

She agreed and said she'd slip out first. "If anyone sees you, sees us, *grin*."

"Grin?"

"Grin like an idiot. Pretend we've been humping in here. Or trying to, anyway."

I flushed, and Juno left the office as if she were practiced at slipping away quietly, something I found hard to fathom. But she didn't need to be worried about someone spotting us together, because as I closed the door behind me to follow at a casual distance, shouting erupted from the inner lobby.

"Let me go! Assholes, let me go!" The voice was loud but mellifluous, and receding.

When we got to the reception desk we could see Fred Gundersen and Heath Wilmore dragging a good-looking guy out towards the club's front doors. Each of them had grabbed one of his arms in both of theirs and they were moving him along as

fast as if he had wheels on his sneakers, despite his struggling to break loose and trying to kick both men. "Let me go, I want to say something about Vlado! Let me say something about that rat-ass motherfucker!"

The memorial service was apparently over, or at least interrupted, because dozens of people from that room were standing and gawking.

I didn't recognize the guy, but was struck by his rampant good looks. Even red-faced and being ousted from the club, he looked handsome, which was some kind of achievement, or a gift. Wearing black jeans and a heavy black sweater, he was over six feet tall with a swimmer's build, cleft-chinned, blue-eyed, wide-jawed, with masses of curly dark hair growing back from a perfectly straight hairline.

"That's Fabian Albahari," Juno said. "I bet *he's* the trainer who was fired. I've seen him here at night, but I don't work out evenings that often, so I didn't know he was gone."

His name sounded very familiar, somehow, but I couldn't place it. Had I read it in the news?

Shouting general abuse now, Fabian was ejected from the building and the crowd dispersed, chattering about the incident. There was the same kind of prurient excitement in the air you find at car accidents, cat fights, and White House press briefings. And the silence after his expulsion was almost a letdown—you could see it in the way people had faded a bit.

"He looks like a model," I said. "Not a trainer."

"No kidding."

I glanced around for Detective Fahtouzi, but he was either off talking to someone, or had already left. "What do we do now?" I asked, and Juno said she had to go to the bathroom before heading to campus for a meeting with a graduate student. "Dig!" she advised, as she hurried off. I assumed she was not speaking Beatnik.

As I stood there debating my next move, with the club returned to normal around me, Fred Gundersen passed me

just then and raised his eyebrows in an ambiguous comment about the brouhaha we'd all just witnessed. I stopped him and pretended naïveté. "Who was that guy?"

Voice low, Fred said, "He used to train here. Vlado canned him."

"Why?"

"I don't know." Fred looked very uncomfortable talking about this, and moved towards the stairs as if to lead me away from any potential eavesdroppers.

"Why not? Wouldn't Vlado or Fabian talk about it?"

Fred glared at me, obviously surprised I knew the ex-trainer's name. I didn't know how to get out of this little fix, so I just waited, hoping Fred's IGR (Innate Gossip Response) had been triggered by the shouting and Fabian's ejection from Michigan Muscle. I put my money on the wrong horse.

"What are you up to?" he asked, frowning, but not moving away. That was either a good sign, or meant he was planning to get physical. The chorus of that idiotic Olivia Newton-John song started running through my mind.

"I just had some questions." Boy, was that lame.

"Why?" Now he did look hostile, and he wasn't some wobbly old drunk in a bar, he was young, sober, and in perfect shape. "Why? You're not a cop, you're not a reporter, you're just some teacher. It's none of your business."

I had to correct him. "I'm a professor."

"Yeah, whatever."

"Listen, what's wrong with being curious? I'm a club member, right?"

And that reminder of the difference in our status—after all, he was supposed to be deferential to people like me—seemed to cool his jets.

"Go ask Heath Wilmore."

"He doesn't like me."

Fred grinned, his teeth so bright they were almost scary. "He wouldn't tell you shit, anyway." And he stalked off. Had

he been lying? He had to know something about Vlado firing Fabian. The trainers weren't that big a group and they shared one office.

I couldn't think of a next move, so I decided to head home and strategize. I vaguely hoped that Fabian might be lurking in the parking lot like some kind of stalker, but I didn't see him or anyone worth interrogating and I drove home disappointed, my head a jumble of "Let's Get Physical," that astonishing diamond wristwatch, and those photographs of Vlado wielding his club with various willing club members. Talk about Michigan Muscle.

I had just poured myself a glass of Mark West Pinot Noir when the doorbell rang. It was Ruby Strockbine, with a large Louis Vuitton bag over her shoulder and a puzzled expression. She was clearly surprised to see me. The feeling was mutual.

"You were at the memorial," she said. Not "hello" or even an explanation of why she was there.

I nodded. "And–?"

"Oh, I'm sorry, I've got an appointment with Stefan Borowski, this is his house, isn't it?"

"Our house, come in."

I showed her into the living room and she sat down and put her bag down between her legs as if afraid of pickpockets. "Do you want some wine or coffee or water?"

"I'm good," she said primly.

"What time was your appointment?" I asked, trying not to sound suspicious.

"For now."

Stefan hadn't mentioned any meeting here at the house, and Ruby sure didn't look like any graduate student–what was this about? I excused myself and in the kitchen, I phoned Stefan's cell but got his voice mail instead of him. Why was his phone off again? And why wasn't he here? He was always punctual, how could he be even a few minutes late for a meeting at home?

It's not as if we lived in Los Angeles or Boston and traffic was ever that much of a problem. I tried not to worry, but this was definitely odd. I refilled my wineglass and poured some for Ruby and brought it out to her.

"I'm sure you need this," I said, setting it down on the coffee table laden with enough copies of *The New Yorker* to supply a doctor's office. "After the memorial."

She took it gratefully, but didn't change the pose of Woman Watching Vuitton: the LV bag was still tucked between her legs.

"He sounds like he was pretty special," I said nonchalantly, sitting opposite her. "Vlado."

She nodded, eyes down, sipped from the glass.

"And he was good with women," I went on, feeling my way.

Ruby shot me a hostile glance. "What do you mean?"

Interesting, I thought, not sure how to proceed. "His clients were mostly women," I said neutrally.

"Of course! He knew how to inspire you, without scaring you off. Some men push too hard when they work with women." Now she flushed, and covered it by raising the wineglass and drinking off half of it. "Trainers, that is. The hunks can be scary. He wasn't. He made it fun."

"That's what I've heard," I agreed, noting the word "hunk" just as Detective Fahtouzi had noticed when I used the term to describe Vlado.

She finished her wine and held out her glass for more. I stepped into the kitchen and brought back the bottle and let her help herself. She poured generously, which I hoped was a sign she was loosening up and en route to revealing something.

"It's not true what people said about him," she went on, sounding strangely bitter.

Bingo, I thought.

"Really?"

"Of course not! He did not sleep with his clients. He was devoted to them, but he would never have crossed the line. It

was just rumor."

Nice try, I thought. Shakespeare wrote that "Rumor is a pipe/Blown by surmises, jealousies, conjectures" and Vlado had certainly been the kind of man who'd invoke all of those. But I knew that Ruby was lying to me because I'd seen her in Vlado's photos. This raised two questions: did she know she was lying, or did she believe what she was saying was actually true? In other words, was she living in a fog of denial so thick it made the truth utterly invisible?

After years of shocking pronouncements from congressmen and even the president that raised the same questions for me, I felt the *Through the Looking-Glass* sense of unreality I did watching the news or reading the newspaper. Like our so-called leaders, Ruby either thought I was stupid or gullible–or she just didn't even care. Maybe the whole point was denying the truth no matter who believed what she said; that had become a way of life for Ruby and nothing could faze her. Why should it? Nobody in Washington seemed at all perturbed by the gap between reality and rhetoric anymore.

I couldn't tell her I'd been pawing through Vlado's desk, so I tried to approach the question obliquely. "How can you know that for sure? How do you know he didn't sleep with his clients?"

"Because he told me he didn't," Ruby said proudly, as if she were a prosecutor producing a surprise witness.

"Okay." Note to self, I thought: Find out if she was on medication.

"He was honest," Ruby said. "Very religious. And dedicated. Ambitious. He wasn't always going to work for other people, he was going to be his own boss, he wanted to open a gym." She could have been describing the exploits of some wilderness-taming hero, not another wannabe entrepreneur.

"Did you help him?"

"You mean with contacts–?"

"Money. Did you give him money?"

"Never!"

"Did he ask?"

Her face clouded over.

"He did ask," I said. "A lot?"

She nodded.

"A lot of money? Or often?"

"Both," she brought out. And downed some more of the Pinot.

"So he could be pushy. About some things."

"He's dead. We shouldn't be talking like this."

"But he was murdered."

"No. What? Who said–?"

"It was in the newspaper," I pointed out. "The *Tribune*."

"You can't always believe what you read."

I braced for some kind of conspiracy tirade about UFOs having abducted JFK, Jr. But then Stefan let himself in. With his coat in his hand, he stood in the arched entrance to the living room staring at both of us, looking a bit dazed.

"Ruby? Oh, God, we had an appointment. I can't believe I forgot." He apologized profusely and asked her to wait till he made himself a cup of coffee. Embarrassed, he headed off to the kitchen and I followed. He'd slung his coat over the back of a stool and was fussing with the coffeemaker.

"What happened?" I asked *sotto voce* so Ruby wouldn't hear out in the living room.

He didn't turn around, just slung a tense "Dunno" at me.

I assumed he was still in a funk about the news from his agent. "Listen, so some of your books are going out of print. You can write more. Hell, you can plagiarize somebody and get lots of publicity," I joked. "It worked for David Leavitt." I was trying to get him to relax, but his shoulders didn't look any looser, so I moved up behind him and tried to give him a quick massage, but he shrugged out of my grasp. "I'm making coffee," he snapped.

That was my cue to buzz off, and I did. I thought of a line

from *Tristram Shandy* describing the life of a writer as being "a state of warfare." That was dead-on. In my study, with the door closed, I contemplated throwing or breaking something. I understood how devastated he was about the news from his agent, but ultimately you had to accept that having your books go out of print was a common hazard if you were a literary writer. Publishers couldn't afford to stock them indefinitely in warehouses because of punishing tax laws, and that was a fact of life.

But even thinking so pragmatically turned me around and I felt renewed sorrow for Stefan. He'd given his whole life to writing, with the devotion of an anchorite. And that was a perilous investment of time and self-esteem. I could understand his shutting me out.

Me, I was a bibliographer. I had no dreams of being widely read, though in fact I was. My Wharton bibliography was in libraries around the world and was already a contemporary classic—on a subatomic scale. And in my own room now, surrounded by my Edith Wharton library of first editions and books about her, with framed photos of her and her various homes, all of which I'd visited, I felt anchored in what I knew and loved.

I shut the heavy maroon drapes that really belonged in a larger, more formal room but I had been unable to resist buying. I put a disc of Rachmaninoff's piano sonatas on the computer's CD drive and sat down to read and distract myself. Though the music calmed me down, the book—*Downtown Dybbuk*, a fantasy about a failed New York writer possessed by the spirit of a Holocaust survivor–author—didn't hold my interest. It was dull underneath the hectic surface, and reading about a miserable writer was an unhappy choice at the moment. I picked up *Rubicon*, a study of Ancient Rome's slide from republic to empire, but after less than thirty pages, the subject depressed me despite the colorful writing. Wasn't the U.S. following a similar path?

Contemplating Julius Caesar and his assassination, I found myself musing then over someone hating Valdo enough to kill him. In this case, sexual jealousy seemed the most obvious motive, but Fabian Albahari had been enraged enough to have wanted to hurt Vlado. Being fired could do all kinds of damage, depending on what the reason was. I had to find out why he'd been axed. But how?

I must have fallen asleep because there was a knock on my study door that interrupted a dream where Fabian Albahari was shouting, "Let me say something!" over and over. And he was just about to tell me who had killed Vlado.

Stefan was at my study door, apologizing for being rude before, but I barely took it in. When he asked what was wrong, I explained my dream and he laughed.

"It's like those lines from Raymond Chandler: 'I've never liked this scene. Detective confronts murderer. Murderer produces gun, points same at detective. Murderer tells detective the whole sad story, with the idea of shooting him at the end.'"

"You memorized that?"

He smiled. "Of course. It sums up everything I don't like about mysteries." He corrected himself. "Everything I don't like about the mysteries I don't like."

"Solve a small mystery for me. What did Ruby Strockbine want to talk to you about? I assume she's gone."

"Oh, yes, but she'll be back." Stefan walked in, turned my stiff-backed desk chair around, and sat facing me. "She's written a book about angels. She thinks she'll make millions on it. She wants my 'firm editorial hand.'"

"Is it any good? Not your hand, I mean the book. And what kind of angels?"

"The kind that speak to her."

I was silent and he nodded his own disbelief.

"Were they speaking to her when I gave her that wine?"

"I didn't ask."

"Well, why are you helping her? It doesn't sound like your kind of book at all and she's not one of your students."

"I can't really say no, because she's good friends with the provost."

"Oh, you're kidding! Damn. Can she write?"

"Well, she's not bad. I didn't see much of the manuscript. But with help–"

"–she could have a bestseller since angels are hot."

"Exactly."

"What's she going to call it? *Tuesdays with Gabriel?*"

He shook his head. "We don't have a title yet."

I grimly noted the "we." Then I asked, "Did you talk about an editing fee?"

"Are you kidding? She said God would reward me."

"I hope she means here and not in heaven," I said.

"Amen to that, but I doubt it. I'm doing 'the Lord's work' helping her."

"Puh-leeze. Doesn't the Lord have an agent?"

"There's some of that Pinot left," Stefan said, rising.

"We'll need a whole other bottle," I said, following him out to the kitchen, "Wait 'til you hear what happened at Michigan Muscle today."

We broke out some truffled pâté and sat at the kitchen counter while I took Stefan through the memorial service, my discovery in Vlado's office, and Fabian Albahari's outburst and heave-ho.

Stefan considered it all, then said, "We need to find out what happened between Fabian and Vlado. But why didn't he say what he wanted to?"

"You try giving a speech while you're being schlepped across a lobby."

"What if he didn't really have anything to say, but just wanted to cause trouble?" Stefan answered his own question. "We still need to talk to him. I could try."

"You know him?"

"I think he's spotted for me once or twice when I went to work out at night."

"Ever seen him in the showers?" I asked, finishing my glass of wine.

"Oh, yeah. Hot. Lean, tight, and beefy where it counts."

"Jeez, who hires these guys? Is there any trainer there who isn't gorgeous in one way or another?"

Stefan was musing aloud, "I wanted to talk to Didier about the trainers. I bet he knows Fabian, but I forgot that Didier's in Montréal for the week. Maybe when he gets back..."

"Would Fabian talk to you anyway?"

"Why not? I can tell him I want to put a trainer in my next novel and want to get some tips from him to make it realistic. That is, if I ever write another novel. I don't feel like a writer anymore."

I quoted that camp classic, *What Ever Happened to Baby Jane?*: " 'But ya are, Blanche, ya are.' " Stefan laughed and gave me a hug. I decided not to ask him where he'd been before or why his cell phone had been off–again. I also did not tell him that Juno was planning to write a mystery thriller. Given her previous bestseller, he didn't need to be expecting her to strike it rich once again, another reminder from the universe of his apparent insignificance.

12

I WENT SHOPPING the next morning for groceries since our local supermarket was usually not crowded early on a weekday and I could get through the aisles without bumping into other people's carts or spending too much time in the checkout line. On the short drive I caught the local news and heard that illness had forced a member of the university's Board of Trustees to resign and the governor had made an interim appointment of Franklin Pierce. The announcer said this did not change the balance on the board between Democrats and Republicans, but that was bullshit. Pierce was rich and powerful and he was bound to sway the board.

This was bad news, but of a piece with the whole rightward drift of the country since the last election. Idly, I tried to imagine what my life would have been like if my French-speaking parents had emigrated to Montréal before World War II. I'd at least be able to speak decent French. Would I have met Stefan, I wondered? Or gone into teaching? Would I have a French-Canadian accent when I spoke English? Those were very sexy. Would I have met Juno? She was Canadian, after all.

I met somebody quite different at the supermarket. As I rolled my cart towards the vegetable bins I saw Fabian Albahari with a small handbasket standing by the organic produce, studying a lettuce, I thought. He looked perfectly normal in his jeans and black ski parka with its lift ticket, not someone who'd make a fuss.

I stopped, trying to think of some kind of opening line a bit

more subtle than "Why did Vlado fire you and who do you think killed him?" Around me the glaring fluorescent lights gave a hard edge to every box and can and display sign—as if this wasn't a place of plenty, but a danger zone of some kind, and was so hazardous that you needed as much visibility as possible. Were supermarkets in other countries lit so brashly? It was bright enough for Kay Scarpetta to do an autopsy right there.

Fabian moved on down the aisle, not picking a lettuce, and I tried to follow inconspicuously. But then I remembered the advice from *The Importance of Being Earnest* and agreed that now was "not the time for German scepticism." I headed back and around the next aisle to meet him head-on, sort of. I wheeled past pastas, sauces, rice on one side and Mexican, Indian, and Chinese foods and dinners on the other. I didn't see any point in sneaking up on him, and my honesty, if you can call it that, was rewarded. Fabian nodded as I moved past, which meant I could legitimately stop.

"You're a trainer at Michigan Muscle," I said, not mentioning his recent spectacular exit.

He shrugged and took a closer look at me. Standing only a few feet away now, I thought even more that he resembled any number of international models. It wasn't just that he was young. He was head-turningly perfect, with looks so vivid and crisp that they made his surroundings one-dimensional. It was as if the cans and boxes around us had shrunk in significance and even taken on a touch of unreality. I'd entered a photo shoot and he was the star. Vlado was handsome and had an amazing body, but Fabian had something more, a confidence, a glow. I wondered what Sharon as an ex-model would think of him.

Fabian's answer was flat. "I used to be."

"You moved to another gym?"

"Not yet."

We weren't getting anywhere and I could already feel him

wanting to end this encounter, so I asked if he ever did private training, and he smiled as if he were some ogre guarding a treasure and I'd given him the correct runic password. "I love it. Are you looking for a personal trainer at home?"

I said it had crossed my mind, which was true, but only like an advertising banner flown behind a twin-engine prop plane over a football stadium. Interesting, inconsequential. So I guess you could say I lied to him if you were a stickler for the truth.

I asked if he had time for coffee, since there was a Noir right next door in the mini-mall, and he said he'd meet me there in ten minutes after he finished shopping. My cart was only half-filled with items from my list, but I hurried to a checkout lane so I could load the Lexus, get some coffee, and plan my interrogation.

U2's "Zoo Station" from *Achtung Baby* was playing on the sound system as I got a double espresso and picked one of the many empty tables. Was I, like Bono, ready to duck and dive?

The place was a bit dispiriting without a crowd.

Fabian joined me and I stifled any shame I had about getting him there under false pretenses. Here, too, the background was diminished by his rich presence, not that it was hard to do given the black-and-white color scheme, and the relative emptiness.

I paid for his latte and double-chocolate-chip muffin. How could he eat junk like that and stay fit? I settled down for some fakery, but surprisingly, as we talked about workouts, what I liked and didn't like, my past goals, where I felt I needed to be now, I found myself thinking that maybe I actually could hire him as a personal trainer. He sounded more than knowledgeable enough and he had the quiet, flattering attention of an analyst.

Maybe working out with his tutelage would help me deal with the boredom factor at the club when I did much of anything but swim. Fabian had even been a lifeguard and we

talked about swimming together, the idea of helping me with my weakest stroke, the butterfly. But then it hit me that he could never train me at Michigan Muscle if he'd been fired— or could he? Could I bring my own trainer with me? I doubted it. Which meant we'd work out at home, and that left the question of finding a pool up in the air. Stefan and I had very little equipment at home since the club was where we went for exercise.

Fabian said equipment wasn't the issue, it was motivation. "You can do an awesome workout without a lot of stuff." He methodically peeled the paper off his muffin, turning and peeling, turning and peeling—but after that broke pieces off at random, from different parts of the muffin, rather than the same spot, and placed them carefully in his mouth, chewing discreetly.

He sat there looking foursquare and reliable, not at all the kind of person you'd imagine getting fired and going ballistic about it. His blue eyes—which matched the royal blue Eddie Bauer-style shirt he wore out over his faded and torn jeans, cuffs unbuttoned and collar "popped"—radiated honesty and calm, so what had happened at Michigan Muscle? I tried to stay focused on that and not on the twin arcs of his perfect chest and the strong column of his neck, at the base of which was a sprig of dark hair. He was so alien to me, in a way, an inhabitant of another planet, living the life of the body. People like him didn't just train others and train themselves, they ran, biked, golfed, skied, played racquetball and tennis—living strenuously in their bodies, relating to the world through them. For me, despite swimming and my regular workouts, a good book meant much more to me than a great run ever could. I would never choose a vacation spot because the hiking was good, or I could do helicopter skiing. I wanted to relax, or bathe in another culture.

I finally took the plunge, sort of, and asked, "What was Vlado Zamaria like to work for?"

The change of subject obviously startled Fabian, and he was silent.

"I mean, everyone at the memorial service raved about how great he was, and I wondered if..."

"If that was real?" He was smiling sourly.

"I guess."

"Why's it matter?"

I stalled by finishing my espresso, which was cold. "The club's got a new feel to it, it makes me wonder what's going on."

That was vague and not exactly to the point, but it seemed to be enough for Fabian, who nodded a few times, and said, "Okay" as if giving himself permission to let go.

"What kind of things did they say?"

As best as I could remember, I summarized the speakers I'd heard, and with each comment, Fabian gave a soft "Huh," as if he'd been hit and was trying not to show the impact. Finished, I shrugged, waiting for him to give his version.

"He was a fuckhead jerk asshole," Fabian said. "He was the worst."

"How?"

"You name it."

"You mean he wasn't a good trainer?"

"He knew his shit, but we all do. All of us have degrees in exercise physiology from State and we go to workshops and seminars, we read journals and magazines, we listen to tapes, watch DVDs. We know what's new and smart. But Vlado, he was head of training and he fucked people over, and liked it. He'd be all nice to you and then you'd get the shaft and he'd pretend he didn't do it. He'd tell you how good you were doing but then he wouldn't give you referrals and he would bad-mouth the workouts you designed to members and, like, other trainers."

"Why?"

Fabian leaned forward. "I don't know and I don't care. He was a sick fuck and him being dead is like the best Christmas present I ever had."

That made two people who thought Vlado's death was a gift. Or two I'd heard say it. There were likely more than that.

"What else did he do?"

"To me? To other trainers?"

"Both."

He breathed in through his mouth, leaned back and crossed his arms, the long, heavy biceps pushing out against the blue cloth of his sleeves. "You go into training because you want to help people, work with people, teach them, train them, change their lives no matter where they start. You know? Make them feel good, make them look good, sometimes. So that asshole could get on your case and force you to do notes on every single workout, real detailed notes. Do all kinds of paperwork, track retention of clients and new business, all that shit."

"Things that take you away from what you love."

His eyes widened with agreement and perhaps appreciation for my understanding of what made him tick. I felt like a high school student scoring his teacher's approbation for a well-thought-out answer. But I also admired his quiet passion; he really did love his job.

And then he said, "This is why you wanted to talk to me, right? You're interested in Vlado."

"Uh–"

My embarrassment made him switch course. "Or was it personal?" His voice had dropped so that only I could hear him, even though there weren't more than three or four people in the coffee shop now besides us, and that included the staff.

"What do you mean?"

"Hey, it's cool, a guy like you wants to hang out with someone like me, I get it all the time."

"A guy like me?"

He went on genially. "I don't mind. But it's not cheap."

"What?"

"Hey, there's training, and there's training." And now his

grin was as lascivious and showy as Bourbon Street on a Mardi Gras night.

"You're kidding," I said.

His face snapped closed as quickly as an over-tight window shade flaring upwards. "No offense, dude." He looked ready to grab his parka from the back of his seat and bolt.

"Whoa, it's okay. I mean, you're really handsome, and–but I'm in a relationship and I wasn't looking for–" Why the hell was I apologizing to him? What had I done? Except deceive him, of course. But then he'd tricked me, too, by pretending not to know what I was after. No, wait, he was pretending because he thought I was after something else. But that was still deception, wasn't it?

I tried to think of something to say to get us out of this little quagmire, but drew a complete blank. Fabian saved me by starting to laugh. He had a warm, softly theatrical laugh, just about what you'd expect from someone that good-looking who was used to being the center of attention wherever he went.

"They're always in relationships, or married. That's why they need a good half-time show to keep them in the game."

I risked asking him if he was gay, but I didn't have to be concerned he'd take offense. My question made him laugh even more. "Everything's different now, it's not like when you were my age," he said, and he could have been talking about a time when dinosaurs stalked the land. "I'm not gay, I'm not straight, I'm just available."

"Under the right circumstances."

"Exactly," he said, pointing at me with both index fingers as if I'd stumbled on some deep and very hip truth.

"So what about Vlado?"

"Don't know his story." His eyes narrowed. "All I know is he was hassling me, but that wasn't enough." He lowered his voice some more. "Dude wanted me to blow him, in the steam room. Then he said he would stop riding me about my clients and shit like that. Just one time, and that would be it."

"In the steam room? Anybody could walk in."

"Danger freak, I guess. He said it would be near closing time with nobody around, but still–"

I whistled. "He could have got you both fired."

"Yeah, well, it never happened."

"Did you complain?"

"To the manager? Right, and sound like a pussy. I say anything and Vlado tells him it was my idea."

"Were you going to repeat any of this at his memorial?"

Fabian shrugged, looking dejected for the first time that morning. He waited for my next question.

"Did he, did he pressure other trainers?"

"Yeah, like I'm gonna ask around for something like that."

Point taken.

"But Vlado had to have a reason for firing you, a legitimate reason."

Fabian frowned.

"I mean, an excuse."

"He said I was training club members at their homes. Which is true. I needed the money."

"But what's wrong with that?"

"We're not allowed to do that–we sign a contract. Which is bullshit. Who's it hurt, I do some training off the books? Michigan Muscle gets millions and I can't do a few extra sessions on my own time? That's bullshit."

And Vlado broke the rule himself.

"How did he find out about you? God, I need some more coffee, can you wait?" He nodded and I dashed to the counter to order myself a latte, and tried not to turn and see if he was staying at the table while they made my coffee. I left a large tip because I didn't want to wait for change, and I sat back down opposite him, not knowing what to expect.

Ruefully, Fabian said that the client had let it slip to Vlado.

"Why?"

"Good question."

"So who was the client?"

He hesitated, and I pushed. "It's not like doctor-patient privilege, or lawyers or priests."

"Why should I tell you?"

I had the impression that Fabian was not used to being questioned. He reminded me then, in his aura of bristling self-satisfaction, of a student in one of my classes at SUM the first semester I'd taught. Chet was in a popular local band, good-looking, used to groupies and easy adulation, smart but lazy. He came to almost every class late, turned in papers late or not at all, and was shocked when I said his work was marginal.

"What's the difference who it was?" Fabian asked with the start of a sneer.

"The difference is, he was murdered."

"And you're the 'Law and Order' team minus one?"

I waited. Silence could turn people off or it could turn them out. It did the latter for Fabian. "That Juno babe," he said at last.

"Juno!"

He smiled. "Just fucking with you. She's pretty hot. For an older woman. I know she's a friend of yours. I saw you guys talking in the pool once. You looked pretty friendly."

That was one way to put it. I remembered Juno's tight gold swimsuit and its surprising physical effect on me as we stood chatting at the edge of the pool in adjoining lanes, nothing but the divider rope and some cloth between us. I hoped he wasn't going to start cataloguing her hotness.

"So who was it really?" I asked.

He pursed his long, thick lips. Was he playing me or legitimately reluctant? Had anything he said so far been the truth?

"Mrs. Aftergood."

"Celia!"

"You know her?"

"Not really, but I've met her. So, was it training, or *training*?"

"Both. She has a basement gym." He didn't leer. He didn't need to. I could imagine him guiding Celia's body through a very personal workout. I wondered if he could break the spell of torpid boredom she seemed to live under. Probably not. I sipped my coffee, thinking about the possibility of Celia Aftergood getting sex from two different trainers. Was it some kind of Catherine the Great thing? She was rich and bored and felt she had her pick of the local studs?

"Vlado," I said. "He was training her, too."

"He thought he could get away with it. He was king. No rules for him."

Did Fabian realize that what he'd been telling me made him a perfect suspect for Vlado's murder? He had the perfect motive, hell, more than one motive, and what better place to kill Vlado than in the steam room Vlado wanted to humiliate him in?

"I didn't kill him," Fabian said with quiet force, reading my mind. "But I thought about it. I thought about it a lot. Mostly I hoped he'd drop dead, get hit by a truck, or his car would get stuck on railroad tracks, or he'd drown or something."

That was a list. I drank more coffee.

"We all did," Fabian added. "Lots of us had it in for him. Wasn't just me."

"His wife says you were drinking buddies, all you trainers."

"Yeah, right, like his wife would know anything."

My head was buzzing from the information as much as the coffee. I wondered then if Detective Fahtouzi knew what Fabian had to say about Vlado, but then figured interviewing the people he worked with had to have been a logical step. But would Fabian say the same thing to a cop that he said to someone like me, someone he thought might want to hire him for, well, whatever?

I was contemplating a way to ask where he'd been when Valdo was killed, but I was sure Fabian would have a good alibi. His talk was as smooth as his looks.

"What about his gym?" I asked. Fabian looked puzzled. "Wasn't Vlado going to start his own gym? A personal training studio. He was raising money for it."

Fabian shrugged. "Never heard about it."

Which contradicted Celia's claim that the trainers at Michigan Muscle were envious of his plans. I was thinking now of the photos in Vlado's office of him and various women having sex. Would he have bragged about those to Fabian or another trainer?

"Did Vlado have a best friend among the trainers?"

Fabian finished the last bit of muffin on his plate and while chewing, said, "Vlado's best friend was Vlado."

"How about Fred?"

"Uh...maybe." I made a mental note to make sure I talked to Fred Gundersen again, because I remembered his evasiveness when we'd spoken.

"So who do you think killed him?" I asked.

"Could have been anybody, could have been a lot of people."

Great, I thought, a consortium.

"Do you know anything about his ethnic background?" As I said it, I wondered why I was bothering to ask him.

"Just that his people come from someplace over in Europe that starts with a 'K.' "

"Croatia." I didn't bother spelling it.

"That's the one."

"Did he ever talk about it, or the wars in Yugoslavia?"

Fabian stared at me as if I'd asked whether the trainers had discussed feminine hygiene.

"Gotta go," Fabian said, rising and slipping on his parka. He brought out a slim wallet, pulled out a card and placed it on the table in front of me. "Thanks for the coffee."

When he loped off, I glanced at it. His name, his cell phone number and email address were under an embossed line that read: PERSONAL TRAINING 24/7.

Now that was a concept. What was that line in *Gypsy*? "Ya gotta have a gimmick." Maybe Fabian was his own gimmick. Someone that handsome was used to being looked at and ad-mired—what if he used it as camouflage? He seemed to imply that Vlado was almost sociopathic in the way he abused his power, but what if Fabian was the real sociopath? He was at-tractive, plausible, reasonable, articulate—could that all be a cover?

I didn't see how I could find out the real reason for Fabian getting fired. Heath Wilmore wouldn't talk to me, Vlado was dead, and I doubted that he'd told his wife or the other trainers. So all I had was Fabian's story, but what did it mean? How much was jealousy about Celia, and was that even real? Had she been getting it on with both of them?

As I drove off, it struck me that there was a problem with Fa-bian as a suspect. He had ample reason to be angry at Vlado, though whether it was enough to kill him I didn't know. But he'd been expelled from the club and everyone had to show a club ID at the reception desk, so how could he get inside to commit murder?

PART FOUR

"Careful the tale you tell."

—*Stephen Sondheim,* Into the Woods

13

UNPACKING GROCERIES in the kitchen and talking to Stefan about my morning out, it struck me once again how bizarre my life was. I wasn't describing sales or interesting new products I'd noticed at the supermarket, or even how once again certain aisles had been reorganized so as to make shoppers crazy. I wasn't lost in the low-level hum of the quotidian that was the background of most people's lives. No, I was talking about taking life, about murder. Underneath which was of course envy, hate, and who knew what other kinds of emotional corruption. This wasn't about a body lying in rubble in the aftermath of a storm, seen on TV or in a movie. This was death a few feet away from me in the steam room, a murder probably committed by someone I had spoken to, or even lived near to.

I doubted I had really absorbed what had happened.

But could I absorb it, ever? I wasn't a cop or an intelligence agent or especially accident-prone. As a bibliographer, my brief did not include death and darkness and I'd always responded more to Edith Wharton's social satire than her naturalistic little masterpieces like *Ethan Frome* or even her ghost stories. Maybe I'd reached my limit, and so this latest gruesome experience would always shadow me, haunt me, a specter moaning to be set free, only there was no spell or exorcism within my reach. Stefan was still burdened by his parents' once-secret past; why should I assume that death, which wasn't just a generation ago but in my own sphere, would fade?

"So I don't have to talk to Fabian, do I?" Stefan asked. "Now that you have."

"Well, I'm not sure. I couldn't figure out how to read Fabian," I said, as Stefan finished preparing a quick *cassoulet* for lunch. The kitchen smelled of rosemary and tomato paste. He held up a hand to stop me while he put the buttered bread in the Cuisinart and ground it up for the bread crumbs. I watched him, and forgetting the age difference between them, I thought Stefan was almost as handsome as Fabian. But there was nothing especially theatrical about his looks. Stefan was somehow more various, less fixed than Fabian. Maybe I'd been wrong about the trainer, maybe it was Fabian who was one-dimensional and not the settings I'd seen him in.

"He was weird, I think."

"It's like one of those horror movies?" Stefan used a spatula to scrape the bread crumbs into a bowl. "Beautiful day, beautiful scene, but there's something wrong with it. Flickering. Out of the corner of your eye. Eerie music. *Bam!*"

"Well, I didn't think Fabian was going to grow tentacles or that his head would flip back like a Pez dispenser and somebody would crawl out of his neck."

"I guess I'm saying he could be a sociopath–he looks plausible, sounds fine, but you get a feeling in the pit of your stomach you're being had in some way."

"Maybe. Can you believe he thought I wanted to hire him for sex? Just because I wanted to talk to him? And Celia Aftergood was his lover? And Vlado was sexually harassing him? It's like there's this whole underground life around here, I mean at the club, and who knows what the hell else is going on, what people are hiding." Then I laughed at myself. "Welcome to the world."

Stefan didn't seem to be listening now, and I didn't feel it was a question of concentrating on the next step of the menu. I watched him scoop the mixture of cooked white beans, carrots, onions, celery, white wine, chicken broth, and diced tomatoes into a blue oval casserole dish, top it with the already prepared

cooked chicken legs and chicken-apple sausage. He sprinkled the bread crumbs on top, added some chèvre, and then popped the dish in the oven, every movement deliberate but relaxed.

Stefan turned from the stove. "Cider?"

I nodded and he brought two glasses and a can of Strongbow to the counter, split it between us, and sat opposite me.

"How do you ever know if someone is lying to you?" I asked rhetorically, but Stefan seemed startled by the question anyway.

I went on, thinking aloud. "Celia says her husband knew about Vlado having sex with her, which sounds far-fetched, and now Fabian tells me he was having sex with her, too. What if he wasn't, and what if he did blow Vlado in the steam room to keep his job—and Vlado screwed him over anyway?"

Stefan thought it over. "Why would Fabian say that? Lie about what he did with Vlado?"

"Because he was humiliated."

"But you said he has sex with men as well as women, or at least he's—what?—available."

"That's different than being forced to."

"Okay. But you told me he said he thought about killing Vlado, or he wanted him dead, at least. Why would anyone say that if he was a murderer?"

I tapped the counter. "Oldest trick in the book. It diverts suspicion."

"It diverts something," Stefan muttered sourly.

"I thought you were into this as much as I was."

"I am, but—"

"But?"

Stefan took a slug of the cider and set the glass down too heavily. "We have vultures flying around us."

"What?"

"Seriously, all my career trouble, yours too—and the murder."

"*And* the murder? I think the order's wrong."

"Not for me. I've given my whole life to writing. It's real to me. All this crime and investigating, it's surreal, it's not where my heart is. It's on the list, but it's at the end."

I hated when Stefan talked about his career as if it were his child doomed to die young because of a wasting genetic disease. Would he be this gloom-and-doomy forever? What would it take to make him feel successful?

"Shit! I completely forgot—did you listen to the news this morning? Franklin Pierce is on the Board of Trustees now. The governor appointed him to fill a vacancy until the election."

Stefan looked stunned, but the doorbell rang before he could comment, and he went to the door.

"News!" I heard Juno cry from the open door, which slammed behind her like a thunderclap. "News!"

She swept into the kitchen decked out in leather boots, midiskirt, and a bevy of shawls that made her look like Faye Dunaway in *The Eyes of Laura Mars*. Stefan followed and ducked out of her way as she melodramatically slung a few of her vestments onto the back of a chair and surveyed us with all the self-importance of a messenger from the battlefield. From her skirt pocket she pulled out a canary-yellow flyer, unfolded it, and plunked it down on the counter. Arms akimbo, she commanded, "Look at that!" with all the fire of a young Sophia Loren.

Expecting this to be somehow about Franklin Pierce, I surveyed the crumpled sheet with confusion. The flyer gave the date and time for an upcoming seminar at Michigan Muscle titled "*Mens Sana in Corpore Sano*: Bringing the spirit and the body together."

"A healthy mind in a healthy body, what's wrong with that?" I asked Juno, who was quick to reply.

"You don't know the whole quote, do you?" she shot back. "It's from Juvenal's *Satires*, and it's '*Orandum est ut sit mens sana in corpore sano*' and it means 'You should pray for a healthy mind in a healthy body.'"

I still didn't get it, neither did Stefan. Juno advanced on the

counter and stabbed at smaller print on the sheet. "Look at who's presenting it! Reverend Luther Pierce. I Googled him. He's the chaplain at Neptune College and he's a cousin of Franklin Pierce."

Now I understood her outrage, but she had more to say.

"He's also a coach at Neptune and he's taught classes called Christian Living/Christian Lifting."

"It's catchy," I said. "But I thought you were going to tell us about Franklin Pierce being on the board."

Now she looked confused, and she sat down cursing under her breath. "The university's doomed."

I wasn't ready to deal with that particular apocalypse. I waved the flyer at her. "So you think that's what this really is, missionary work?"

Juno nodded fiercely. Members of the club were always hungry for more physical self-improvement, and every month it seemed there was some new program or plan offered to change lives forever. This one sounded like it offered to change the afterlife, too.

"Something smells good, what is it?" Juno asked with an abrupt shift, and when Stefan told her, she asked to see the recipe and they were soon over by the stove talking about *haricot lingot* beans and where on-line you could get the best Toulouse sausage for real *cassoulet*. He hadn't ever talked to her much and certainly not about cooking, and they had the rapt intensity of all foodies when they discover a soul mate. He was more animated than he'd been in days, and within minutes he was inviting her to lunch and they were opening a bottle of a good Australian Shiraz.

Stefan asked me to set the table. While we let the wine breathe and waited for the *cassoulet*, Juno expatiated on what she suspected was going on locally.

"Let's start with Merry Glinka." That was the new provost at SUM. "She was the president at Neptune College and isn't that the most conservative school in Michigan?"

I nodded. "They've had Karl Rove speak there, Dick Cheney, Pat Robertson, the whole gang."

"Okay. So she's the new provost at our school, the real power. And our department is looking at a White Studies Program? And then the Pierces buy the biggest health club nearby. And Pierce gets himself appointed to the Board of Trustees? He's one of those people who can't tell the difference between himself and God."

"But so what?" Stefan asked. "So what if the Pierces are trying to influence the university or people who work out at the health club. So what?"

"Because it's a crusade! These are religious fanatics and they want everyone to be like them."

Stefan seemed underwhelmed, which surprised me. He was an ardent opponent of the administration in Washington and its adherents across the country. Like me, he believed in a strong wall between church and state, he was pro-choice, and he believed in strict limits on presidential power, based on the world his parents had survived. He had said to me more than once after 9/11: "We're turning into an absolute monarchy, only there's no crown."

But I saw holes, too, and asked Juno, "Why here? Why would the Pierces target this place? The University of Michigan's a much more prestigious university to take over, if that's what's going on. It has more respect, a better reputation, faculty with more awards and grants and prizes." The State University of Michigan had begun over a hundred and fifty years ago as an agricultural college and had never quite outgrown its humble origins. And despite being the state capitol, Michiganapolis was still less urbane than Ann Arbor.

It was strange talking about the university so much. Even though we were less than ten minutes away by car, and classes were starting up again soon, I had not been going in to get my mail. My classes had long been planned, and I think Stefan and I both lived during breaks in a kind of parallel universe. We

were irremediably "gown," but we had a taste of "town" those days and liked it. That went along with traffic being lighter, movies less crowded, and every other comfort connected to students not being around in great numbers.

"Why here?" Juno asked. "Jews, that's why. Too many Jews in Ann Arbor," she said baldly, and Stefan and I both laughed at the sound of it. Laughed out of embarrassment at the truth. She was right. In some parts of the state they didn't call our rival university in Ann Arbor "U of M," but "Jew of M." Not the most fertile ground for a religious revival, takeover, underground campaign, or whatever might be going on.

"We can't do anything about what's going on with the country, even elections don't matter anymore if voting machines can be rigged with one little computer card," Stefan said. "But maybe we can help solve Vlado's murder. That's right here, right now."

It was a novel interpretation of Voltaire's *"Il faut cultiver notre jardin,"* but it worked for me.

"Tell her about Fabian Albahari," Stefan said as he poured the wine and Juno complimented him on his selection.

I told Juno everything that had passed between me and Fabian, and she was agog. Hell, she was Gog and Magog.

"I can't believe it! That wench Celia not telling us she was doing Fabian, too."

"Did you know he was freelancing?" I asked, wondering if that was the right word or not.

Juno shook her head and angrily wiped the corners of her mouth with a napkin.

"Wait a minute," she snapped. "Celia never mentioned Fabian Albahari when you and I were talking to her, but she referred to him, didn't she?"

I tried to remember, but Juno was certain. "Yes, she did. She said Vlado fired someone. She was giving us a suspect and pretending she didn't know him. But she was sleeping with him, too. That's evil."

"Maybe she got bored with him."

"Or maybe she's protecting her husband."

We put the question on hold since the *cassoulet* was ready. We settled down to enjoy it, Stefan chatting more amiably with Juno than ever before, now about Rhône wines. I remembered then two French verbs for chatting: *bavarder* and *causer*, and wondered what the difference was between them. Why now? If I were trying to speak French, I doubted the words would come to me at all. Perhaps there was a diagnosis–Delayed Language Syndrome, where you thought of words in a language you didn't need–and a medication.

While they traveled the Rhône Valley, I enjoyed Stefan and Juno's conversation a bit ambivalently. I was glad Stefan was getting along with her so well, but I was still physically attracted to her and hoped that Stefan didn't notice. I mused over Celia's life of wealth and ease and wondered at her seeming so rootless or dissatisfied underneath that torpor. You'd think having as much as she did would make her happy, but then I remembered lines from Lisa Zeidner's novel *Layover* about a woman drifting out of her own life: "Truth is, *hardly anyone is happy*. Not even the people with nothing wrong. They're all hunkered down in the bunker of self, in self's fragile failure."

"We've got to figure this out," Juno said. "The police haven't gotten anywhere and if they don't solve a case in the first forty-eight hours, isn't it usually hopeless?"

She and Stefan looked to me for confirmation, so I was clearly the delegated expert in things forensic. I nodded, even though I wasn't sure if that were true. I think we were all a bit drunk by this point, and Stefan and I had a head start because of the alcohol content of the cider.

"Who do we have, then?" she demanded and Stefan and I sat up straighter like slacker students called to order.

"Celia Aftergood," Stefan said, holding up one finger as if starting a list. The wine, the food, the company had definitely brought him out of his funk. "She lied to you, it sounds like,

and she told you way too much. I think she wanted to send up a smoke screen. Talk about sex, and you wouldn't see anything else."

"How could she get into the men's locker room and steam room without somebody noticing?" I asked.

"Good point," Juno agreed. "I think it had to be a man who did it. Her husband makes sense–didn't you say he threatened you at the restaurant? So he either did it on his own because of the affair or maybe it's more complicated than that. I can picture the three of them in a ménage à trois that went bad."

"Bad enough to end in murder?" I asked.

Juno nodded savagely. "Trust me, I've seen it happen." But she refused to say more.

"It's Alfred Aftergood or Fabian. Both of them were probably jealous, and you get the extra dimension of whatever happened between Fabian and Vlado–or didn't happen."

"What about Vlado's wife?" I asked. "What if she found out he was cheating on her? Found out for sure, I mean." I answered my own question. "Same problem of a woman in the men's locker room."

Stefan breathed in sharply, clearly struck by an idea. "She and Fabian did it together. Or she hired him. They both had motives, but he had the opportunity."

"He had more motive than you realize," Juno said. "I just found out how much the full-time trainers make at the club. Seventy-five thousand dollars."

I gulped. That was more than my salary at the university. And it was more than any of us had imagined the trainers made. And it was a damned good salary in Michiganapolis, where the cost of living is lower than in many parts of the country.

"Even if Vlado wasn't harassing Fabian for sex, losing a good-paying job would push lots of people over the edge."

And then we were all silent, as if musing over our own obscene willingness to convict other people of murder. For all our ease of speculation, we could have been talking about a

plot development on our favorite TV show, or a minor political scandal reported in *Newsweek*. Yet someone had done it, and most likely it was someone we knew or had spoken to.

Something joggled into place and I jumped up and rushed to the laptop over by the TV and pulled up Google.

"What are you looking for?" Stefan asked, sharp-eyed.

I found it before I could answer. "He's Serbian," I said, clapping my hands together. "Fabian is. Albahari is a Serbian name. I knew it was familiar. There's a Serbian writer named David Albahari and I was just reading a review of one of his novels, something set during World War Two, I think."

"Oh my God, you're right," Juno said. "He teaches in Calgary. Why didn't I recognize it?"

I turned from the computer, feeling as solid and implacable as Perry Mason. "Yeah, Fabian's got a Serbian name, and when I asked him–for some reason–if he knew Vlado's heritage he acted like a typical American who can't tell the difference between Slovakia and Slovenia. He said he thought Vlado's people were from some country with a 'K.' I must have made the connection about his name unconsciously...."

"He was lying," Stefan said. "He didn't want you to know that he knew."

"Unless he was trying to protect himself, somehow," Juno pointed out.

"It sure looks like Fabian, based on motives," I said, crossing my arms.

"But that's so obvious. Too obvious," Stefan said slowly, his wineglass up near his chin where he breathed the bouquet and inhaled it as deeply as an asthmatic trying to clear his bronchia. "Maybe Juno's right."

She beamed vaguely since it wasn't clear what Stefan meant.

"Juno's right," he said carefully, as if walking a rhetorical tight rope. "This whole Christian thing does sound suspicious. A fundamentalist family buys the club. They install one of their minions as manager. They offer what's probably going to be a

religious seminar masquerading as something about health and fitness, and it's taught by a chaplain who's a cousin of the Pierces. Meanwhile, one of their allies has already become provost of the neighboring university and the head of the family is appointed to the Board of Trustees at the same university. What are they up to, what do they want?" If the wineglass weren't in the way, he could have put a finger to his lips like Mike Meyers playing Dr. Evil in the Austin Powers movies.

I waited for more with bated and even debated breath.

"Conversion," he said. "Submission. Power. Why try to convert people in a foreign country, why not turn Michiganapolis into a Christian bastion? Maybe they're planning to buy the local paper, too–or they could even own it already."

"So where does Vlado fit in?"

"He was a threat. Vlado sounds like a sexual Cirque du Soleil, doesn't he? He was unclean, polluted. If it got out, it would be terrible publicity–"

"Some people would join the club in a flash," Juno interrupted.

"It would be a public relations disaster," Stefan insisted.

I asked, "So it's the Pierces?"

He nodded somberly.

"The Pierces killed him to shut him up? That's kind of–" I hunted for the word.

"Extreme?" Stefan asked. "But these people *are* extremists. They think Jews are damned to hell, they think queers are evil, they think Darwin was the Devil." Stefan was just getting started but Juno spiked his gun.

"Why couldn't they just *fire* Vlado?" she asked innocently.

"Not enough. He would be a moral cancer for people like that."

"So who did it?" I asked. "Heath Wilmore, the new manager? Or did he bring in some right-wing ninjas?"

Stefan shrugged. "It's got to be all connected."

"You sound like a Don DeLillo novel," I said.

Juno laughed. "In America, Don DeLillo isn't fiction, he's hard, cold reality. But I put my money on someone close to Vlado in some way being the murderer. It's less likely it was an execution. As for Don DeLillo, what's wrong with sounding like one of his novels–there are worse things to sound like," she said jovially. "How about David Baldacci? He's got a line in one of his books about a fat man leaning back into a chair until his bulk extrapolated outward and engulfed the space."

"No way!" I chortled, with the fleeting sense that a Baldacci book was somehow connected to Vlado's murder, but the thought was gone before I could pin it down. "Where did you read that? Why did you read that?"

"I was at my sister's house and couldn't sleep–I thought it would be boring enough to knock me out, instead I was laughing so hard I woke *her* up."

We traded bad lines from bad books for a while, ranging from Mitch Albom to Steve Martini and back, clearly taking refuge from darker subjects. But Stefan, the most serious of our triumvirate, stopped the growing hilarity by asking, "What do we do now?"

"Legwork," Juno said, and I had a searing vision of her sturdy legs and how they might wrap around a lover in bed. I shook my head clear of it, or tried.

"I'm going to talk to Celia," Juno announced.

Stefan reminded us about the diamond watch in Vlado's desk and the photos.

"Yes?" Juno said. "And?"

"They must mean something. I want to figure that out." He yawned heavily. "Why were they in his office? Wouldn't the police have taken them?"

"But the office wasn't the crime scene," I said. "It wasn't even sealed."

Stefan thought about that. Juno, not entirely convinced that he was going to be gainfully employed, turned her sultry, commanding gaze on me, waiting for me to volunteer a mission.

"I could– I could try to follow Fabian and see if I found out anything? Or interview Vlado's wife..."

"Would she talk to you again?" Juno asked, looking dubious and a bit blurry.

"I can tell her I'm having a party and want to order petits fours."

"Brilliant!" Juno smacked a fist into her hand, stood up quickly, swayed, then sat back down. Stefan busied himself making a pot of coffee since caffeine was–for us, anyway–the better part of valor.

"Hold it," I said, "there's somebody else." The talk of extremism had reminded me of that guy in the hot tub, who called himself Serbian. I explained about the flag in Vlado's living room and speculated on some kind of ethnic violence–killing. As I said it, it sounded incredibly far-fetched.

Juno asked what he looked like, and when I described him and his ranting, she shouted, "David Karamata! He's a menace and he's a drunk. He and his wife live a few houses down from me and they're bizarre. They've asked neighbors to cut down trees because they drop leaves in *their* yard. It's not even as if the Karamatas have offered to pay for the removals. His wife is a little bitch. I was walking Turandot past their yard and she came rushing down from the porch to say she hoped I was planning to clean up after her, because she was trying to create a formal English garden and dogs would destroy it." Juno's eyes widened with outrage. "I waved a bag at her, I always carry a bag, and she just kept on and on about it till I told her if she didn't shut up I was going to take a dump on her lawn myself."

"How do you know her husband is a drunk?" Stefan asked, apparently wanting to move quickly along from the image of Juno with her pants down.

"Because last July Fourth, midafternoon, Turandot was out in the yard, barking at a squirrel. She's a dog, she's a Westie. She barks. That's what they do. And from down the street I could hear him shouting his bloody head off to shut my dog

up–and then he started blowing a Klaxon as if he was at a football game. Of course it made my dog bark louder. This was mid-afternoon, not midnight, she wasn't keeping anyone from sleep. Later, I found out from a neighbor that he's often drunk, they see him on his deck with a bottle of something or other. He drinks it right from the bottle." She shuddered. "And don't think his wife isn't a horror, either. After my run-in with her, I heard that she berates anyone walking by with a dog–she even drove by someone a few blocks over and warned him to keep his German Shepherd off her lawn."

"That's nuts," I said.

"And I have heard from other people over time, that David's always going on about the threat of Islam and raving about Serbia being betrayed."

"Where does he do that?" Stefan asked, looking fascinated.

"At a funeral home, at football games, wherever you see him he's apparently obsessing about the Muslims bringing on the end of the world. And of course the Croatians are evil, too. He's a lawyer or something, but most people I know consider him a nut job."

"Is he crazy enough to kill someone he thinks is his enemy?"

Juno shrugged. "I don't doubt it."

I asked how we could proceed. Surely it wasn't enough that he was drunk and sometimes out of control. I had never heard of any Croatian or Serbian nationalist groups of any kind in Michiganapolis. I didn't even think there was a Serbian Orthodox church in town, or a Croatian Catholic church, where we could somehow troll for information. I didn't see what Dave's hatred could be fueled by or where we could explore it. If there were no Serb or Croatian community in town, wouldn't any ethnic hatreds just fizzle out as soon as they flared up? If they even *had* flared up.

Thinking aloud, I said, "I guess I could mention him at the club, see if anybody knows about him, or something like that." It sounded lame, but then asking questions was about all we

could do in this case. We weren't going to get anywhere going on-line.

"Nick," Stefan pointed out, "hatred like that doesn't need any more fuel, it's got history behind it. Some people in Europe still think that the Turks are at the gates of Vienna, and some Serbs still think it's the fourteenth century and they've just been wiped out as a nation on the Field of Blackbirds."

"Well, the Croatian concentration camps are a lot more recent than all of that," Juno noted. "And the Serbian ones happened with the media watching."

" 'Never again,' " I muttered, but my thoughts turned back to Dave in the hot tub at the club and his insisting that al-Qaeda was responsible for Vlado's death. That not only fit with his monomania, it was a clever way to deflect blame if he were the killer. And he was so loud, too, who would think anyone calling that much attention to himself could be a cold-blooded killer? I was restless enough to forgo the coffee and rush off to start investigating again–somewhere, anywhere–but Stefan picked up on my mood and stopped me before I could even leave my chair.

"Nick. First things first," Stefan said. He nodded at me and I knew what he was suggesting. I got up, more slowly than Juno had, to bring over plates, forks, and what was left of an amazing chocolate bread pudding we'd made a few days ago that was still moist.

"There's also white chocolate Amaretto sauce that goes with the bread pudding," I said. "We have a little left."

"Oh, yes," Juno sighed happily, reaching for a fork and licking her full, glistening lips. "Yes, yes, yes…"

Stefan laughed over by the Chemex pot.

As for me, I blushed, but they were both too busy to notice.

14

BRIMMING OVER with sugar and caffeine an hour later, I thought of that figure in a comic novel by Stephen Butler Leacock who "rode off in all directions." Once I got to my car, my sense of purpose and my sense of direction both faltered and I could have driven anywhere.

With Juno gone, and Stefan taking a nap, I sat in the Lexus in our driveway, motor running, musing over the last few days, trying to pick through what people had said to me and find a flaw, a point of entrance. Hell, who was I kidding? I knew right then that I wanted a lever that would move the Earth, as Archimedes had said, sort of.

What had we left out? What had we ignored?

Thinking about Archimedes, I remembered some documentary I'd seen as an adolescent where he ran out of his bathtub shouting, "Eureka!" because he'd figured out the principles of buoyancy and density. It probably stuck with me because the idea of running naked through the streets was so mortifying. But I remembered some of the content–his discovery was connected to trying to figure out if his king's new crown was made of gold or gold mixed with silver. Meaning the king might have been stiffed by the goldsmith. And hadn't Archimedes also designed an advanced model of the clepsydra, the water clock?

Clocks. I saw myself standing in Vlado's office looking at that beautiful diamond wristwatch. Now that I knew he'd made $75,000 a year, it was just possible he had bought it himself, though at a guess the watch would have easily cost $100,000

or more. I couldn't see Barbara Zamaria wearing anything that elaborate. Was it for one of Vlado's women? But if the watch had been intended as a gift, why was it stuffed in an ordinary little padded envelope? It should have been in a fancy box if it was a present, unless it was a fake and he'd bought it from some crook or maybe even on-line after an e-mail solicitation. I got one or two almost every day, advertising replicas of fine men's watches–maybe there was a female version of those e-mails.

The watch decided my next move. Though Michiganapolis and the malls around it were crammed with as many chain jewelry shops as there were mattress stores, I didn't think I'd find out much there. I had never shopped at any of them, but I had once bought Stefan an emerald ring–it was his birth stone–for his fortieth birthday at Michiganapolis's best jewelry store, Romanov's. The current owner was the great-grandson of the founder, who had built the first store when the university was just swamp, log cabins, and mules. Now it perched near the vast, swollen campus, flanked by a struggling Gap Store and a struggling Tower Records. Rumor had it that both stores were under-performing and would close soon. Most of the businesses downtown had trouble competing with the mall stores, even though students could just walk over from campus or off-campus housing. It was very strange, but Romanov's had survived, as had some other stores surrounded by T-shirt shops, coffee shops, and used book stores.

The streets were slushy and the driving was slow with the approach of Christmas and shopping hysteria in the air, but the student population had thinned out, so that balanced things a little. I parked behind the jewelry store and entered through the back to the sound of a quiet electronic *ding*. The whole narrow rectangular store was powder blue: walls, carpet, and velvet in the discreet display cases. There was a massive antique two-door safe behind the main counter that seemed to promise quiet joy to serious customers only.

And standing in front of it was Eric Romanov, who beamed

and welcomed me as casually as if it hadn't been three or four years since I'd last dropped by to browse. He was six feet four with a face all angles, and masses of unruly dark hair that made him, even at thirty-five, look like a student at Oxford in some film set during the 1930s. Played by Rupert Everett, perhaps. The heavy gold rings he wore in each ear were a bit off the look, but they did match the soul patch on his dimpled chin and the black-and-blue chain tattooed around his neck that you could always see because he wore his silk shirts open at the collar. I'd never seen him in a tie. Typically wearing blue shirts and well-draped black slacks, Eric combined courtliness and funkiness, which I imagined made him appeal to older customers and younger ones, too. Sometimes when I worked out at the club on weekends, I'd see him there playing pick-up games of basketball. I didn't know much about the game, but he struck me as fast and determined on the court, with a mean hook shot.

"Nick, how can I help you today?"

If he was disappointed when I mentioned I was doing "research" about a watch, he didn't show it. I described the Chopard watch in Vlado's office as best I could and he nodded quickly at each bit of information I gave him.

"We don't sell anything that high-end," he said with no trace of apology. "I actually repaired one of them not too long ago. Lovely piece. The clasp was broken."

I didn't know if he felt honor-bound to keep his clients' business confidential, no matter how trivial it was. Like someone in Malcolm Gladwell's *Blink*, I had a lightning-fast insight and said, "Celia mentioned it, which made me think of coming in." It was a statement masking a question, and was comprised of two lies. Surely I had used up my quotient.

He nodded. "Lovely woman." Then he almost frowned. "And you're, what, interested in a lady's watch like hers?" He sounded ever so slightly dubious, but open to helping me. He probably dealt with vague male shoppers all the time, looking for "something special."

"Yes, it's for my cousin. She's recovering from brain surgery. She's on St. Thomas now," I babbled.

"Ah." He studied me a moment. "We have some lovely pieces you might want to look at if you don't feel like going to Chicago or New York to find that particular watch."

I apologized for wasting his time and beat an embarrassed retreat back to my SUV.

Vlado had either stolen the watch from Celia, or she had given it to him. Finding out which one seemed important. Before splitting up earlier, Stefan and I had exchanged cell phone numbers with Juno and I called her now to find out if she was at Celia's or en route. She said she was still at home because she'd had to circle back and walk her dog. When I explained about the watch, she asked if I wanted to meet her at Celia's, "assuming she'll talk to us. Though she does like to talk, doesn't she?"

"Yes," I said, and then quoted Dame Edna taking down a garrulous actress on her mock-talk show, "She's a chatty little thing."

I was off to Celia's subdivision, speculating on what Vlado had intended to do with the watch. Sell it? Hock it? And use the money for his personal training studio, perhaps, or was he up to something else? I thought about that Croatian flag again. What if he was involved with some kind of Croatian fascist group and was supporting it? What if the studio was a front and he never actually intended to start one? Fabian Albahari hadn't heard about it, or so he said.

I wasn't so lost in complications that the wintry beauty of our college town escaped me. There was always a lovely sense of discovery for me when the leaves fell and the true structures of trees revealed themselves, standing out even more starkly against the evergreens. Now, with snow etching most tree limbs, Michiganapolis looked like a postcard, at least this part of town, anyway.

As I drove, Christmas jingles started running through my

head, and why not? I'd grown up with them in New York and you couldn't escape them at this time of year, with wreaths and reindeer and all the rest of the trumpery creeping up around you like quick-growing jungle vines that smothered and choked. But I didn't remember them as omnipresent when I was growing up, or feeling so put-upon. With all the commotion of life in New York, maybe it had been easier to screen them out. Whatever the case, they had certainly infiltrated my inner iPod and lodged there for good.

To drown out that noise, I put Spoon's *Kill the Moonlight* on and skipped ahead to my favorite song, "Stay Don't Go." I loved the quiet chorus–"It's the wrong words that make you prick up your ears, when later alone"–and sang along on the way to Celia's mansion.

Going there by myself, without Juno as a go-between, leveler, or something, I felt a bit uncomfortable. Though my parents had rich friends in New York publishing and I'd visited their homes on Park Avenue, Sutton Place, Beekman Place, none of that felt as lavish as Celia's house or as intimidating, even though I'd been to parties in New York where I stared down a Matisse or two. Maybe because New York itself seems rich–in life, noise, textures, crowds, highs and lows–everything so extreme as it blended into a vision half-F. Scott Fitzgerald, half-Olivia Goldsmith. But here, in quieter, tamer, duller Michiganapolis, there was something almost shocking about Celia's wealth. Her attitude was also new to me. My parents' well-off friends had always seemed casual about their status, but ever-so-subtly grateful and pleased (some of them were immigrants or children of immigrants). Celia, on the other hand, radiated more than just extreme boredom. I couldn't figure out what was underneath her languor, but it felt insidious, maybe even corrupt. Though not as strange, she reminded me of Carmen Sternwood in *The Big Sleep*.

I knocked on the same side door as last time and she opened it with a surprisingly genuine smile of welcome, and waved me

in. "Juno's on the way, she just called." She might have been announcing a late arrival at a party.

I expected another session by the fireplace but after I'd kicked some snow from my shoes on the mat inside the door, and she hung away my coat, Celia led me out of the mammoth kitchen and down a short hallway. "The library's cozy this time of year," she threw off.

That depended on your standards, I guess. The room wasn't double-height, but the ceiling was easily twelve feet high, and formality gripped the library like a drowning man clutching wildly at his rescuer and taking them both down. Two high-backed, stiff-looking oxblood leather sofas, at right angles to the door, confronted each other across a dark Persian rug with a fervid pattern that was like some kind of hall of mirrors. The pattern was so bewilderingly complex you needed a guide book to figure it out. Between the sofas loomed what looked like a small sarcophagus–a six-sided solid coffee table lavishly inlaid with rosewood and mother-of-pearl.

The walls were painted a glossy deep burgundy, and behind each sofa were ceiling-high built-in library shelves with row upon row of heavily tooled sets: I made out Dickens, Balzac, Trollope, but I couldn't imagine they'd been chosen for anything more than the jewel-like richness of their bindings. The whole dimly lit room would have been a great retreat for Dracula after a busy night out feasting on blood, and I could easily imagine a bookcase sliding open to reveal a hidden staircase–and worse.

"Sit, sit, sit," she said. "Can I get you a drink?"

I begged off, and wondered where to begin. Celia saved me the trouble.

"Are you making progress? In your investigation? I assume you're back to grill me about inconsistencies in my testimony." She smiled broadly as we sat opposite each other. She was wearing black heels, a wide-necked taupe, cashmere sweater with a metallic lace overlay that I knew was Marc Jacobs

because my cousin Sharon had one, and matching cuffed slacks cropped above the ankles. On Sharon, the outfit looked stylish; on Celia, it was armor. Like the woman in *The House of Mirth* wearing a new gown, Celia seemed to be establishing herself in relation to her clothes. "She's not in command," I could hear Sharon concluding, and that imaginary comment relaxed me.

I eased back in the couch, well, as much as it allowed me to, and said, "It wasn't testimony. We were just chatting."

"Chatting about a murder."

"And other things."

"Now we're fencing," she said, without a smile. "Or you are. Are you killing time until Juno gets here?" She didn't let me answer because she marched ahead. "Juno tells me you're gay. What's that like?"

I told her I had no idea what she meant.

"Are you sure you don't want a drink?" She rose and walked to the window where a huge urn-like console table topped with black-veined red marble held some decanters and barware. She poured herself a very stiff drink and rejoined me. I tried to imagine what this room could be used for, it was so formal and rebarbative. It didn't invite anything but flight. But then there was probably a family room somewhere in this complex, and a media room, and most likely a game room.

Though I bet Celia played games in every room.

"Why do you ask?" I said, trying to gain momentum. "About my being gay."

She shrugged gracefully, and sipped her scotch, which was so peaty I could smell it from where I sat. "It's such a different lifestyle."

"It's an identity."

"But it comes with a lifestyle. And hate."

"Self-hate?" I was set to lecture her about internalized homophobia but she meant something quite different.

"No. You're constantly exposed to what people might say or

do. It's unsafe." Celia was glancing off thoughtfully (for her) and in a wild moment I thought that she was on the verge of coming out to me, and then suddenly I felt as if my whole body had shifted to another plane. I was both tingling and incredibly still.

"Your husband was getting it on with Vlado."

She met my eyes as if trying to look through me or make me disappear.

It fell into place as I spoke. "That's why you were so specific about having sex with Vlado. It was a cover. You knew your husband would be the main suspect if it got out. The police would assume he was jealous of Vlado's affairs with everybody else, or that Vlado was blackmailing him, or both. The gay angle would mean more to them than anything else."

"It won't get out," she assured me.

So that's why Alfred was so angry and shocked in the steam room, I thought. I pictured his furious glaring at whatever I had said, and heard the pain in his voice. I'd missed it because I was stunned, but now that the shock had started to fade, the scene played over and over in my mind with plasma-screen clarity. He hadn't just been freaked out because Vlado was his trainer; there was a personal element to it, there was anguish in his voice that I had either overlooked or interpreted as a doctor's inevitable reaction. His actions had been calm and controlled, but his voice and face gave him away—at least in hindsight.

"Does Detective Fahtouzi know?"

"Don't bother telling him, because I'll deny it."

"But you *were* having a relationship with Fabian Albahari? That one was real."

She nodded, then looked startled, apparently wondering how I knew. If it bothered her, she didn't say anything.

"And you pretended not to know his name, and you even pointed at him to me and Juno as a suspect."

She nodded, not remotely contrite.

"Because you think your husband might be responsible for Vlado's death. Like, maybe he didn't do everything possible to save him...."

Again, Celia nodded as calmly as if we were discussing her favorite radio station. "I would never hurt Alfred."

"But he's gay, I mean, why are you still married to him?" She sat up straighter, as if I'd insulted her. "Alfred loves his work and his marriage. I told you, I would never hurt him." She took a slug of her scotch and added, "And I'd never give up my home." She could have been a peacock then, slowly unfolding the splendor of his tail. I remembered visiting Castle Howard in Yorkshire with Stefan years ago and we'd seen glorious peacocks on the grounds of the palatial house used in *Brideshead Revisited*. For some reason, few tourists were there; when we stumbled across the peacocks they struck me as a little pathetic, like Gray's flower wasting "its sweetness on the desert air."

Hadn't Juno told me this? That she knew women in extremely comfortable circumstances who tolerated their husband's behavior because they had beautiful homes. But was that a life?

Celia rose and got herself another drink, and this time I accepted her offer, but asked for just a finger of scotch. When I sniffed it, I asked, "Lagavulin?" and she nodded with appreciation for my nose.

"How did you find out about your husband's affair?"

She rolled her eyes, tensed her shoulders, then relaxed them. "He always seemed, I don't know, a little high after training with Vlado, and I wondered if it was more than endorphins. Then Vlado started coming here a lot to swim or play tennis, and one afternoon I saw the two of them heading to the pool together. I knew right then. Something about how they were walking."

Yes, posture and stance could give away great secrets, or maybe it was better to think in terms of confirming unconscious awareness, or even ringing a bell of warning. In *The*

Portrait of a Lady, Isabel begins to unravel the anomalies in her husband's connection to Madame Merle because she comes across them at home and Merle is standing while Isabel's husband is sitting–a clear violation of nineteenth-century etiquette. She didn't need a private investigation, just her own insight.

Sitting there with Celia, I sensed she was holding something back. Just like before, she was apparently being honest and forthcoming, but there was more to her story. Yet I felt sorry for her despite her lying to me, maybe because of it, and asked if she was seeing a therapist or if they'd done couples counseling. I guess I was trying to encourage her to do so if she hadn't, but that's my innate prejudice as a native New Yorker, where people go therapy-shopping the way Midwesterners visit the mall.

Celia grimaced and crossed her legs tightly. "I suppose I could have read a Dr. Phil book, but what's the point? I don't want things to change from how they are."

Or were, I thought.

"Why did your husband accuse me of harassment when I was at the restaurant?"

"Oh, that. Well, I told him about your visit, yours and Juno's visit. And he got the wrong idea." I didn't buy that at all, not even when she added with quiet satisfaction: "He's very protective."

I sipped the smoky scotch and tried to sort out what she was saying. I felt lost in Dante's dark wood where the way was not straight, literally. I wasn't like some queers who believed everyone was gay until proven otherwise, so I was having some trouble absorbing the notion of Alfred Aftergood and Vlado getting it on. And besides, Celia had admitted lying to me and Juno, so who was to say she was being honest now, or what else she might be hiding.

"But what about Vlado's women?" I burst out, not mentioning the photos Juno and I had seen in his office.

"I don't think Alfred expected Vlado to give them up. Why should he?"

"You're defending Vlado."

She sighed. "He made Alfred happy, for a while."

God, I thought, that was almost like the last line of *Long Day's Journey into Night.* Was she playing me again, was she acting? How could anyone tell if her whole life was a kind of performance?

"You know, Nick, it's not something we talked about." She said it as sternly as if she were Martha Stewart and I were suggesting some disreputable table setting.

"Did you know Alfred was gay or bi when you married him?"

"I knew he was a doctor, and I knew he'd be a good husband. That was enough."

"Okay. But why do you think your husband might be responsible for–for Vlado's death?"

She hesitated, either gathering strength to confess something, or marshaling the ranks in an army of lies. "Vlado made a pass at me once, here at the house. Then he told Alfred about it. Vlado thought it was funny. He liked sex, but he liked control most of all, having people want him. I could tell, and I wasn't going to get caught."

Not to mention that Vlado was already doing her husband. Celia and Alfred were a whole season's worth of plot twists on a daytime soap opera. It made my head spin, or was I dizzy for another reason? Just briefly, I glanced down at my drink. Celia caught it and laughed.

"Oh come on, you don't think I'd poison you, and do what? Drain the hot tub and hide you in there until the winter was over, perhaps. And what would I do about your car, I wonder?" She grinned.

What was taking Juno so long? I needed backup. No, I needed clarity, because Celia's story was far too complicated and confusing.

Just then Celia uncrossed her legs and adjusted a sleeve. That's when I saw her wristwatch. It looked like the same gorgeous treasure I'd seen in Vlado's desk. I stared. I couldn't help staring.

"Alfred gave me this," she said. "For our twenty-fifth. That's another reason I thought something might be going on with Vlado: Alfred is generous, but this present was unusual." She sounded calm and unemotional as she adjusted the watch on her slender wrist, admiring it, hell, probably admiring her whole life since that's what it represented.

Was it the actual watch I'd seen with the photos or just a similar one? That meant she'd snuck into Vlado's office–or Alfred had–and gotten it back. They were both members, so it was possible. Juno and I had done it. After all, it was a health club, not a secure government installation.

"It's a beautiful watch."

She nodded.

"Vlado had one, too."

Her eyes flickered, then she went on fiddling with the watch, enjoying how it sparkled like a tiny chandelier. "Yes." She sighed. "Vlado told me how much he liked the watch. I got him one."

"But it's a lady's watch, isn't it?"

"So?"

"That meant he wanted it for a lover."

"Or his wife," she shot back, eyes tight.

"Bull. He stole it from you, didn't he, and–" It came to me, slowly but surely. "And you bought another one. Why?"

As if she hadn't just lied to me, Celia smoothly reversed course. "I didn't want to upset Alfred, and I figured Vlado probably wanted to hock it or use it to help finance his training studio. Fine." She shrugged.

"So that's what you meant by helping him out, financially." I wondered what other hot rocks Vlado had boosted from his var-

ious paramours or their homes. Were they all as obliging and forgiving as Celia, or had Vlado stepped over somebody's line and been murdered for it?

Celia was about to say something when the doorbell chimed so mellifluously that we might have been in a Zen garden. I think we were both relieved at the interruption. I know I felt a bit wrung out by acting as her confessor or therapist. She set her drink down and I followed her out to the kitchen door where she let Juno in. Looking as intense as Delacroix's bare-breasted *Liberty Leading the People*, but wearing much more clothing, Juno planted herself in front of us and announced:

"Vlado was poisoned!"

15

BUT JUNO INSISTED on a drink before she would say anything more and Celia, a paragon of languid intensity, supplied her with a scotch. Celia was obviously as rapt as I was, but she hid it beautifully, which made me that much more suspicious of her and of everything she'd ever told me.

Breathless with self-importance, Juno managed to drink some scotch, ask us to wait, and divest herself of some of her fashionable winter layers–all this while perched on a stool at one of Celia's kitchen islands.

"Actually," Juno continued, "he was drugged, according to the medical report. But that's almost as good," she insisted.

"What kind of drugs?"

Now her fog lights dimmed a bit and she said, "He was on Valium."

Celia laughed harshly. "Everyone's on Valium. My dog's on Valium!"

"I didn't know you had a dog," I said.

Celia gave me a twitch of a smile. "Exactly."

Juno, for her, looked somewhat abashed. "Vlado had more Valium in him than a normal dose. Being drugged *is* like being poisoned, sort of. I'll bet he blacked out before he was killed...."

Something in that rang a bell for me, but I was damned if I could figure out what. I just was not thinking clearly enough; it was either the scotch, or the surprise of Juno's entrance.

Celia eyed her a bit scornfully.

Me, I just shook my head at Juno. "We're not getting any-where," I said, frustrated.

"What made you think you would?" Celia asked, as disdain-ful as Napoleon meeting the ruler of some tiny German state.

"Well, I think you should tell Juno everything you told me," I advised Celia, and that knocked her momentarily off her perch.

"Again?"

"Tell me what?" Juno asked, avidity lighting her up like the Eiffel Tower at night.

"You'll see." I said then that I was heading back to the gym to talk to one of the trainers. That was part of it, perhaps, but I felt that if I could only sit down somewhere and quietly sift and sort what people had been telling me, and what I'd seen, I would come up with the solution to Vlado's murder.

I grabbed my coat and said my good-byes and was glad to leave that palace of privilege behind me. Outside, just as I was about to get into my car, a red Intrigue pulled up and Detective Fahtouzi got out, looking very pissed but stylish as usual, wear-ing now a chic black wool car coat with a double collar.

"What are you doing here?" he asked.

"Getting in my car." Even said neutrally, it sounded rude, but out here in the shadow of Celia's home, I didn't feel like apologizing or backing off. I opened the door and before I could get in, Fahtouzi stepped closer and growled, "It's a crime to interfere with an investigation."

"I was just visiting a friend."

He nodded dourly, but if he had any real evidence or was planning to arrest me, he wouldn't have let me drive off, or would he?

I headed for the closest branch of Noir on "The Mile," every-one's nickname for the stretch of evergreen-lined Michigan Avenue bordering the northern edge of campus. It was a typi-cal college town blend of pizzerias, T-shirt stores, used book stores, and national chains like Tower and The Gap. There

were occasional visual and commercial respites, but for the most part you could have been almost anywhere in the country where students flocked to bargains. The movie theaters had been torn down before Stefan and I got to Michiganapolis, as had most of the other colorful shops that had given the street a touch of individuality.

I parked down the street and when I got to Noir, I ordered a double espresso and sat by the window, hoping the cars and pedestrian traffic on the other side of the glass would help me focus inward, that they would act like the visual equivalent of white noise.

I sat in the comfortable chair trying to mentally arrange the facts, or what passed for the facts, as if I were working on my bibliography. Mick Jagger was singing "Paint it Black" on the sound system but I ignored his advice.

Okay. Vlado had inspired passions of all kinds, that was clear. He'd infuriated Fabian Albahari by harassing him and then firing him from a good job. And there was always the possibility of ethnic hatred flaring up between them. Fabian was strong enough and angry enough to have done it, but if he'd been fired from Michigan Muscle, wouldn't they have barred him from coming in? He would surely be on some kind of watch list.

Ruby Strockbine had insisted that Vlado wasn't sleeping with any of his clients, but that was clearly untrue. I'd seen the photographs in his office. But why did Vlado take them? For blackmail? For fun? A little of both?

Vlado's wife said the other trainers were jealous of him because of his ambitiousness, but Vlado's plans for a personal training studio might just have been a ruse to get money. If that was the case, get money for what? I wondered then what it might be like to train these wealthy clients. He could have been just wanting to get some quiet revenge after endless hours listening to their talk about problems with their new Jaguars, or the drop in real estate values, or petty hassles on an exotic

vacation. It was even more of a reversal of power than his show-ing them how to live healthier lives.

The whole notion of his being killed because he might reflect badly on a club owned by ultra-conservative Christians struck me now as more than far-fetched, so I let it go. Someone like Vlado couldn't matter enough to people like that.

Then it was always possible that Vlado might have been somehow involved in raising money for a right-wing Croatian group back home, but that was so much more far-fetched than thinking of him as a simple con artist and a Lothario. And a polymorphous one at that, since according to Celia, Alfred Aftergood was having some kind of affair with Vlado. Alfred had plenty of motive for being angry if Vlado really had made a pass at Celia, if he really had stolen the watch, and if Alfred was jealous of Vlado's many other lovers.

But the business with the Valium was confusing. I needed to find out if Vlado had been dealing with stress or something that required a prescription for the Valium, but wasn't sure how to find out. I could ask one of the trainers if he knew, like Fred Gundersen, but the logical choice was Barbara Zamaria. She really was the one to talk to. But how much did she really know about Vlado? Juno insisted women always knew when their husbands cheated on them, but could we even call what Vlado did cheating?

It was more like poaching or something like that. Or per-haps call it a reverse *droit de seigneur*. I had a sense from what people had reported about Vlado that he had felt his youth and good looks gave him the right to bed whomever he wanted. It was a more muscular version of Tom and Daisy Buchanan in *The Great Gatsby* restlessly destroying people's lives and then retreating. In his case it would be retreating into a different kind of wealth: his perfect body and blazing sexuality.

I sat there, eyes shut, trying to picture someone stalking Vlado, watching him go into the locker room, lurking, then fol-lowing him into the steam room and striking. It would have

been easier if he were tired after a workout and since he was apparently taking Valium. But I still couldn't see the blunt instrument.

I opened my eyes and Stefan walked by outside. I rapped on the glass but he was too intent to hear me. I downed the last of my coffee and grabbed my coat, but he was walking so quickly that by the time I got outside he was already turning the corner at Grand, a street of restaurants close to campus and frat houses further away. I was about to call his name when I saw him hurry across the street to St. Mark's Church and go inside.

That stopped me dead. Stupefied, I studied the mock-Gothic façade of what I knew was a student-oriented Catholic church as if it could reveal Stefan's purpose for going inside. To the right of the arched double doors was a large glass case bolted to the dark brown bricks with information inside about times for Confession and Eucharistic Adoration. I had no idea what the latter thing was, but there was a lot of it. Was it the same as Mass? I'd been to wedding and funeral Masses years ago, before meeting Stefan, because some of my friends were Irish Catholics, but couldn't remember what the term signified.

Wondering what it meant was a neutral diversion because when I stopped I felt as if I'd been dropped from a plane and was about to hit the ground and break every bone in my body. As puzzled and shocked as I was to have seen Stefan go inside, I knew for sure that this church probably explained why he'd been out of touch recently. I imagined that if I bothered to think back to the times his phone had recently been off, they might match the times inside the glass case.

Someone muttered, "Freak," as he quickly walked around me, and I realized then that I was blocking foot traffic on the narrow sidewalk, or at least calling attention to myself and thereby annoying strangers. I stepped into the empty doorway of a smoke shop, and watched the entrance of the church, which took up half a block. Stefan and I had visited many churches in Europe: the eerie Durham Cathedral, which was

used as a setting for the Cate Blanchett movie *Elizabeth*, and of course Notre Dame. But they had always seemed distant, relics of another time and consciousness. I knew that Stefan had been brought up believing he was Catholic, but his crazed parents, hiding their Jewishness and Holocaust past, had not been able to go all the way with their imposture. So he hadn't really gone to church or been affiliated–at least that's what I had always understood. Maybe I didn't know the whole story, and though Stefan had used his own history in his fiction, he had never written a memoir. Not that memoirs equaled truth anyway.

Seeing him stride into a church with such confidence in his steps alarmed me. Where was he going, really? When he discovered as a teenager that he was Jewish by birth, I thought he had abandoned his parents' attempt to cloak him in a safe identity, but what if all those times we'd toured churches and cathedrals together, me noting architectural details or paintings, he was longing to get on his knees and pray. Did he even know the prayers?

The image of him with his hands clasped, kneeling, shocked me out of my stupor and I fled back to my car and drove home.

People who own dogs will tell you that when their dogs are boarded or at the vet, their homes feel oddly quiet. I didn't have a dog, but still that's exactly how I felt, as if some warm, constant, comforting presence were stripped from the house, and I wandered from room to room, completely oblivious to the murder investigation that had been obsessing me for days.

I put *Carmina Burana* on the stereo and cranked up the volume, filling the house with the brazen music. I knew some of the lyrics from a music appreciation class back in college, and as the opening washed over me I thought about Fortune, hymned at the beginning of the piece, cruel and changeable.

Stefan arrived almost an hour later, as *Carmina Burana* neared its climax and the chorus was thundering once again

about the monstrous wheel of Fortune turning and threatening health and happiness. I could tell from his expression he thought the volume was too high, but he knew as I did that it was almost over so he waited. I rarely played music so loud, and the wariness in his eyes showed he knew something had happened.

As Stefan hung back in the doorway to the living room, I thought of lines from *The Ambassadors* when someone asks the hero what he's going back to, in America, after his traumatic discoveries and after everything in his life has changed. He says simply: "To a great difference."

Here we both were, facing a great difference.

When the music stopped, I said, "I saw you going into St. Mark's before. I was in Noir around the corner from the church, and you walked by really fast. I guess you parked at the city lot?"

"I was late," he said, not missing a beat, coming to sit down opposite me in the striking silence. I found myself feeling glad that he wasn't sitting closer. My having seen him at St. Mark's didn't seem to trouble him especially, the lines of his face seemed to relax a little. I wondered darkly what music would be best to accompany the conversation we were having. Nine Inch Nails? Ozzie Osbourne?

"I've been seeing a priest there. For counseling."

I nodded somewhat automatically, as if waiting to understand what he'd said.

Stefan was looking at me, but not directly. "I've been feeling empty."

"Why a priest?" I asked. "You're Jewish."

"Am I?" His eyes darkened.

"Of course you are—your mother is."

He waved that away. "So what? That only means something if you want it to. Hell, lots of Jews wouldn't think I'm Jewish because I'm not circumcised."

That was for sure. Because so many Jews in the Holocaust

were found or betrayed because they were different, his parents had probably without even verbalizing their fear refused to have him circumcised as a baby, the way most American children were. By not letting his flesh be marked, they had ironically branded him as different no matter who he was. He didn't fit in with non-Jews and certainly didn't fit in with Jews—not that it had ever bothered me.

"But your parents are Holocaust survivors, what's more Jewish than that?"

"Nick, if that's my Jewishness, I don't want it, it's not enough."

"Whoa! You write about it. It's been the center of your career."

"And what has that gotten me? It's a dead end."

I didn't tackle that one because I knew trying to convince him that his career hadn't hit an iceberg was a waste of time. He'd long since jumped into a lifeboat and started rowing. "So what's this priest going to do for you?"

He hesitated. "I'm seeing him to figure out if I'm going to take instruction and be baptized. I want to understand if this is what I need to do."

"You want to *convert?*"

He didn't respond to the sharpness of my tone, just to the words. "Is it converting? How am I really Jewish? There was mostly a blank until I was a teenager and my parents never were Jewish in public again until they got older. That's fine for them, but it doesn't mean I have to do what they did. We don't belong to a synagogue. We keep *shabbat*, sort of—"

"More than sort of!"

"Okay, but as far as living a Jewish life, I don't. Not much, not most of the time. I want to belong somewhere, I want to have a home, to feel *connected.*"

"Catholic," I said. "You want to be a Catholic." I knew lots of writers converted to Catholicism in later life—but they were Christians already.

"Maybe. I've gone to a few Masses and I think I like it."

"You 'like it'? Stefan, you're not talking about buying a new car. You think you can believe in Jesus and the virgin birth and the saints and limbo and hell and everything else?"

"I don't know what I can believe in."

"Listen, you can't be a Catholic without believing in *all* of that. It's not a buffet where you can pick and choose. They have *dogmas*."

"That's looking too far ahead."

"You have to look ahead, you can't just blunder into changing your whole fucking life overnight."

"It's not overnight," he said calmly.

Did that hurt. "You never mentioned it before." If he had said he was contemplating a sex change, I couldn't have been much more devastated.

"Because I didn't understand what was going on, and when I did, I thought you'd be upset."

"You were right," I snapped.

"I'm not asking you to change who you are," he said a bit plaintively. "It's my journey."

"Like Saul on the road to Damascus?"

"Cheap shot," he said.

I didn't deny it.

"So this is, what, your midlife crisis? Your career's in the toilet and you need to feel like your life hasn't stopped?"

"You make it sound phony."

"But it is phony, for you. Your family was Jewish and they only pretended to be Catholic, and not that well either. You weren't baptized, you didn't go to Catholic school—it wasn't real, it was a disguise, a smokescreen. How can you turn that into who you really are?"

"I don't know. Does it have to make sense?"

"It would help."

He smiled, and so did I and the momentary truce was very sweet. I broke it first. "What about me? I don't want to be Cath-

olic. Does that mean you'll go to heaven and I'll go to hell, is that what you think is gonna happen to us?"

He shook his head. "I haven't thought about it."

"Maybe it's time to start. And how can you be gay and join the Catholic Church, how can you *choose* it? You might as well join the Republican Party while you're at it. How can you want to join any group that rejects you? Look at all the things the Pope has said against gays."

"American Catholics aren't the same, not all of them. There are gay students who come to St. Mark's. And there's Dignity." The national organization for gay Catholics seemed a weak limb to hang a new identity on, given how marginalized gays and lesbians are in the Catholic Church from everything I'd ever read.

"What if they ask you to move out, to stop living a sinful life with me?"

"I would never let that happen. Never."

It was good to hear, but could I believe it? If he had come far enough to imagine being a Catholic, how much further might his "journey" take him and where would both of us end up?

"Listen, Stefan, how do you think you're going to be connected when they don't want you?" I asked.

"You can't stereotype all Catholics," Stefan said a bit sullenly and I could feel us on the verge of a real argument that would be filled with blazing half truths and accusations we'd both regret. It would be wise for one of us to leave and cool off.

"I'm going to the club to swim some laps," I said.

He frowned and looked hurt and I reassured him: "I need to get out of my head right now. Just to unhook."

"Okay."

"Why don't you order pizza for an hour from now? I'll be back by then." Though the club with all its various courts and rooms and studios got crowded late in the afternoon and after work hours, the pool didn't attract quite as many people then and I knew I could swim without feeling put-upon.

Stefan seemed relieved that I still wanted to eat with him, and he headed for the phone in the kitchen. Wisely, he did not try to say anything more or hug me before I left. This was not a time for demonstrations of a closeness neither of us felt though both may have wanted. I zipped upstairs for my swim trunks and swimmer's shampoo and got myself going as quickly as possible, fleeing the house as if it were the scene of some terrible contagion. The farther away I drove from our home, the less I could imagine returning, despite my having set up a dinner time and assuring Stefan that I wasn't running from him, just taking a time out.

Stefan had become as much a stranger to me as if he'd revealed an affair, a criminal past, or a secret drug addiction. I could not imagine the havoc that waited for us if he continued following the frightening path he was on, though even as I trembled inside, I knew it would be wrong to try and stop him. Wrong, unkind, dishonest. But maybe necessary.

Although I was driving to the club, I felt adrift and unmoored. Stefan being Stefan was the bedrock of my life. He would always be there, always be himself. We weren't married by law, but married by conviction, by how we lived. And I didn't think our life together could stand this eruption of uncertainty. Despairing, I recalled lines Katherine Anne Porter had translated from some French poet: "Which of us has had/His promised land, his day/Of Ecstasy, and his end in exile!"

16

THE MAIN PARKING LOT was crowded and I had to drive around to the back, which I usually never did, for some reason. Like lots of club members I'd circle the rows of parked cars at the front of Michigan Muscle for as much as ten minutes waiting for someone to pull out rather than go round to the back. But this day I couldn't wait; I needed a swim badly.

The back lot was quite a bit newer and had been added just a few years ago as the club expanded. Decorated with trees so spindly they seemed like failed art projects more than anything horticultural, it had an improvisational air to it, and felt somehow neglected. The back wall of this part of Michigan Muscle was blank beige concrete, completely uninviting.

I parked and followed a guy I didn't know up the winding path to the canopied rear entrance. He had gotten out of a green Jaguar and his spiffy green suit almost matched. His heavy gym bag bulged in all directions and his heels clicked on the concrete walk like a tango dancer's. I tried not to fall into the same rhythm.

At the door he stood squarely in front of a low-mounted camera, pressed the button beneath it, and someone from the front desk, I assumed, asked for his name and member ID. He gave them, the door buzzed, he opened it, and I hurried forward to save time. He didn't even glance back at me as he headed down a hallway I realized must lead to the locker room I usually went to. I'd often seen people coming from this same direction.

I doubted anyone up at reception had seen me because I had

stood back from this guy as you would at an ATM or a teller's cage at the bank when you were next in line.

And that's when it hit me that Fabian Albahari must have killed Vlado.

My anxiety about Stefan temporarily dropped away as quickly as a sheet pulled from a statue being dedicated, and I felt in the presence of real clarity.

Fabian. Of course. He had the best motive, he had clearly shown how combustible he was (as well as dishonest), and he could have gotten into the club after he was fired just as easily as I had, waiting for someone else to go first. After all, he'd been an employee, he would know exactly how things worked there and wouldn't have to stumble into it the way I just had. He'd know that getting in the front entrance would not have been possible for someone who'd been fired because there were just too many people around. The pro shop, the restaurant, and all the various administrative offices were clustered upstairs nearby. He'd have to show an ID and there were always several people at the desk, so sneaking through simply wasn't possible.

Something else occurred to me: who better than another trainer to know Vlado's schedule, to know where he'd be and when, and even to know (or notice) that he was taking Valium and was not as sharp as usual. Or if Vlado wasn't taking Valium, Fabian could have slipped some into one of those sick-colored protein drinks the trainers were always downing for more energy. No, wait, he would have to have gotten someone to do it for him, wouldn't he? He could sneak in, but he couldn't have gotten to Vlado's office without being seen. I let that go for the moment, absolutely convinced it was Fabian, and not so worried about the Valium since that wasn't what had killed him anyway.

It shouldn't have made me feel good, happy almost, to think I had identified the murderer, but it did and I bopped along into the locker room feeling confident and clear. Stefan's

confession had receded in importance as I thought I'd swim, go home, and call Detective Fahtouzi and share my discovery. I was sure I could present it to him as heavy on the ratiocination, light on the interference.

The locker room was jammed with many dozens of students, businessmen, everyone changing and heading out or to the showers in a hurry. The pool, however, was not crowded and I had one lane all to myself. I nodded to the lifeguard, who looked like a marine with his beefy shoulders and shaved head.

Just smelling the chlorine and hearing the splashes of other swimmers echo off the walls and ceiling made me feel good, feel free. I stretched at the pool's edge, sat down with my feet in the bracingly cool water, wetted my goggles and slipped them on, then slid down into the pool and left everything behind me. I swam for half an hour: butterfly, breast stroke, and back stroke, alternating strokes, occasionally using a pool buoy and flippers from a box near the pool, taking myself through workouts I remembered from high school. It was bliss to let go and work hard and just not *think*.

I left the pool exhausted but refreshed and headed to the showers, which were crowded and noisy as guys shouted to each other about business deals, game scores, classes, girlfriends, politics. My right shoulder was a bit sore so I took my towel, bathing suit, and shampoo and headed for the dry sauna next to the steam room. It was half the size of the steam room, though designed similarly, only the benches were wooden. Inside, to the left of the door was a reddish metal sauna heater filled with black rocks. It stood inside a wooden frame and a loose metal screen covered the whole thing.

I was glad no one was inside so I could relax for a few minutes without trying to screen out someone's chatter.

Maybe because I was alone, I found myself studying the little room, looking at the sauna heater, the benches, the door, and the heater again since it was directly opposite me.

As I sat there on the upper bench letting the dry heat penetrate my muscles, another crucial piece of the murder fell into place.

I called Stefan as soon as I returned to the parking lot, told him what I had figured out, and asked him to keep the pizza warm in the oven, that I'd be back home very soon. He didn't ask where I was headed, and that was fine by me.

Before saying anything to Detective Fahtouzi, I had a question that only Barbara Zamaria could answer. Was Vlado taking Valium?

It was dark when I drove up to her shabby little house a few minutes later, and the lights were off. I rang the bell anyway, and knocked persistently, but the door that opened wasn't hers, it was in the split-level house to the right. A white-haired woman in her late seventies leaned out and said, "She's not in."

I'd seen this woman before, the first time I had visited Barbara after Vlado's death. She'd been walking a dog. I crossed the small scrap of snow-dusted lawn.

"We've met before," I said.

"Not really," she said. "But I do know you." She was tall, willowy and freckled, and her grin was like a hug. She wore a heavy purple turtleneck over black wool slacks. "I know *about* you," she explained. "I've seen you in the newspaper. You're the 'professor of death.'" She chuckled. "And 'Poirot with a Ph.D.' Come on in and get warm, I imagine Barbara will be back soon since she'll have to let her dog out."

I kicked the traces of snow off on a jute doormat and walked into a very warm living room not much larger than Barbara's but infinitely more appealing. It looked very British, with lace curtains, chintz-covered chairs in front of a small fireplace, brass lamps with pleated shades, and porcelain Westies filling every shelf and table top that wasn't covered with silver-framed photos of babies, children, and family portraits. It was all plush and comfortable.

"I'm Maureen Jones, and a friend of Barbara's. How about some tea?"

She took my coat, waved me to a chair. On a hooked rug in front of the fire lay a shaggy-haired Westie who wagged his tail a bit at me, and then settled back down into his nap. His hair was so thick he had the air of a miniature sheep.

"That's Milo," Maureen called from the kitchen, and she was soon setting a tea table between us. "You'll have some madeleines," she said, and it wasn't a question. "I don't bake as well as Barbara, but I'm not bad." Her movements were very brisk for a woman her age, and she had the ranginess of a former athlete.

"Have I seen you at Michigan Muscle?" I asked.

"Probably. I swim now and then."

"I just came from swimming."

She smiled. "I know, I could smell the chlorine. Don't worry, it's not very strong at all, but when you bake, you develop a good nose. It's there, under the shampoo and the cologne."

Maureen poured out some tea and handed me a cup and saucer. It looked like antique china and two madeleines lay on the plate. I tried one and it was superb.

"The girls will be thrilled I've met you. I belong to a mystery book group and someone suggested we invite you to speak to us because you've been such a magnet for crime. I'm sorry, that sounds a bit–" She shrugged. "And also because you're going to teach that course at State about mysteries," she added. "A lot of us are retired faculty or wives of faculty. Well, widows, mostly. My late husband was in Philosophy, but I taught high school English. Would you consider speaking to us, nothing fancy, just about your life of crime and what you read and all that? We're very opinionated, but attentive."

"Sure." I fished out a card with my e-mail address and asked her to get in touch with me about scheduling.

"You wouldn't have to make anything up," she said. "We're not expecting you to be like those memoir writers who–"

"–shade the truth?"

"Cast it into the outer darkness is more like it. I'm sick of those memoirs–they remind me of what Bertrand Russell said about D.H. Lawrence's poetry collection, 'Look! We Have Come Through!' And Russell said, 'They may have come through, but I don't see why I should have to look.' I tell you, I think we'd be a better country if there was an embargo on memoirs about people's addictions and torment and abuse and mental illness and what-have-you. These people think they're entitled to attention because they've suffered. Everybody suffers, life *is* suffering, the Buddha said."

"Are you a Buddhist?"

"When I need to be." She sipped some tea and then glanced at her watch. "But I also believe what Lauren Bacall says, 'Nobody in life owes you a goddamned thing.' "

Suddenly her accent seemed sharper. "Brooklyn!" I pounced.

She nodded.

"It's just there, under the Michigan," I said.

"Clever man."

"So how long have you known Barbara?" I put my teacup down and munched on the second madeleine.

"Since they moved in three years ago. I'm very fond of her. The houses here are very close together and both our kitchens are at the back, so we can see each other cooking and when the weather's nice, we just open the windows and chat." She nodded, sipped her tea. "I love watching her in the kitchen, she's so graceful. And very sweet. Ever since last Christmas, she always uses the silicone oven mitts I gave her. She swore by them, even though she has little hands. Do you like dogs?" she asked suddenly.

"Yes, but I don't have one. What kind of dog does Barbara have?" I asked, remembering that I'd heard whining at Barbara's house, and that there was something odd about how she mentioned her dog. Just as there was something odd about

Maureen switching subjects, unless that was just age, or her own individual restlessness.

Maureen hesitated. "It was Vlado's dog more than hers. Radovan. A very big name for a small dog, I think. Also a Westie. He and Milo sometimes play together."

I looked at Milo, who didn't seem as if he'd even be up for a game of video poker.

"Wait. Radovan? That was the name of–"

"Yes, the war criminal. Radovan Karovic. It was a joke, I suppose, not a very good one. Of course, he was Serbian and Vlado was Croatian, but my husband was half-Jewish and he'd never have named a dog Himmler."

Unless it wasn't a joke and it showed Vlado as an extremist or nationalist: there was real, barbed intent behind it. But would he be that obvious?

"You're wondering about that flag, aren't you?" she asked. "The big Croatian flag in their living room?"

I nodded.

"It bothered me about the dog, too, but someone involved in shady politics would be more careful, even Vlado, I'd think. I did run into him a lot at the post office mailing packages to Croatia, but I doubt it was anything suspicious." She eyed me carefully. "But I admit I did wonder when he was killed if it had something to do with terrorism or politics over there in some way. When you read so many mysteries, you often assume the worst of people, and over time you learn you're often right."

I asked her who she liked reading and she mentioned Barbara Cleverly, P.D. James, Sue Grafton, and Martha Grimes. "Though even before I got older I sometimes had trouble figuring out what was going on in Grimes and I'd ask my husband to explain the endings."

"You could sit in on my class if you'd like," I offered, telling her who was on the reading list.

"Oh, you don't want some old crone making the children nervous, or expecting me to tie their shoelaces. Figuratively."

"Think about it," I said. "I'd love to have you there."

"Pity about Vlado," she said out of the blue, and her violet eyes narrowed as if she were testing me in some way.

"Did you know him as well as Barbara?"

"No. He wasn't my kind of person. Too hard, too boastful. He was always making fun of me for taking arthritis medicine, or anything like that. He said he kept his body pure, wouldn't even take aspirin, and that you could overcome pain if you had will power. My dear, when you get to be eighty-five, you have a right to as much pain medication as you can get your hands on, is what I think."

"You look much younger than that."

She smiled.

"What kind of marriage did Vlado and Barbara have?"

Her face tightened as if I'd offended her, or something had. "Barbara is better off with him dead, let's put it that way."

"Meaning?"

"He was abusive, you'd call it now. In my day, we were more direct. He was a wife beater. Barbara didn't talk about it, she didn't have to. I'd hear it when the weather was warm and windows were open, and once I saw him hit her in the kitchen. She wouldn't talk about it, so I gave her some books to get her thinking about where she was and how she could break free."

"Like *The Color Purple*?" I asked.

"That was one, how did you know?"

"I saw it in a bookcase next door that was filled mostly with thrillers. It stood out."

She squinted as if reassessing me. "You have a good eye."

Something about her tone put me off. Maybe not good enough, I thought, as if I'd been in a trance and suddenly been snapped out of it by the hypnotist. In a rush, I thought of the Stones' song "Paint it Black" I'd been listening to a little while ago, and the sauna and steam room and the new dress code for the staff and everything else that made me question how I could have been so blind.

Maureen glanced at her watch and frowned. "She's almost always back by now. It's past her pup's dinner time." She breathed in and made a decision. "I'm going to let Rado out and then feed him. I have her key. Why don't you come with me—he's an adorable puppy. I call them all puppies, even though they're older. Westies are just that size."

I told her about Juno's Westie and we donned our coats and walked out across the front yard to Barbara's door. Maureen opened it with some difficulty, but wouldn't let me try when I offered. She turned on the lights and we heard whining and barking from another room. She hurried off and I could hear something unlock and a Westie came tearing out into the living room, raced around the coffee table, then me, and started to do figure eights before Maureen shepherded him out into the fenced yard through the kitchen, and I heard him barking quite happily out there.

Maureen called me into the kitchen, and offered me a seat while she took out kibble from a counter canister, measured some into a bowl, and added some powders from various containers, then brought out yogurt and what looked like shredded chicken from the fridge. Radovan was back inside by now, sitting at her feet, gazing worshipfully up at the counter. She set the bowl down and he surprised me by not gobbling the food but approaching it slowly, licking a bit of yogurt here, there, then eating as gracefully as a cat. He had a thick, fluffy tail and looked like a Westie out of a calendar.

"He's beautiful," I said. He looked bright and energetic.

Maureen could have been his grandma by the size of her smile. "He truly is, and a sweetheart, so it's sad that Bar—"

"She doesn't like him?"

Maureen sat down heavily across from me. "I wouldn't go that far. But he is, was, Vlado's dog, not that he took care of him well enough. So who do you think killed Vlado?"

It was oddly timed and even odder given where we sat, but I told her how I'd finally landed on Fabian as a suspect, and while

I spoke, I experienced the same kind of double consciousness I often had in the classroom. I heard and observed myself speaking, judged the performance, while holding part of myself back. Only here, I wasn't telling her the truth, because in the last half hour I had completely changed my mind and felt I knew for sure who the killer was and even understood how the murder had been committed. What I would do with this knowledge was momentarily beyond me. I felt I was drifting in a lifeboat, a ship struck by torpedoes going down behind me.

The front door opened, and Barbara Zamaria called, "Hello?" Radovan tore out to her but she didn't do any of the cooing you'd expect from someone with a dog that adorable.

"We're in here," Maureen called, and Barbara entered the kitchen without a coat, the Westie whirling around her with a little squeaky toy in his mouth. He shook it at her, clearly expecting some kind of game, but she didn't engage with him.

"Finish your dinner," was all Barbara said, taking the toy from his mouth, pointing him towards his unfinished meal, and pushing him to the bowl, a bit too roughly, I thought. "Thanks," she said to Maureen, then looked from her to me and back again, eyebrows slightly arched. With her hair clipped back, she was wearing black, and no makeup, and looked the way Juno had first described her to me: drab, inconsequential. You'd never notice her passing you.

"He was knocking at your door, I invited him in," Maureen explained. "Then we came over to feed the dog because it was getting late."

Barbara sighed, and she struck me as looking as faded as her house. She glanced around her as if wondering where she was and how she could escape, if she only had the energy.

"You can't keep this going, sweetie," Maureen said softly, and Barbara started to cry. Maureen shrugged. "If I guessed, and *he's* figured it out, the police probably have, too. He's just an amateur like me, remember?" She smiled my way, showing she meant no insult by that characterization.

"How did you know?" Barbara asked me, face creased and broken-looking, leaning back against a Formica counter.

"I didn't think it was you, not right away, not until tonight. And I don't have it all figured out, just some. Juno told me you were inconspicuous. But when I first met you, you were wearing bright colors. Why would you be dressing like that after your husband died? Even if you were glad he was dead, you wouldn't want anyone to see it. It was to throw people off, that's not how you really dress, but you had to get the image of you as inconspicuous out of everyone's heads. Because when you went into the steam room, you were wearing black like all the attendants who carry towels, and you had a cap, and your head was down. Nobody pays attention to them when they scuttle by. They're invisible. All you needed was black pants, cap, and a black polo shirt. They don't even have a logo on their shirts, which was perfect for you since you didn't have to steal one."

She nodded soberly, wanly, as if wishing she really were invisible.

"And you had that pair of silicone oven mitts stuffed in the pile of towels." I pointed to where the pair loomed atop *The Joy of Cooking* behind her. "He was killed midmorning and it's mostly men working out then. So neither one of the women's locker rooms would have been crowded, and you could get some towels and nobody would notice." She was short and slight and boyish enough to make it work. Juno could not have carried off a similar disguise.

Maureen was studying Barbara, with deep sympathy and pain etching more lines on her face. Off in the living room, the puppy had some toy that was making a kind of pig grunt in odd counterpoint to the serious sounds here in the kitchen.

"You used a silicone kitchen glove to take a lava rock from the sauna heater. And you put the rock into another glove. When you hit him, the glove covered the rock so that there wouldn't be any burn mark, just the fracture to his skull."

Barbara glanced away.

"Did you loosen the grate?"

"It was loose the first time I checked," she brought out. "Maintenance doesn't know."

I pictured her sneaking the rock back into the sauna. Nobody would have suspected it could be used as a weapon.

"You probably didn't go in through the front, because then they would have you on the computer as being in the club when he was killed. You went through the back, behind someone else–I just figured out today that you can do that."

I took her silence as a yes. And Maureen studied the both of us, seeming not to have heard all these details.

"You knew Vlado's schedule that morning."

"Every morning," she said quietly. "And he always goes to the steam room around the same time." She didn't correct her tense.

"So did you put Valium in something?"

"His oatmeal," she whispered, sounding years younger. Maureen rose and brought her over to the table, but Barbara wouldn't sit, just stood there hugging Maureen like a child holding fast to the mother she thought had abandoned her.

"And you did put the rock back?" I asked, wanting the scenario to be finished in my head.

Barbara was beyond answering now, she was crying steadily and softly. I looked at her in her slacks and black sweater and marveled that she was a murderer. She seemed so ineffectual, so harmless, so *small*.

"Why didn't you get a divorce?" I asked. "Since he was abusive."

And now she glared up at me, eyes wild. "I woke up one night, in the middle of the night, after I told him I was sick of his affairs and he had a hand around my throat and he was smiling and he said he could kill me with just that one hand, right then, and nobody would find me until the next day. He wasn't joking. And he said if I ever tried to leave him or had an affair,

I'd be dead. He wouldn't let me go. He was a devil. He said he could do whatever he wanted with me, because I was his wife! He said it was his right."

Maureen shushed her. "One of the gals in our reading group, her son is an attorney. We'll call him, sweetie, and you'll tell him everything. And we'll all go to the police together. You have to, before they come and get you."

Barbara gazed at me with entreaty, and I nodded. I did not need to turn her in.

Radovan, apparently annoyed at being left out, had wandered over to me, pushed his head against me and I scratched his neck, wishing I could live a life filled with such simple pleasures as he had: food, yard, walks, chasing squirrels. All of it.

Barbara looked like a rag doll that hadn't just lost its stuffing, but had somehow been thrown into the wash. "What about the dog? I can't deal with him anymore, it's too much."

"I'll take care of him," Maureen said. "Trust me." She filled an electric kettle at the sink, plugged it in, and set it to boil, while rooting around in a cupboard for tea. She clearly knew her way around this kitchen. She made Barbara sit down and asked me if I could hold my peace until the police were told. Humbled by Barbara's story and by her grief, I nodded. It was one thing to work it all out in my head as if putting together a model of a ship, it was another entirely to see that this wasn't about parts, but about lives gone terribly wrong. As my own might be, very soon, if Stefan decided he was going to leave me because he wanted to live with a Catholic. It wasn't inconceivable. I thought then of a haunting line of longing in *The Thin Red Line*: "How do we get to those other shores, to those blue hills?"

Maureen raised her eyebrows at me and I knew it was time to go. She saw me to the door and whispered, before I walked outside and she closed the door behind me, "He was a beast. Having affairs wasn't enough, he had to have photographs, too."

"I know about the photos."

"No you don't." Maureen clutched my hand, her face twisted with revulsion. "He made *her* take the photos. When Barbara told me that, I knew there was only one way it could end, and there was no way I could stop her."

Epilogue

NEXT FRIDAY, with classes beginning on Monday, I was summoned to the department chair's office at EAR by a phone call from his secretary. The call came at 8:05 A.M. and woke me from a long dreamless sleep, which I had desperately needed. After Stefan's burst of communicativeness, he had relapsed into brooding, and I felt somewhat broody myself, wondering not just where my life was headed, but why and how I had been swept up into investigating a murder I should have left alone. I felt sorry for Barbara, who had been released on bail supplied by Maureen Jones, but more than that I felt stained and assaulted by everything I'd learned in the last week or so. Life seemed more than particularly nasty, dull, brutish, and short.

Stefan was snoring, and I left him a note after I showered, dressed, and made a quick breakfast. I had no idea what was up at the university. My role, such as it was, in the follow-up to Vlado's murder had not been advertised in any way that I was aware of. Maureen Jones had promised not to mention me at all to Detective Fahtouzi, and Juno, crushed to have missed the confession scene, was off in Chicago shopping. She was now more interested in buying Rodolphe Menudier fox fur boots, or their equivalent, than talking about Vlado's murder.

Parking at EAR's dilapidated building, I felt the kind of dread that in movies is accompanied by theremin music. My new chair, Byron Summerscale, had recently risen to the top through politicking as arcane as some of the references in *The Da Vinci Code* and he didn't like me, didn't seem to like any-

one. When I got to his office, which still had the air of a stage set in a play about the Raj in the 1920s, he was flanked by SUM's provost Merry Glinka, and someone else I didn't know. Summerscale loomed behind a massive dark desk looking like Death eating a sandwich, despite his double-breasted chalk-stripe blue suit, sky blue tie, and carefully brushed hair, which belied his hippie-ish, rabble-rousing past. Before his elevation, Summerscale had worn Birkenstocks, dashikis, torn jeans or baggy chinos, and he had actually helped spark a small riot at the university. Now he was a suit. A big, loud suit, but a suit just the same. Like so many of the powerless at our university, once given the chance to exercise any power at all, he had started to abuse it. He had been victimized, so he felt entitled to victimize others. I'd heard a rumor that he refused to read his own e-mail now, but insisted that his secretary read it aloud to him, while he dictated answers for her to send back. He claimed it saved time, but that was ridiculous.

Glinka was our university's real power, in control of the purse strings, a helmet-haired Borgia who seemed to detest me, and today she was dressed as usual like a chorister on the Lawrence Welk Show. As for the mystery man, he seemed just as unhappy as the other two. He was pale, frayed, with a senatorial comb-over and big ears. He reminded me of a Vermont friend's favorite insult: "He looks like a bag of assholes with the best ones picked out."

"This is the university attorney, Parker Bush," Summerscale said, with an air of threat, and I wondered what kind of legal jeopardy I could possibly be in. Was someone sueing me and the university together?

I wasn't asked to sit down, but I sat anyway. The last thing I needed was to feel like a schoolboy talking to the principal.

Bush got the ball rolling, speaking to me as if he found our propinquity in a room of any size offensive. I'm sure he wasn't used to talking to as lowly a creature as an assistant professor. "The university has received a donation from a former student

of yours. His father invested in Halliburton before the war and has made a killing." Bush briefly looked uncomfortable at his choice of words but suppressed whatever he was feeling. "He left most of his money to his son, who was in one of your classes and liked you very much as a teacher." Bush paused, looking even paler, evidently strained by the effort of saying something nice about me, even secondhand. "The son doesn't want anything to do with the money himself." Bush frowned and added darkly, "Apparently some kind of malcontent."

"It's a donation for me?"

"Not for you!" Summerscale rumbled. "Idiot."

Glinka put a hand on his shoulder to quiet him down. I eyed the door, speculating on how fast Summerscale would be if he leapt across the desk to assault me and whether I could get out in time. He had a madder-than-usual Captain Ahab gleam in his eyes.

Bush went on. "It's to establish a visiting lectureship. Once a year, a writer or scholar or public figure will be in residence for a full week, teaching, giving lectures, et cetera."

"So what do I have to do with this? I don't get it."

All three of them looked like I'd farted. Clearly, like the figure in the Mozartean opera within *The Phantom of the Opera*, my role was to be silent.

Summerscale slammed his meaty paw down on the desk and bellowed, "You're going to be the director of the program, you get to make the decisions, you pick the guest, you're in charge. That was a condition of the gift."

Bush corrected him: "There's actually a committee of two other faculty members who will assist and advise you."

A committee, I thought, with a twinge. But at least it was small, and I was in charge.

Now Glinka spoke up, quietly. "It means a substantial raise in your salary, immediate tenure, and promotion to full professor. That's appropriate," she added grudgingly, as pained as if she were a saint going to her martyrdom. "Appropriate for

someone in your new position." In other words, it would look strange if the university let a pipsqueak direct this new program, so they had to elevate my status.

I thought of a line from *Cymbeline*, which Stefan and I had seen the previous summer at the Stratford Festival in Ontario: "Fortune brings in some boats that are not steer'd."

"You've been asked to give the program a title. The university will control the fund, but you'll control the interest it earns and determine remuneration for the guest speakers," Bush added with a disgusted frown. He made those speakers sound like a cross between lepers and moderate Republicans.

"Who's the student? How much money is it?"

Bush told me a name that didn't ring a single bell, Schuyler Overpeck, and you would have thought it might. Then he added, "Two million dollars."

As cable news networks love to declare about almost anything, this was a "miracle." Like Alexander the Great's sword cutting the Gordian knot, the news changed everything in a single stroke. I finally, triumphantly, had security and status in a department where I had up till now been classed as a nobody to those who ignored me, and a menace to those who didn't. Not so long ago, when it looked like I would never get tenure at SUM, I had wondered if I even wanted it, wanted to be committed to academic trench warfare. Yet now I felt as defiant as Huck Finn declaring that all right, he *would* go to hell.

"Where do I sign?" I asked, feeling like a superhero just discovering the extent of his powers. "I'll need a bigger office, of course. Plus a secretary to handle all the correspondence and publicity. And my own letterhead, too."

I was just getting warmed up, and though they didn't keen or curse like *Macbeth*'s Weird Sisters, I could tell they wanted to.

Gersh Kaufman

About the Author

A prize-winning author of seventeen books in several genres, Lev Raphael is the host of *Book Talk* on Lansing Public Radio. His books have been translated into nearly a dozen languages. He lives in Michigan with his partner of twenty-one years, and they recently married in Canada. He welcomes visitors and e-mail at www.levraphael.com.

MORE MYSTERIES
FROM PERSEVERANCE PRESS
For the New Golden Age

JON L. BREEN
Eye of God
ISBN 978-1-880284-89-6

TAFFY CANNON
ROXANNE PRESCOTT SERIES
Guns and Roses
*Agatha and Macavity Award
nominee, Best Novel*
ISBN 978-1-880284-34-6

Blood Matters
ISBN 978-1-880284-86-4

Open Season on Lawyers
ISBN 978-1-880284-51-3

Paradise Lost
ISBN 978-1-880284-80-3

LAURA CRUM
GAIL MCCARTHY SERIES
Moonblind
ISBN 978-1-880284-90-2

JEANNE M. DAMS
HILDA JOHANSSON SERIES
Crimson Snow
ISBN 978-1-880284-79-7

KATHY LYNN EMERSON
LADY APPLETON SERIES
**Face Down Below
the Banqueting House**
ISBN 978-1-880284-71-1

**Face Down Beside
St. Anne's Well**
ISBN 978-1-880284-82-7

Face Down O'er the Border
(forthcoming)
ISBN 978-1-880284-91-9

ELAINE FLINN
MOLLY DOYLE SERIES
Deadly Vintage
(forthcoming)
ISBN 978-1-880284-87-2

HAL GLATZER
KATY GREEN SERIES
Too Dead To Swing
ISBN 978-1-880284-53-7

A Fugue in Hell's Kitchen
ISBN 978-1-880284-70-4

The Last Full Measure
ISBN 978-1-880284-84-1

PATRICIA GUIVER
DELILAH DOOLITTLE PET
DETECTIVE SERIES
The Beastly Bloodline
ISBN 978-1-880284-69-8

NANCY BAKER JACOBS
Flash Point
ISBN 978-1-880284-56-8

JANET LAPIERRE
PORT SILVA SERIES
Baby Mine
ISBN 978-1-880284-32-2

Keepers
*Shamus Award nominee,
Best Paperback Original*
ISBN 978-1-880284-44-5

Death Duties
ISBN 978-1-880284-74-2

Family Business
ISBN 978-1-880284-85-8